ReMembering the Body

This book is published on the occasion of the exhibition STRESS at the MAK, Vienna

Editors
Gabriele Brandstetter, Hortensia Völckers
on behalf of tanz2000.at (a cooperation of Wiener Festwochen and Im Puls-Tanz)

Assistant editors
Claudia Blümle, Verena Stössinger, Heide Wihrheim

Copy editing
Tas Skorupa

Editorial coordination
Regina Dorneich

Translations
Andrea Scrima, Rainer Emig (text by Siegmund)

Book Design and STRESS image-essay
Bruce Mau Design. Bruce Mau with Anita Matusevics,
Barr Gilmore, Maris Mezulis.
Image research by Kyo Maclear.
STRESS texts by André Lepecki.
STRESS texts edited by Kyo Maclear.

Photo credit
Photoarchiv C. Raman Schlemmer, I-28824 Oggebbio: p. 161

Reproduction
Bruce Mau Design
C + S Repro, Filderstadt

Typesetting
Bruce Mau Design
Archetype, Toronto

Printed by
Dr. Cantz'sche Druckerei, Ostfildern-Ruit

Published by
Hatje Cantz Publishers
Senefelderstraße 12
D-73760 Ostfildern-Ruit
Tel. 00 49 / 7 11 / 4 40 50
Fax 00 49 / 7 11 / 4 40 52 20
Internet: www.hatjecantz.de

Distribution in the US
D.A.P., Distributed Art Publishers, Inc.
155 Avenue of the Americas, Second Floor
USA-New York, N.Y. 10013-1507
Tel. 212-627-1999
Fax 212-627-9484

ISBN 3-7757-0905-3

Printed in Germany

ReMembering the Body

Edited by Gabriele Brandstetter and Hortensia Völckers
With **STRESS**, an image-essay by Bruce Mau with texts by André Lepecki

Hatje Cantz Publishers

Contents

10 Preface

14 Introduction
 Gabriele Brandstetter

44 ***Membra disiecta*: Embalmment and Anatomy in Egypt and Europe**
 Aleida and Jan Assmann

 42 Re-Membering Osiris: From the Death Cult to Cultural Memory
 Jan Assmann

 78 Body, Text, and Transcendence
 Aleida Assmann

102 **Choreography As a Cenotaph: The Memory of Movement**
 Gabriele Brandstetter

136 **Bending towards the Breaking Point: The De-Formation of Dance and Mannerist Images of the Body**
 Gerald Siegmund

224 **The Human Touch: Towards a Historical Anthropology and Dream Analysis of Self-Acting Instruments**
 Allen Feldman

260 **From Poetry to Prose: Sciences of Movement in the Nineteenth Century**
 Friedrich Kittler

272 **Step by Step – Cut by Cut: Cinematic Worlds**
 Gertrud Koch

286 **Images of the Body: On Sensory Perception in Medicine and in Everyday Life**
 Peter Moeschl

302 **The Other City of Silence: Disaster and the Petrified Bodies of History**
 C. Nadia Seremetakis

332 **Still: On the Vibratile Microscopy of Dance**
 André Lepecki

368 Bibliography

374 Index

378 Biographies

Stress is the inevitable outcome of a system that incorporates every gesture into a global competition for resources. It is a condition that announces the brutal inscription of a system of production pushing the body's endurance to ever new limits. Stress seeps into the body, shaping flesh, dreams, images, desire, policies, products, life forms, value, violence. Stress expands into the world, creating a new, post-natural ecology – an information-based ecology, aimed at the ultimate fusion of capital and nervous system. The techno-neuronal system produced by this stressed ecology provides contemporaneity with a new gestural lexicon for the human body – behavioural templates for the survival of the fittest. Parts of this lexicon were identified, alphabetised, explored, and rendered in their visual/visceral aspect in the installation "STRESS".

Streß ist die unvermeidliche Folge eines Systems, das jede Geste in einen globalen Kampf um Ressourcen einbindet. Es ist ein Zustand, der die brutale Einschreibung eines Produktionssystems anzeigt, das die Grenzen der Belastbarkeit des Körpers immer weiter hinausschiebt. Streß sickert in den Körper ein und formt das Fleisch, die Träume, Bilder, Begierden, Strategien, Produkte, Lebensformen, Wertbegriffe und die Gewalt. Streß greift über auf die Welt und bringt eine neue, post-natürliche Ökologie hervor – eine auf der Information basierende Ökologie, die auf die endgültige Fusion des Kapitals mit dem Nervensystem abzielt. Das techno-neuronale System, das von dieser gestreßten Ökologie erzeugt wird, hat ein neues gestisches Lexikon für den menschlichen Körper hervorgebracht – Verhaltensmuster für das Überleben des am besten Angepaßten. Einige Artikel dieses Lexikons wurden in der Installation »STRESS« identifiziert, alphabetisch geordnet, untersucht und in ihrer visuellen/emotionalen Gestalt wiedergegeben.

An image-essay by Bruce Mau
with texts by André Lepecki.

Preface

Remembering the body, calling the dismembered and reunited body to memory –
wasn't that the signature of the 20th century? And isn't it the rivalling media –
image, movement, and writing – within which this process of forgetting and remem-
bering developed?

The project "ReMembering the Body" set out to take the representation of the
body and of movement as its subject in three different media of presentation exist-
ing in our culture, and to place these in relation to one another: in a dance festival,
in an exhibition, and in book form. Each of these media, taken separately, has
brought forth its own complex tradition of body representation. The challenge was
to bring about an exchange between these conventions of representation, and to do
the complexity of this interrelationship justice while preserving the independence
of the three forms of presentation.

The tension within this constellation of media suggested to us that we should
be raising questions concerning the representability of the body and presenting con-
cepts and images of the body as a remembered history extending into the future.
In the process, it has been important to include those discourses and scholarly
scenarios of our Western world which have made a deep impression on our concept
of body and movement: scientific reflection, from anatomy to media science; the
image archives of the body created both in art and the media; and the fleeting per-
formances of movement theatre and of dance.

An open project such as this one – "ReMembering the Body" – requires a frame-
work and structures capable of making an experimental field of this kind possible
in the first place: in the nexus of various institutions such as (dance) theatre, exhi-
bition, university, and publishing; in constructive work and in experimental thought

ALARM

between different disciplines. Our special thanks go to "tanz2000.at", a cooperation of the Vienna Festival and Im Puls-Tanz, which was called into being for the unique purpose of making a project of this kind possible: a constellation of festival, exhibition, and book project which crosses back and forth between the disciplines. Without this bonus of trust, without this generous and unconventional support, this project would never have been able to succeed.

Thanks to the cooperation with Bruce Mau, it became possible to realise the book project *ReMembering the Body* concurrently with the exhibition *STRESS*. In this way, a catalogue to the exhibition has been produced which neither illustrates nor documents, but rather creates another venue. The image-text, created by Bruce Mau, and the essays in this volume, written by the representatives of different disciplines, are each able to stand on their own, with each developing individual panoramas on the theme "images of body in motion". Peter Noever, the director of the MAK (Austrian Museum of the Applied Arts) in Vienna, evinced an openness and readiness to take risks on this unusual combination of exhibition and book. We extend many thanks for this productive cooperation.

Producing a book such as *ReMembering the Body* requires a publisher that bears part of the experiment. We were able to find this partner in Hatje Cantz Publishers. Our special thanks go to Annette Kulenkampff, who has supported this book project from the very beginning with interest, advice, and action, and has accompanied its transformations in concept with flexibility and humour.

We would like to thank the authors of this book for their readiness to contribute to this theme with fundamental reflections coming from their respective areas of scholarship and work; and finally, all persons who have contributed to the realisation of the project – especially Heide Wihrheim, Verena Stössinger, and Claudia Blümle for their indefatigable and competent support in the sometimes hexed organisational and editorial production of this volume.

January 2000
Gabriele Brandstetter and Hortensia Völckers

Clocks ticking ubiquitously, in alarming precision, regulate the global system. Electronic impulses synchronise labour with capital, missiles with targets, catastrophes with their images. Gradually, the constant state of alertness this ceaseless pulsing provokes is embodied as state of emergency. Alarming clocks everywhere, counting the beat, from birth to dying.

Überall ticken Uhren, mit alarmierender Genauigkeit, und regulieren das globale System. Elektronische Impulse synchronisieren die Arbeit mit dem Kapital, Geschosse mit Zielen, Katastrophen mit ihren Bildern. Allmählich nimmt der beständige Zustand der Alarmbereitschaft, den dieses unablässige Pulsieren erzeugt, körperliche Gestalt an als Notstand. Überall alarmierende Uhren, die den Takt schlagen, von der Geburt bis zum Tod.

Introduction

Gabriele Brandstetter

It is quite significant that our own body is inaccessible in so many ways: we cannot see our face, our back, our head – the most elegant part of our body – we cannot lift ourselves up with our own hands, cannot embrace ourselves [...]. Thus it is essential that our body metamorphose us in the moment of pure perception. – *Walter Benjamin*

The contributions to this book all focus on the perception of the body and its transformation throughout modern history. The intention here is a revision of the theme of "the body", a theme which at the end of the century is present more than ever in the discourses of art, the sciences, and the media. The body is referred to, remembered, and upheld as a residue of the animalistic quality in mankind in the face of the rise in transhuman visions of the world. At the same time, the body nevertheless appears increasingly abstracted in images, writing, and numbers – indeed, it is apparently hardly possible any more to render the body and movement visible in a theory of the civilisational process.

It remains undisputed that the body occupies a key position in Western culture. For, to be precise, "the body" is comprised of a multitude of bodies and concepts of bodies which are all available in a modern society for the purpose of forming identity: a veritable assortment of all body types which guide the strategies of body formation and its masquerades. At the same time, this perfecting process repeatedly entails a mystification of the body. Complex rules of codification determine the choice and the arrangement of body markings and signs; it is only a certain label and its legibility, the meaning of the label, which in the end signalise identity, the affiliation with certain social groups and their respective practices of body

modelling. But where are the boundaries of those disciplinary and representational practices which Michel de Certeau called "apparatuses of incarnation"?

Jean Baudrillard wrote that the body is the most beautiful and favourite consumer object, its value of exchange and of erotic implementation being universally applicable. But what does this value of exchange consist in, and how might the convertibility of this body currency be determined? And might it not suddenly turn out to be counterfeit? To find this out, the cultural forms of representation and the corporal structures of performance must be examined more carefully. The question as to the possibility or the impossibility of representing the body crops up here time and again. "I'd like to know how we represent with the body" is a central concern for the choreographer William Forsythe. And this question is addressed not to a static body, but rather to the human body in motion.

Movement is the magic formula which left a deep impression on the mentality and everyday world of the 20th century. The fathers of the modern period – Baudelaire, Nietzsche, Proust, Valéry – all regarded human movement as a corollary of the new technologies and media. Film, to all intents and purposes the genre of the 20th century, exposes the paradox of movement: the inextricable interweaving of stillness and motion, of body image and the simulation of movement.

For this reason, it is the body in motion and moving bodies which are the subject of this book. The theme of dance and choreography runs as a leading thread throughout the images and texts. For, like no other form of art or knowledge, contemporary dance and movement theatre reflect and test out the representational possibilities of the body in motion – guided by the perception that the moving body cannot be fixed as a unified form. Choreographers such as William Forsythe and Meg Stuart are concerned with this problem of representation and with finding new solutions for it – solutions which do not presuppose the body, its images, the writing and reading of it as given, but rather postulate the body as a hypothesis and orchestrate figures of its dissolution. "Dance, the body itself only exist in a form of time" (William Forsythe). This aspect of temporality, as "a form of time", also harbours precisely that experience of the perception of body as it passes through representational traditions. The "occurrence", the performative energy of the (moving) body, evades any attempt at translation.

ReMembering the Body – this title conjoins two areas of inquiry. "Remembering the body" touches on the complex subject of the memory of the body and of movement and the concomitant processes of remembering and forgetting. And at the same time, "re-membering the body" signifies the dismantling of the body and its reassembly, and thus also refers to the specifically Western problem that

has existed since the Renaissance: that of the subject and of corporeal identity. Inextricably bound to this is the body as a location of memory. Which myths, which ritual practices entrust the ephemeral, mortal body to cultural memory? And are these not often acts of dis-membering and of re-membering reconstruction? The mnemonic monuments (as writing, as image, as architecture) which are erected upon the "handed-down body" denote a paradox: they mark and veil death, and they reconstruct a synthetic body out of the *disiecta membra*.

In the attempt to remember the body, a process begins which sets in motion the remembered images, the traces of the body's history. Admittedly, these are always only parts and fragments which assemble themselves again and in different ways in this process. Fragments, limbs, and torsos thus reach us from the imperfect storage of the memory of movement: "ReMembering the Body" as a historically changing formulation and reformulation of the memory of body cannot, for this reason, be based on an intact natural body which is in harmony with itself. On the contrary, history and the creation of myths involve violence, destruction, pain, and loss: dis-membering the body. This dismemberment has always taken place – "the body in parts".

A book such as this carries out a kind of searching for traces as an archaeology of the body. This project is also intended as a forum for the discussion of perceptual processes which give rise to the body experience in the first place. Michel de Certeau referred to two basic operations which characterise such interventions: additive and subtractive practices of working on the body.

> One is concentrated on *removing* an element from the body, the superfluous, diseased, or unaesthetic, or *adding* to the body whatever it might be missing. The instruments differ according to the task for which they are implemented: cutting, tearing out, removing, taking away, etc., or inserting, placing into, gluing onto, setting on top of, assembling, sewing, fitting together, etc. – not to mention the things which replace missing or damaged organs...

But where are the boundaries of such manipulative practices and the mechanisms of body representation that go along with them? Which part can be allocated to the senses in the changes of perception, and how do the processes of partial and total anaesthetising take place within the framework of the political and economic implementation of the body? Are these processes of anaesthetising not complementary to that long and painful history in which physical violence was made aesthetic? And which part do the development and differentiation of technologies and media play? Our goal here is to once again discover bodily movement in the

theatre of perception, representation, and recognition of our Western culture, and to pursue this with a gaze that has become sensitised – through the phenomena of globalisation and the post-colonial and gender-political perception of difference – to the alien in one's self. What emerges over and over again as the central problem in reconstructive attempts such as these is the question of the (un)representability of the body.

The following contributions reflect this problem of representation and thereby enter into a paradoxical writing situation: to nonetheless speak of the impossibility of representation in text and image without postulating bodily movement as positively established, as a given. In this way the question of the body is to a certain extent passed on, delegated: it cannot be substantially answered, but is rather arranged according to specific historical concepts of perception.

The essays collected here reflect facets of this complex problem of the perception of the body, which, the more it appeared to have been analysed and understood through science and art in the 20th century, the more it became transformed into an "unfocussed object". The texts are grouped around those fundamental categories which refer to the forms of observation and representation: space and time, on the one hand, and the media – as a process of transferral – on the other.

The first three essays (A. and J. Assmann, G. Brandstetter, G. Siegmund) examine from different angles the relationship between the body and space. The body itself is not a given, natural (spatial) unit, but rather becomes configured, as it were, through images and myths which postulate it as a symbolic force (for example in the myths of Osiris and Orpheus) and as a rhetorical figure (for example in Mannerism). In this way, concepts of the body arise as topographies and choreographies (both meaning the description of space): a body realisation which at the same time describes a mnemonic space.

The next three essays (A. Feldman, F. Kittler, G. Koch) are dedicated to questions concerning the media-orientated and virtual nature of the body. Since the Renaissance, the perception of the body cannot be conceived as being in any way removed from the conditions governing its "format" in the media. In a perspective of this nature – regarded not merely *as* a lens, but rather at the same time observed *through* the lens of its constitution in the media – the body appears as an artificial figure and automaton, as a film body, a computer-animated "datum". Yet the interfaces of this body created by the media are not concealed, but are part of the horror scenario of perfect anthropomorphic morphing.

The third group of contributions to this book (P. Moeschl, N. Seremetakis, A. Lepecki) brings together considerations on the subjects of time and temporality.

The body, even when we think of it as being "at rest", is at all times a body in motion. A phenomenology of the body necessarily implies a microscopy of motor processes: the "vibratile body" is the unfocussed object of various discourses – fleeting, dissolving, impossible to grasp and hold as an unequivocal image. In contrast with this dimension of the body's continual subjection to the temporal is the aspect of the time boundary: the liminal turning point of death, the dismemberment of the individual as well as of the collective body. Only an archaeology of the remembered images, through another formation of time in layered form – as a chronotope – can restore the body: a "ReMembering" as a figure of temporality.

Space and making spatial, time and making temporal, the media and making "medial"; these do not only mark the forms and conditions of perception, but are also the fundamental parameters of the body art that dance is – choreography. Thus regarded, dance forms something like the paratext of the texts and images configured here: less as a historic and exemplary object of analysis, and more as a paradigm of the representation of the body in motion. As choreography, the complex changes in perception which occurred in the modern period are converted into a spatial and temporal form: re-membered as art/figure.

The first key scene of "ReMembering the Body" is told in the ancient Egyptian myth of Osiris: in the story of the god Osiris whose body was dismembered and scattered over the land by Seth. The goddess Isis collected the dispersed limbs – *disiecta membra* – and fitted them back together again to form the body, thereby restoring it to life. In the myth of Osiris, a figure of memory unfolds as a process of the fragmentation and the re-collection of the body.

Aleida and Jan Assmann's contribution traces the "metamorphoses" of this myth of the *membra disiecta* from the ancient Egyptian death cult up to its transfiguration following the Renaissance. In each essay section, the process of "ReMembering" appears in doubled form: on the one hand, as a restoration of the body into symbolic form, and on the other, with the fragmented and dispersed limbs designating the political body, as Jan Assmann demonstrates with the example of the Osiris cult and Aleida Assmann with John Milton's political allegory of the power relationship between head and body, head and limbs as "body corporate".

In his essay, **Jan Assmann** investigates the concept of body which was dominant in ancient Egypt. There not the living body is at the centre of attention, but the body which first had to be created – after death – through the rituals of embalment: the "final form". This form, assembled from the mortal remains and veritably "formatted" limb by limb, produces that body which becomes immortal, even divine through the process of its cultural construction and its implicit religious signification.

"Re·membering" does not merely refer to the mental process of recollection, but rather to a quite concrete body ritual through which the person is restored to a whole "under the conditions of being deceased" and transformed into a symbolic form. The body image at the heart of this is not a "natural" one, thought of as a unified entity, but is rather a "constellative body" assembled out of the multitude of its disparate parts. The transformation process is based on a process of transferral: after death, along with the body's subjection to the physical practice of embalm·ment, it receives its symbolic form through writing. The reintegration of the limbs into a final form is accompanied by metaphorical texts. The dispersed limbs are named individually in liturgical manner, collected together as a linguistic body, and brought into eternal form as the text of a lyrical "limb deification".

Bodily practices and rituals of language work together in this process to recre·ate the body as a symbolic form and pass it on to posterity as a figure of memory. This immortalisation of the mortal body takes another turn within the context of the Christian-Western tradition, as **Aleida Assmann**'s text demonstrates. In con·trast to the Egyptian world, the transfiguration, as a transference of the body into another form, is here simultaneously a transfiguration in the Christian sense, with the spiritual taking the place of the corporeal. The Osiris myth of the dismem·bered body once again restored to its former unity was incorperated into a rational image of the world in subsequent times. In the Christian-Western view of the world, death marks a boundary which separates the *body* as matter subject to destruction from the *soul* as a metaphysical form of existence. This involves a concept of the body which no longer subscribes to the Egyptian idea of transfiguration, but rather to the logic of transcendence. The body is no longer comprised of its recollective parts. Instead, the final form follows the idea that the whole is more than the sum of its parts. Taking the example of John Milton's "Areopagitica", which offers an interpretation of the Egyptian myth of Osiris, Aleida Assmann traces a modern form for reading the body and its dispersed parts: as a political fable of the head and its limbs. The final form of the body, the concept of which evolves from the logic of transcendence, is not the transformed body as it is in ancient Egypt, but rather the book – which becomes the vessel of cultural memory in the sense of an immortal textual corpus.

The words 'disiecta membra', which offer the basic formula for the constructive process of "ReMembering", can be traced back to Horace. The "disiecti membra poetae" refer here to the poet Orpheus, whose body was torn apart and scattered about by the Thracian women. The ancient myth of Orpheus thus contains a basic scene of memory which – differently than the Egyptian myth of Osiris – is bound to

the transgression of the boundary of death and, at the same time, to the loss of the body's integrity. In **Gabriele Brandstetter**'s essay, the figure of Orpheus, who crosses the interspace between Earth and the realm of the dead in his search for Eurydice, accompanies a movement of thought which revolves around the connection between body and memory, movement and notation. One of the oldest forms for handing down the memory of movement is the recording of it in writing – as a notation of movement. In this context, the concept "choreography" points to two things: the fixing of spatial paths and bodily movements in a movement script, and the activity of choreography, that is, the composition of movement as spatial script. This movement itself is clearly transitory, while the dance is always remembered; writing and the notation carry the traces of this loss.

Yet how is the memory of movement formed? Brandstetter pursues this question using examples of various concepts for the memory of movement in the choreography of the Renaissance and the 20th century. Renaissance theorists as well as Postmodern choreographers such as William Forsythe, for example, develop in very different ways a system which situates memory as a phantasmal movement between the rhetoric of the body and cartography. Moreover, to the extent that the capacities for computer memory and animation have opened new storage possibilities in the 20th century, the aspect of the unpredictability of movement becomes a productive one: as an uneasiness and as a fallibility of a concept of body for which memory is not a reliable instrument for reproducing movement, but is rather a remembering interspersed with gaps of forgetting and of the inaccessible. The pattern of the chance that this fallible remembrance of movement opens up is falling: the loss of equilibrium and the disruption of skilled movement. This work of "ReMembering" – the memory of a body which has slipped out of its form – opens up a poetry of movement which is different than that of the choreographic script: a poetics of disappearance which risks the unexpectable in the rejections and the confusion of fragmented images of the body, and which leads the viewer into a limbus of subjective body memories.

Fluctuations in perception and the formation of a plural concept of body also mark the images of the body in Mannerism which **Gerald Siegmund** observes in his contribution. The dynamics which characterise these images of the late Renaissance reveal a peculiar autonomy of movement, of agitation. Characteristics of the Mannerist representation of the body – the shifting of classical proportions, the organisation of space and the form of the body, all of which are deformed as though in a distorting mirror – follow a movement-orientated pattern of perception. Anamorphosis is the paradigm for the dissolution of a static pictorial composition

based on the compositional principles of one-point linear perspective: that bending of the bodily form which results from adding a perceptual perspective to the process of observation by means of a convex mirror. The anamorphic view implies a change in the viewer's point of observation – as well as the movement of the viewer himself; it also opens up another dimension in pictorial space, thereby also inserting movement into the picture. Thus, anamorphosis reveals a compositional principle which is essentially theatrical: as a perceptual option, it creates a space for movement within the picture. Siegmund traces the inherent concept of movement of the Mannerist body image with the question as to how the formation principles of Mannerist representation can be transferred to Postmodern dance. In the process, he singles out two stylistic figures which have an important meaning for the images and rhetoric of Mannerism: the arabesque and the *concetto*. The arabesque as a pictorial composition and the combinatorics of the *concetto* as textualisation can be reconstructed as two patterns for the representation of body and movement in 20th-century dance. In the juxtaposition of examples of works of important choreographers both at the beginning and at the end of the 20th century, it becomes apparent how these compositional techniques are, firstly, effective, and, secondly, have themselves experienced a transformation: on the one hand Loïe Fuller and William Forsythe, both influenced by the arabesque as a spatial and bodily figure, and on the other Oskar Schlemmer and Meg Stuart, influenced by *concetto* combinatorics of text and body.

A system which is different from that of the Mannerist moving gaze governs the mechanistic image of the body. **Alan Feldman** analyses in his article which perceptual structures are linked to a mechanistic image of the body, as can be seen in the history of the automaton. Feldman assumes, following Michel Foucault, that the development and function of the automaton run parallel to the discourse on the political and economic instrumentation of the human body. In an sketch of the history of machine bodies and musical automata, he traces their development from the early time-measuring apparatuses to the musical clock mechanics of Athanasius Kircher and Robert Fludd in the 17th century and up to the anthropomorphic automata of the 18th century. These figures imitated human activity perfectly, including artistic activity as well as "natural" bodily processes. The machines represent a scholarly discourse of the time which initially focused on anatomy – on the form and function of bodily parts – and gradually took up questions of physiology and began mechanically imitating the functioning of bodily processes. Vaucanson's digesting duck is the best-known example of the fascinated view into the internal processes of the body. The nature of

the body and technology of the body enter into a remarkable combination in this machine.

If enlightened discourse, a sensualistic image of the world, and anthropological thinking worked together in the body constructions of automata in the 18th century, then it was increasingly economic and therapeutic discourses which were interwoven in the topos of the machine in the 19th century. In this constellation, Feldman interprets the great popularity of mechanical clocks and musical automata which were an essential part of the furnishings of the 19th-century bourgeois salon: consumer articles and fetishistic elements of the domestic ambience. At the same time, the clockwork automaton was central to an economy of play and mechanised labour. It equally embodies the mechanics of production and of consumption. And all the more so, since the mechanical clockwork was reminiscent of the inexhaustible motion of the *perpetuum mobile* and thus modelled a functional view of the body which had to be seen in direct contrast to the fatiguability of the human body through labour. Feldman demonstrates that the enthusiasm for an anthropomorphic machine – which neither grew tired itself nor tired the person who operated it – should be seen in the context of 19th-century conditions of production and theories of labour. Precisely this quality also predestined the various musical automata for use as therapeutic instruments of "melotherapy" in the cure of illnesses of exhaustion and nervous distress, such as neurasthenia and hysteria which in the 19th century became the diseases of the times.

Automata incorporate images of the Other. The exoticism of these technical bodies, for which Kempelen's chess-playing Turk is a famous example, are incarnations of the colonial view of the Other. The mechanics of the automaton orchestrate the foreignness and the alienation of the body. The machines thus became the embodiments of the repressed images of body in the culture of the 19th century. The perceptual structures of modern times are laid out in these body concepts, with their functions of separation and transference. According to Feldman's hypothesis, elements and basic structures of this perception reappear in 20th-century hybrids of human and machine, for example in the form of the cyborg.

The musical automata more or less symbolise the physical aspects of those sciences of the 19th century that were dedicated to the conditions for perception of movement as well as to the possibilities for recording it. Taking off from there, the research of the "movement sciences" and the representation of physical, bodily movement in the media are **Friedrich Kittler**'s object of study.

Here, in historical retrospect, it is the transition from the analogue to the digital image media which marks a fundamental difference in the representation of body

BLITZKRIEG

and movement. The movement that becomes visible on the computer screen through animation no longer refers to a concrete body, as does the representation of movement in film. It is not the representation of the body in film, but rather the product of a matrix which appears as the phenomenon of movement on the monitor. What does this mean for the future of the image media? Should we feel threatened by the fact that it is now also possible to simulate "moving pictures", and not just "still pictures" such as photography, which could always be falsified?

The prehistory of film, reaching back to Athanasius Kircher, is characterised by attempts at representing movement as moving bodies. Apparatuses such as Kircher's *smicroscopium parastaticum* or the 19th-century bioscope ("wheel of life") set body images into motion in circular, repetitive figures. The movement sciences of the 19th century were dedicated to the transcription and representation of the periodicity of movement: they developed concepts of transcription which brought the body to dance in technical media and developed forms of notation which made visible the periodic movements exceeding the perceptual ability of the human sense organs, as is the case with certain acoustical vibrations. If this technically induced repeatability of movement is at the heart of the principle of "rhythmic return" which after Nietzsche had become the very principle of poetry, then "science produced pure poetry from motion until around 1850". In contrast to this, "prose" – in Kittler's remarks referring to the recording and storage of movement, which is unpredictable, in film and the phonograph – is a situation which would in principle require an infinite storage capacity. However, the kinematics of computer animation have brought forth moving bodies possessing only a limited freedom of movement. Is this where the element of poetry lies? "Whatever animated beings skip across the monitors, their movements can only change according to a finite number of degrees of freedom, and so they are dancing (as does all art, according to Nietzsche) in fetters."

Are the animated bodies on the computer screens doubles of the puppet, figures like the marionettes whose action is the subject of Heinrich von Kleist's reflection in his text "On the Marionette Theatre"? Like these puppets suspended by strings, the virtual bodies are also not subject to the laws of gravity. They are, in a material and physical respect, "bodies without weight", and the question as to the poetry of the movement of bodies is, according to Kleist, connected to the shift in gravity. Do we only then experience the simulation of disequilibrium as the beauty of movement – as grace – when it has overcome the resistance of gravity? The moving body in film would then occupy the mean between the real body of the dancer and the marionette: firstly, the represented body in film, as a likeness of a concrete

Total mechanisation reconfigures the temporal experience of violence. The tedious pace of wars of attrition is replaced by lightning bursts of highly concentrated destruction. In order to deliver such concentrated brutality, the state endures a profound metamorphosis. It can no longer conceive of itself as geographical extension – it must evolve into a predatory organism. As predator, the state's circuitry must be streamlined toward rapid information gathering. Its infrastructure must be designed toward swift discharges of force. Its ethos must be to strike only to kill.

Durch die totale Mechanisierung verändert sich die temporale Wahrnehmung von Gewalt. An die Stelle der ermüdenden Langsamkeit von Zermürbungskriegen treten blitzschnelle Ausbrüche einer hochkonzentrierten Zerstörungskraft. Um eine solche konzentrierte Brutalität anwenden zu können, macht der Staat einen tiefgreifenden Wandel durch. Er kann sich nicht länger als eine geographische Ausdehnung verstehen – er muß sich in einen räuberischen Organismus verwandeln. Zu diesem Zweck muß alles im Staat so geschaltet sein, daß er schnellstmöglich Informationen sammeln kann. Seine Infrastruktur muß so angelegt sein, daß sie schnelle Entladungen von Gewalt erlaubt. Sein Ethos muß darin bestehen, daß er wirklich mit jedem Schlag tötet.

body, is subject to the laws of physics, and secondly, the possibilities of the media lift it out of the temporal and spatial binds of real corporality like Kleist's marionettes on strings: it can float freely, fly, fall, and walk upside down.

In her essay, **Gertrud Koch** considers the cinematographic body as a body which has always been fragmented and, at the same time, rendered unreal. Three modes of the movement of the body in film can be determined: the moving body as an object in front of the camera; the movement of the camera itself; and finally the movement of the moving images – "movies" – before the viewer, whose eye movements, moreover, follow all these patterns of movement which are interwoven in the medium.

Film thus stages the images of movement of the represented body – yet, at the same time, this movement appears to be removed from these bodies. The cinematographic bodies are imbued with the representational requirements of the medium itself. And the premises of the medium are precisely those of movement: the movement of the camera and the movement of the "moving images". In contrast to this stands the motionlessness of the viewer who sits transfixed in his chair and follows the spectacle of moving bodies in the phantasmal space of his own memory of movement, continuing the *actus imperfectus* of the movement scenario in his imagination. In a film world in which every movement is possible in principle, it is no longer the bodies themselves which are the carriers of memories. They instead become the surfaces for the projection of remembered images. "The medium itself becomes the location for a memory that collects corporeal images of bodies".

In his "Dream Story" (1925), the doctor and writer Arthur Schnitzler demonstrated the medical gaze onto the body in its characteristic split (different from and more finely differentiated than the film adaptation of this text in Stanley Kubrick's *Eyes Wide Shut*). In Schnitzler's text, the male gaze onto the female body searches for its sexual attractiveness even in the "beautiful corpse" of the autopsy hall – in vain. The protagonist in Schnitzler's novella, the doctor Fridolin, looks at the dead female body in its anatomy, uncertain as to whether this was the very body that he only yesterday had violently desired. This male gaze onto the female body experiences a transformation in the anatomy hall: in a change in perspective from naked body to tissue sample under the microscope, fascinating and "magnificent in colour". It is the shift from the desirous gaze onto the sexual body to the scientific gaze onto bodily tissue and cell cultures.

The incision into the body which separates the surface of the body from the texture of the tissue corresponds to this split of the gaze. **Peter Moeschl**'s contribution investigates the changes in the adjustment of the gaze on the body from a

medical perspective. In the context of the great public interest in anatomical speci-
mens reaching back in the history of the anatomical theatre to the Renaissance,
and which now, at the turn of the 20th century, has again become apparent through
the large numbers of visitors to the exhibition *Body Worlds*, Moeschl reflects on
the sensuous perception of the body in anatomy. Which perception, which percep-
tual training does the doctor or the surgeon need who opens the body with an
incision and who penetrates into the interior of the body with his gaze? In medical
practice, this occurs in the old laws and rituals of distancing, through which the
break in taboo is carried over into a scientific context. The split of the gaze has to
be virtually internalised. The shift from a symbolic code, which in our culture
marks the body as individual and aesthetic, to a specialised medical discourse – a
shift as it occurs in Schnitzler's novella as the change in role from lover to scientist
– becomes the prerequisite for making the cut into the flesh possible in the first
place. Otherwise, a breakdown occurs – which Moeschl terms the "aesthetic col-
lapse", for, if all measures for making the body anonymous on the operating table
and for dividing it into segments by covering it over are counteracted and over-
turned by the viewer's fantasy such that his gaze is no longer governed by a med-
ical perspective onto an anatomical topography of the opened body, it instead
falls into chaos and horror, induced by the perception of a horribly injured body.

The split of the medical gaze follows a linguistic operation which runs parallel
to the surgical operation. Both operations are based on a cut. The split of the gaze
on the cut surface into the interior of the body corresponds to a shift in language
on the texture of the body: a shift which signalises a fracture in perception, a shift in
perception which paradoxically results in an "anaesthetising" of the medical gaze
onto the body, as the condition for and a result of medical knowledge.

Nadia Seremetakis's contribution also turns to the injured body, but in a dif-
ferent way. She asks in what way a process of remembering could occur as a
"ReMembering" which calls the traditional hierarchy of public interest and private
memorialising into question. Seremetakis observes the public space of the
Western European city as a corporal topography formed by historically important
monuments. Statues and representative structures (architecture) mark this land-
scape of the cultural body (of a city such as Vienna) as a unified form. In the closed
scenario of this urban mnemonic space, monuments, memorials, and statues dis-
play a "scopic power" through which they appear as the carriers of a cultural
legacy which founds itself on the idea of the constancy of history and its urban rep-
resentation. Thus, statues become "icons of mnemonic enforcement".

In contrast to this, we find the history of injury to the urban body, its destruction

through catastrophe. How does the memory of its history become reconstructed when the public, the representative form of this collective body becomes broken by war or by an earthquake, and the trauma of burial forces the images into obscurity? Taking the example of the Greek city Kalamata which was destroyed in 1986 by an earthquake, Seremetakis traces the process of a (re)construction of memory: an excavation of fragments of memory which assemble an image of memory out of the ruins of the city. This excavation work itself takes place as part of a process in which the inhabitants erect a double of the buried city through personal objects and stories, a double which however carries the scar of the injuries. The dismembered urban body becomes visible in a process of the assembling of memory fragments as phantom bodies (re-membered). Thus, this exhibition project, put together ten years after the destruction of Kalamata as a collective memory ritual from scattered, private fragments of memory, refers to another form of cultural legacy and of chronicling which sets a "poetics of fragments" as an open figure of memory in place of the closed ideology of the memorial.

André Lepecki's essay observes movement from its dialectically opposing side: from the still point within motion. Here, 'still' does not mean the standstill of movement, not a fixed, motionless non-movement, but is rather to be understood, with the help of a poem by T. S. Eliot, as the vibratory moment of a "movement as stillness". This "non-fixed stillness" is, according to Lepecki's hypothesis, the core of dance. And with this, the signature of the modern period becomes characterised at the same time: dance is – seen in this way – the fundamental art of the modern period, for the reflection and representation of this fundamental shift in perception of movement takes place within it. This involves the creation of a body image whose integrity is endangered and whose shape deformed: the corporeal analogy to the discourse concerning the subject's decomposition which took place at the beginning of the modern period.

Lepecki directs his gaze on those significant moments in 20th-century dance marking a reorientation of the traditional paradigm, according to which dance is characterised by a continuous flux of motion. In contrast, a phenomenology of movement begins with the modern period, one which regards the resting body not as "still", but rather as moving, as being veritably exploded and ridden with multiple vectors of motion. Vaslav Nijinsky realised this body concept of animated stillness with his choreographies *L'Après-midi d'un faune* (1912) and *Le Sacre du printemps* (1913). While with Nijinsky this dynamic was still bound to the pose, in Postmodernism this figure relaxes. Steve Paxton, founder of contact improvisation, finally allows the movement of the resting body to simply turn inward: expressed

through the concentration in perception which locates the trail of the microscopic movements of the body in stillness, it is a "new sensorial" which shows that stillness consists of "many layers of vibratile intensities".

Regarded in this way, body movement as a differentiated perceptual phenomenon enters onto the horizon of our attention, a perspective of observation which Lepecki follows with the phenomenology of Merleau-Ponty. At issue here is not only the perception of the body, but rather the constitution of images in memory which piece together and yield perception. Yet it is not only as a category of perception theory that Lepecki would have the idea of stillness understood, but rather – in connection with the vibrating body's potential for resistance in stillness – as an ontological category as well. In this interpretation, the idea of stillness contains a political statement, which in turn becomes a manifesto in the body actions of artists: a call for a perception which is multi-layered, for an attention to a body which cannot be clearly located in its vibratory state, and which, precisely by means of this, takes on existential validity.

From the perspective of the threshold of the year 2000, the plural image of body in the modern period is represented as a phantom of discourse which evades our grasp; and it does so in a different way than the problems of the perception of body and its representation were regarded for example in the 19th century. Georg Büchner, who precisely observed the theme of the representability of the body in movement as both a scientist and a writer, wrote in his novella "Lenz" at the sight of two girls braiding each other's hair: "One would sometimes like to be a Medusa in order to turn a group like this into stone." The viewer's gaze swings back and forth between freezing the body image – as though in a historically anticipated snapshot – and dissolving the image: "The beautiful group was destroyed; but the way in which they climbed down between the rocks was yet another image." Composing and dissolving images, frame by frame, cut by cut – in this way images of the body in motion are established as text, as film. And it is not so much the reflection of their fleetingness – which Baudelaire, using the defining features of the modern period, termed "le transitoire, le fugitif et le contingent" – which determines the problem of perception in the 20th century, but rather the recognition of a fundamental "crisis in categories" (Marjorie Garber) which bears down in the loss of the traditional images and discourses of the body: in the diffusion of gender roles, a confusion of perception and allocation which no longer allows the masculine and feminine as forms of representation and social appearance of the body to be attributed to customary patterns. The interior landscape of the body, deciphered by the endoscope, and the political and economic systems of the body confront

us in the forms of organisation and in the processes of disorganisation which turn the localisation of the body into a delicate social process of remembering, of allocating, and of reinfusing images. Traces of this kind of archaeology of the body – fragments of its "ReMembering" – are collected here in the texts and images of this book.

Membra disiecta: Embalmment and Anatomy in Egypt and Europe

Aleida and Jan Assmann

RE-MEMBERING OSIRIS:
FROM THE DEATH CULT TO CULTURAL MEMORY
Jan Assmann

The culture of the ancient Egyptians is rooted to an unusual, perhaps unique degree in the cult of the dead. Nearly all aspects of the culture can be traced back in a direct or indirect way to the practices and imaginative world of the Egyptian religion of the dead. This is especially the case for the human body, a foremost provider of images and metaphors in Egyptian thinking; however, it is based not on the living body in its beauty, strength, and vulnerability, but rather on the body of the deceased and the practice of its symbolic reanimation. Taking as my point of departure the embalming ritual, which is certainly pivotal within the framework of Egyptian body symbolism, I would like in the following essay to single out three fields of symbolism and areas of meaning which the topic and imaginative world of embalming influenced in an especially intensive way: romantic lyric in the form of the descriptive song, cosmic theology with its idea of the world as the body of God, and, finally, the political *imaginaire* of the Late Dynastic period, with its image of the land of Egypt as the body of Osiris.

The Body of the Deceased: The Anatomy of Immortality

When an Egyptian died, he was not immediately taken to his grave, but instead first transferred to a space in which he was embalmed and mummified by specialists. Ideally this procedure lasted not less than seventy days.[1] Far from being an obscure borderline area of cultural practice which played no important role within

the imaginative world of the Egyptians, this was, on the contrary, a central cultural phenomenon which was imbued to the highest degree with concepts of value and goal, and whose symbolism extended into the most varied cultural areas. Embalming was at the centre of a cultural construction of the body, as well as being a school of anatomical knowledge of the body, of religious body interpretation, and of the ritual treatment of the body.

The meaning of embalmment and mummification (both are phases of one and the same ritual) is not only the conservation of the corpse, but rather the reintegration or reconstruction of the person. In this process, the deceased is brought into a final form which is not only imperishable, but which possesses a soul and is immortal and alive in a new way. On the one hand, this final form surpasses much that is possible for a person while still alive.[2] On the other hand, however, the new person which the rituals of death strive for as their final form is still very much conceived of as analogous to the concept of person of a living human being. This principle is summarised in the change from "as you were on Earth" to "as on Earth, so in the beyond", the recurrent formula in the texts of the dead. Based on this analogy between the final form of the deceased and the form of existence of the living, the rituals of death tell us quite a bit about the Egyptians' concept of person and thus also about their cultural construction of the body. They are certainly our most important source for this – especially since this type of source hardly exists for Greece or Mesopotamia, if at all.

The Egyptian considered the analogy between life on Earth and the form of existence of the dead to be both a transformation and, most of all, a continuity. The efforts directed at the body stand in the service of this continuity. The body is the symbol and carrier of the biographical past in which the person of the deceased has matured to a final form in which he would like to enter eternity. Thus, the body symbolises a biographical memory, the sum and repository of experiences amassed during life which constitute the nature, character, and identity of the deceased and which he would like to hold on to whatever happens, the form in which he would like to continue when he carries on his life under the very different conditions of the beyond.

What the embalming ritual strives for, then, is the reconstitution of the person under the conditions of being dead. All of this occurs on the "guiding thread of the body", with direct and constant reference to the body parts, organs, and bodily functions of the deceased. Instead of standing for a material substratum of the whole person, which then falls from it in death like a waste product, the body stands here as a kind of symbolic form of the person, which in a mysterious way has a part in

COLLAPSE

the person's wholeness, so that all efforts directed at the body can benefit the entire person, his restoration, and immortalisation. What is missing here – and Aleida Assmann draws attention to this in her contribution – is a concept of transcendence, which is what makes the clear distinction between form and matter as well as between the soul and the body possible in the first place.

The theory of the body, which both forms the foundation of the embalming ritual and is established by it, imagines the body as an organised multitude or, even more, as a spirited wholeness in which all parts function together harmoniously. The body is a multitude of limbs which are joined into a community under the leadership of the heart. Death means that the heart comes to a standstill and, with it, its leadership function is terminated. The Egyptian calls this heart fatigue. The god Osiris, the model for this treatment of the dead, is called "The One with the Fatigued Heart". The body, then, is an organised multitude which is imagined to be analogous to a political organisation: "Your heart guides you, your limbs obey you." Through the leadership function of the heart, the person acquires a body. That still does not make him a person; a person is a social category. Only through social recognition and inclusion does one become a person. In Egyptian, this is phrased: "The one lives when the other leads him". The guidance within, through the heart, animates the limbs and connects them to the body; the guidance from without, through the other, animates a human being and makes him into a person. Man is thus seen by the Egyptians as a creature of relationships in a two-fold respect: his body is a network of relationships which are connected and controlled by the heart, while his self, to whom this body belongs, establishes itself through relationships that connect him to others.

For Egyptians and the Egyptian image of the body, the concept of the relationship or constellation is just as fundamental as the concept of directness for the Greek image of the body. For the Greeks, nakedness appears as a symbolic expression of an awareness of self and of the body, which sees its goal as self-assertion on the basis of one's own strength. The ideal is the individual, entirely on his own, whose strength, beauty, and virtue represent so to speak a currency based entirely on the corporeal and spiritual "capital" at his disposal.[3] This image of the body corresponds to the structure of a competitive society which invests in the individual and in competition. By contrast, the constellative body image of the Egyptians is the symbolic expression of a consciousness of self that sees the inclusion within an interconnected whole as its goal. Furthermore, this image of the body corresponds to the structure of a cooperative society that invests in social harmony and political unity. Here, it is not directness that rules, but rather, on the contrary, the mediated – the construction of long series of action and extensive communication networks, hierarchies of office,

Collapse maps the terrain beyond the boundary. Beyond the threshold, there is the struggle to regain composure, to reconstitute equilibrium, to feed the lungs starved for oxygen, to find our place in the world again, to understand the new conditions of this world, to assess the contours of this new life form, this new body, this new state of being beyond.

Der Zusammenbruch steckt das Gelände jenseits der Grenze ab. Auf der anderen Seite der Schwelle wird darum gekämpft, die Fassung wiederzuerlangen, das Gleichgewicht wiederherzustellen, die nach Sauerstoff lechzenden Lungen zu füllen, den eigenen Platz in der Welt wiederzufinden, die veränderten Bedingungen dieser Welt zu begreifen, die Konturen dieser neuen Lebensform, dieses neuen Körpers, dieses neuen Zustands des Jenseits-der-Grenze-Seins festzulegen.

role playing, paths of authority, graduated power, delegated force, and mechanisms for centralised guidance. What the heart is for the body, the pharaoh is for the state. We have to make it clear to ourselves that – to paraphrase Christian Meier – the Egyptians did not have any Egyptians to look at. Just as the Greeks dared for the first time to implement the experiment of a radical democracy in a world of monarchies and oligarchies, the Egyptians for the first time in a world of small-scale forms of rule undertook the risk of a large territorial state, a monarchy in the grand style. For this reason, life for the Egyptian automatically means living together; his ethics is the art of living together, and his anthropology conceives the body, too, as a society of cooperating limbs.

This constellative image of the body and of the person is the goal which the embalming ritual works towards. The ritual is to be understood as a transformation which guides the person and his body from the given initial state towards a final or target state. Due to fatigue of the heart the body has fallen apart into a disparate multitude of individual limbs, and due to death, the person has fallen out of the social relationship networks of the group. Both catastrophes are felt in all their intensity by the Egyptians, and brought to haunting expression in laments of death. Nevertheless, this catastrophic beginning condition does not stand for an end, but rather for a crisis, for whose rectification a multitude of helping and healing measures are available. The most important of these measures is the embalming ritual. It transforms the hopeless beginning state into a healed end state.

Since the goal of embalming is the creation of unity, the beginning condition can be nothing other than multitude, decline, dispersal, and dismemberment – which is *membra disiecta*. The embalming priests take over the body of the deceased as *membra disiecta*, an unconnected group of individual limbs which, before anything else, must be gathered together. It used to be assumed that the dead were indeed dismembered and chopped into pieces, apparently to render them unhazardous and to protect future generations from their return. Myths of dismemberment, as they are documented in the whole world – in particular in the context of shamanistic rites – were interpreted as reflections of such burial customs. In the meantime, it has been realised that this talk of collecting and uniting of the torn apart and dispersed in Egyptian texts is to be understood in a symbolic way.

The motif of the dismemberment and dispersal of body parts, then, does not describe a literal tearing apart of the corpse, but rather interprets the actual lifelessness of the body as a decay of community and the dismemberment of connection. This interpretation has the sole purpose of defining the beginning condition for the ritual practices now being employed. The dead body as a *membra disiecta* is thus a

metaphor, a metaphoric image of death that serves to set off the image of life into which the dead body is to be guided by carrying out the embalming rites. However, the first surgical/anatomical phase of this seventy-day process is by no means free of violent interventions. Although the body might not be cut apart, it is treated, medically speaking, in an anything but "conservative" manner, even if it is for the purpose of its conservation. The brain is removed through the nose and the intestines through an incision in the side. Only the heart is wrapped and returned to its place; the other organs are placed in Canopic jars (covered urns in the shape of an animal or human head). The other soft body tissues and fluids are dissolved in a solution of natron and resin, and pumped out of the body rectally. Then, the phase of desiccation begins (drying out and salting), which lasts for approximately forty days. At the end, the corpse, reduced to skin and bones, is reconstructed in the ritual of mummification by anointing it with balsamic oils that make it smooth again, by "stuffing" it with resins, gum arabic, fabrics, wood shavings, chaff, and other substances, by inserting artificial eyes, make-up, wigs, and finally by wrapping with fine linen bandages, some of which are inscribed with magic formulae and interspersed with amulets. The desired final form of this laborious procedure is the mummy. More than a corpse, the mummy is a kind of hieroglyph of the whole person, who is now, as the Egyptian would term it, "filled with magic". Just as the magic of writing is able to capture and make visible a meaning, so too is the person of the deceased captured and made visible as a symbolic form or hieroglyph in the mummy.

The embalming ritual is the continuation of Egyptian medicine with other means. Like medicinal therapeutics, the embalming ritual is based on an interweaving of surgery, pharmaceutics, and magic, that is, language – although here the linguistic treatment assumes the major place. The Egyptian term for this therapy of the dead is an essentially untranslatable word whose meaning is approximated in English and French with 'transfiguration' and in German with *Verklärung*. The deceased thereby becomes a spiritual and powerful being capable of living on in a variety of forms. One of these many different forms is the mummy, the reintegrated body, the corpus in which the collected *membra disiecta* of the deceased are united. A function of these "transfiguring" recitations is to collect so to speak the limbs of the body, imagined as being scattered, into a text which describes it as a new entity. Such descriptions normally list the individual body parts from the top to the bottom, beginning with the head, and equate them with deities.

We would like to take a closer look at an example of this form. It is part of a liturgy for the dead of the Middle Kingdom (19th century B.C.) entitled *Uniting the Limbs of a Transfigured One for Him in the Necropolis*. It contains the following text:

You have taken shape by being the entirety of all gods:

Your head is Re,

your face is Upuaut

your nose is the jackal (= Anubis),

your lips are the sibling couple (Shu and Tefnut).

Your two ears are Isis and Nephthys.

Your two eyes are the children of Re-Atum (Shu and Tefnut),

your tongue is Thoth,

your throat is Nut,

your neck is Geb,

your shoulders are Horus,

your breast is He-who-rejoices-in-the-ka-of-Re,

The-great-God-that-is-in-you.

Your rib cage is Hu and Khepri,

your navel is the jackal and the two Ruti,

your back is Anubis

and your belly is Ruti.

Your two arms are the two sons of Horus

Hapy and Imset,

your fingers and your fingernails are the children of Horus.

Your back is the-spreader-of-sunshine,

your leg is Anubis,

your breasts are Isis and Nephthys.

Your legs are Duamutef and Qebehsenuf.

There is no body part on you which is free of a god.

Raise up, oh Osiris – here!

Egyptologists call this topic a "limb deification". The principle is clear: for each body part, a correspondence in the divine world is found. The *tertium comparationis* is usually the form or the function, in some cases also a play on words. One almost has the impression that this dismembering description further intensifies the evidence of a disparate multitude because each body part makes itself independent, so to speak, and the listing of the deities equated with the body parts is lacking in any system. A systematics of this kind can only be found later, in the protective rituals of the Late Dynastic period, which limit the number of body parts to twelve and subordinate them to the twelve deities of the zodiac.[4] Something of this nature is missing in the older texts of limb deification. Some of the deities appear here several times: for

example, Anubis for the nose, navel, back, and leg; Shu and Tefnut for the lips and eyes; whereas some of the important deities do not appear at all.[5] What is apparently important is that each part be allocated to some god or other; such an allocation also allows, without a strict theological system, a new network of relationships to arise which combines the parts to a unity of the body once again. The closing text of another litany of limb deification expresses this very clearly:

> My limbs are gods,
> I am entirely a god,
> no part of me is without a god.
> I enter as a god,
> I come out as a god.
> The gods have been transformed into my body,
> I am that which changes its form, the lord of transfiguration.
>
> My limbs guide me,
> my flesh forges the paths for me.
> Those who have arisen out of me protect me,
> they are satisfied with what they have made.
> I am indeed the one who has formed them,
> I am indeed the one who has begotten them,
> I am indeed the one who let them arise.[6]

The Egyptian expression for 'to be transformed into' is the same as 'to arise out of'. The text plays with this double meaning. By transforming the gods limb by limb into the body of the deceased, the gods arise out of this body, and the deceased can say of himself that he has formed, begotten, and given birth to the gods. In this way his dispersed limbs have once again become a body, and he himself is once again fully in control of the community formed by him.

At the root of this stands the myth of the community of the gods in the body of the original God Atum. According to the cosmogonic myth of Heliopolis, all gods arose from Atum. The name Atum, a typical example for the contrary meaning of original words, means 'the universe' as well as 'nothingness', the entirety of being and the state of the not-yet or no-longer-being. Atum is the entirety of all gods, which he comprises within himself in a state of not-yet-being and releases from himself in a state of being, a *theos pantheos*, a god who is at the same time all gods. All gods came forth from the body of the original God Atum. That renders them

imaginable as a body in their entirety. This idea of a macro-corpus assembled together from many gods is transferred to the mummified body of the deceased, who in this way becomes Atum. The sentence "You have taken shape by being the entirety of all gods" reads in its original version "You have taken shape by being Atum in relation to all gods". The deceased is also Osiris, who has taken on form as Atum. The mummified body of the deceased is transfigured into a pantheon. In computer language, one could say that he is "formatted" by being "converted" limb by limb into an element of the divine world. The expression 'to format' conveys quite well what is involved in limb deification (and in embalmment and mummifica-tion in general): the transferral of the limbs and organs, collapsed into formlessness by death, into the new form of the mummy. It is not only a matter of once again unit-ing the single *disiecta membra* into a virtual "text" of the body, but rather to bring this text into the form of a divine community.

The topic of limb deification not only plays an important role in the liturgies for the dead or transfigurations from the pyramid texts of the Old Kingdom to the papyri of the dead of the Late Dynastic period, but also appears in magical texts which refer to the living and are meant to protect the body and all its parts from disease and accident. The fundamental principle here is always that the body is imagined to be a multitude of single parts and organs, each of which is individually subordi-nated to a deity, compared with a deity, or explicitly identified with it.

If in this way the body appears as a divine world, a pantheon, then it is also conversely true that the divine world can appear as a body as well as a body cor-porate. The body of the deceased represents the body corporate of the Egyptian divine world: "Egyptian gods incorporated". There is actually a comparable concept in the Egyptian language. The word 'x.t' means, on the one hand, 'body', and, on the other, 'body corporate' – and is used in reference to groups of gods.[7] All com-parisons work in two directions. If I compare the brave warrior to a rock in the surf, then the rock in the surf also appears as something heroic to me. Whoever equates the body of the transfigured dead with the divine world is also able to imagine the divine world as a body.

However, the idea of the body as a "body corporate" of cooperating limbs pro-duces, as its shadow, the fearful idea of the termination of such a cooperation. A termination of this kind represents the motif of a dispute over rank between the various body parts. This fable, which spread over the whole world, is first docu-mented in Egyptian literature. I find that to be no accident. This idea virtually pro-duces itself out of the principle of mummification with its deification of the limbs which individualises each part. We are most familiar with this fable in the form of

DEFENESTRATION

the legend of Menenius Agrippa, told by Livy, in which the struggle between the stomach and the limbs serves as an analogy for the problematic relationship between the consuming and the working part of the populace.[8] In Egypt, the head fights with the body, and carries this conflict before the court in true Egyptian manner. Unfortunately, the text is to a great extent destroyed, but the connection to the embalming ritual is unmistakable:

> As the body brought forth its case,
> the head loudly called out with its mouth:
> I am the supporting beam of the entire house [...]
> and every part that leans on me is glad.
> My heart is glad,
> my limbs are able,
> my neck rests firmly under the head,
> my eye looks into the distance,
> my nose breathes and draws in air,
> my ear remains open and listens,
> my mouth is open and knows how to answer,
> my arms are able and do work.[9]

The Body of the Beloved

The descriptive song, called *wasf* in Arabic, is the typical form of the oriental love song. In it, the body of the beloved is praised limb by limb and from head to toe in poetic, often very laboured comparisons.[10] The most famous example is the *Song of Solomon* and its comparisons, such as in the following passage:

> Behold, thou art fair, my love;
> behold, thou art fair;
> thou hast doves' eyes within thy locks:
> thy hair is as a flock of goats,
> that appear from mount Gilead.
> Thy teeth are like a flock of sheep
> that are even shorn, which came up from the washing;
> whereof every one bear twins,
> and none is barren among them.
> Thy lips are like a thread of scarlet,
> and thy speech is comely:

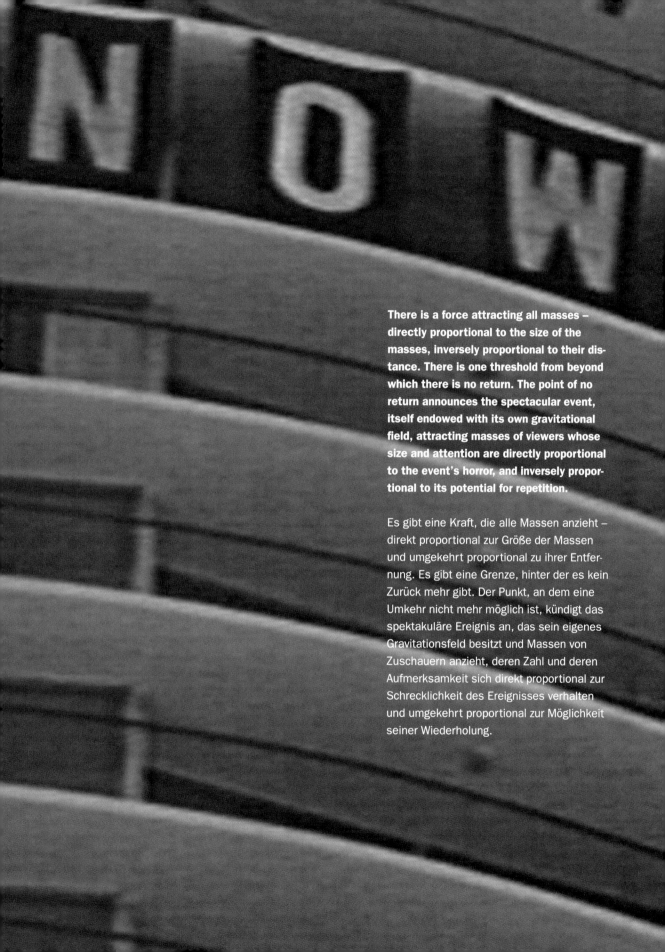

There is a force attracting all masses – directly proportional to the size of the masses, inversely proportional to their distance. There is one threshold from beyond which there is no return. The point of no return announces the spectacular event, itself endowed with its own gravitational field, attracting masses of viewers whose size and attention are directly proportional to the event's horror, and inversely proportional to its potential for repetition.

Es gibt eine Kraft, die alle Massen anzieht – direkt proportional zur Größe der Massen und umgekehrt proportional zu ihrer Entfernung. Es gibt eine Grenze, hinter der es kein Zurück mehr gibt. Der Punkt, an dem eine Umkehr nicht mehr möglich ist, kündigt das spektakuläre Ereignis an, das sein eigenes Gravitationsfeld besitzt und Massen von Zuschauern anzieht, deren Zahl und deren Aufmerksamkeit sich direkt proportional zur Schrecklichkeit des Ereignisses verhalten und umgekehrt proportional zur Möglichkeit seiner Wiederholung.

thy temples are like a piece of a pomegranate within thy locks.

Thy neck is like the tower of David builded for an armoury,

whereon there hang a thousand bucklers,

all shields of mighty men.

Thy two breasts are like two young roes that are twins,

which feed among the lilies.

Until the day break,

and the shadows flee away,

I will get me to the mountain of myrrh,

and to the hill of frankincense.

Thou art all fair, my love;

there is no spot in thee.[11]

Such songs also exist in Egypt:

Shining, precious, white of skin,

lovely of eyes when gazing.

Sweet her lips when speaking:

she has no excess of words.

Long of neck, white of breast,

her hair true lapis lazuli.

Her arms surpass gold,

her fingers are like lotuses.

Full(?) her derrière, narrow(?) her waist,

her thighs carry on her beauties.

Lovely of walk when she strides on the ground,

she has captured my heart in her embrace.[12]

What connects this form with the limb deification texts of embalming is the dismembering style of description which individualises each part of the body. The body of the beloved is virtually dismembered into its individual parts in order to be collected anew in the medium of the text, but now on the very different level of poetic images. Here, too, just as with mummification, the issue in not dismemberment, but rather inspiration. As the "transfiguration chants" animate the corpse of the deceased, so do the love songs animate the body of the beloved. The thought that the tradition of such descriptions of the body of the beloved are derived from the liturgies of the dead used during the embalming process, and especially from the topic of limb

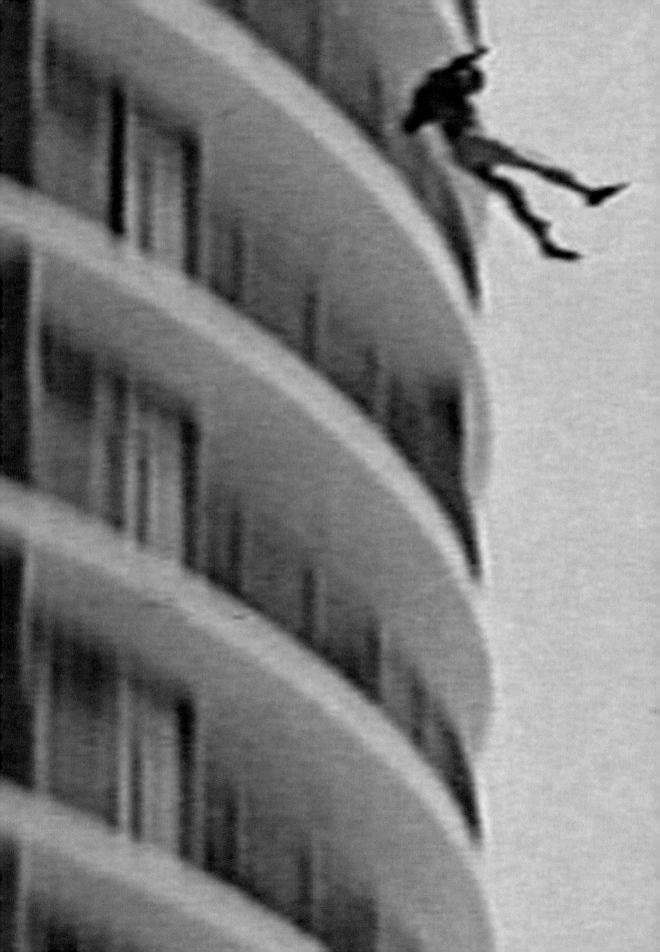

deification, certainly sounds alienating. But there are texts of the dead from the New Kingdom which form a connecting link between the limb deification of embalming and the form of the descriptive song in romantic lyric. Thus, for example, there is a liturgy for the dead in the Book of the Dead which is set up as a cycle of laments to be sung by Isis and Nephthys, the two sisters who mourn their slain brother Osiris.[13] Osiris, according to the myth which this liturgy is based on, has been slain and torn apart by his hostile brother Seth. Isis combs the land and collects the dispersed body parts. Together with her sister Nephthys, she succeeds in reassembling the dismembered corpse of her husband and reanimating it with her songs. In these songs of lament, which exist in great numbers and play a central role in the embalming ritual, the liturgical recitation combines with the lyrical language of longing and approaches the form and mood of romantic lyric. And so, the topic of the limb deification retreats in the face of the assurances of the beauty and function of the limbs, the completeness and aliveness of the body, the good will and help of onlooking deities, and the dignity of the deceased person, who is once again united into a whole by means of the recitation of the transfiguration.

Your *head* is anointed, my lord, when you travel to the north,
like the braids of an Asian woman,
and *your face* is more brilliant than the house of the moon.
Your upper body is made of lapis lazuli,
your locks are blacker than the doors of every star on the day of eclipse,
your hair is [...] with lapis lazuli over your face.
Re shines on your face, so that it is clothed in gold,
and Horus has covered it in lapis lazuli.
Your brows are the two sisters who are united
and Horus has covered them in lapis lazuli.
Your nose is covered with breath,
and air is on your nose like the winds in the heavens.
Your two eyes observe the Eastern Mountain,
your lashes remain at all times,
their eyelids are of true lapis lazuli.
Your two cheeks are the carriers of sacrifice,
the edges of their lids are covered in eye paint.
Your two lips give you *ma'at* (truth/justice),
they tell the *ma'at* to Re,
they ease the hearts of the gods.

Your teeth are in the mouth of the ring-neck snake, with which both lords have played.

Your tongue speaks intelligibly,

and what you say is more penetrating than the call of the bird in the marsh.

Your jaws are the starry sky, your breasts remain in their place

when they travel through the western desert.

O see, you are mourned, are mourned!

Your throat is adorned with gold,

with electrum as well.

Your collar is large, and *your throat* is Anubis.

These *your two vertebrae* are the cobra snakes

your spine is covered in gold, with electrum as well.

Your lung is Nephthys,

your face is Hapy and his water flood.

Your buttocks are a double egg of carnelian,

your legs remain firm while walking.

You sit on your throne,

and the gods have given you back your eyes.

Your esophagus is Anubis,

your abdomen is wide [adorned] with gold,

your breasts are two eggs of carnelian,

which Horus has covered in lapis lazuli.

Your shoulders are illuminated in faience,

and *your arms* remain in their proper location.

Your heart is happy at all times,

your breast is the work of the two powerful ones,

your muscles pray to the lower stars.

The heavens are *your abdomen*, when you lay to rest,

and the underworld is *your navel.*

Both your arms are the flow of water in the flood, of the beautiful,

a flow of water that the children of the flood have covered over.

Your knees are worked with gold,

your breast with marsh plants.

Your soles stand firm at all times,

and *your toes* lead you to the good paths.

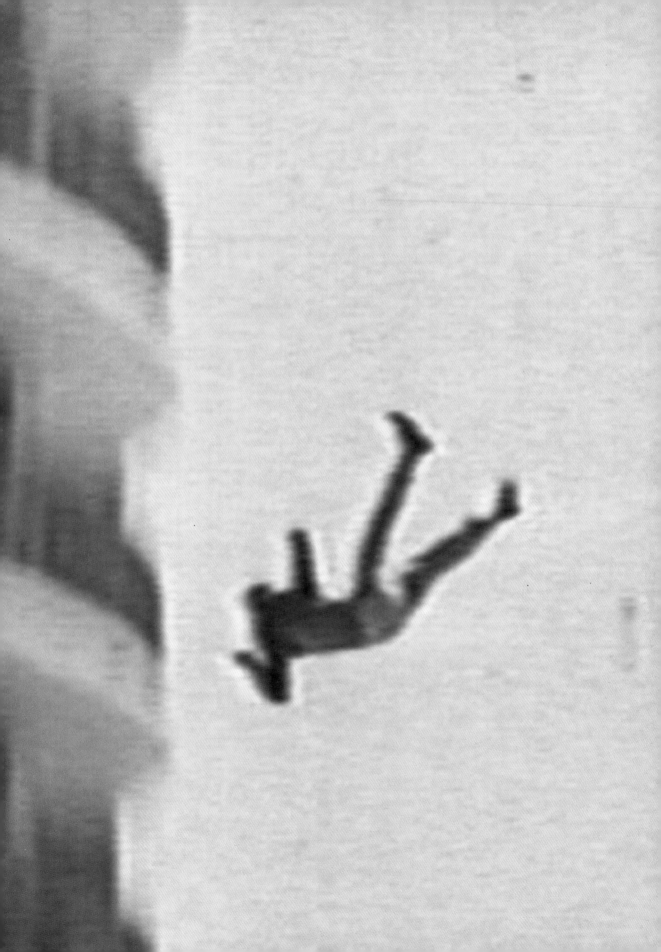

Both your hands are jugs in their stands,
your fingers are kernels of gold,
their nails are knives of flint
against the face of those who have done this unto you.

The first five stanzas list forty-three different body parts and sometimes go into great detail; eyes, brows, lashes, lids, and lid edges are named as well as arms, hands, fingers, and nails. The equating with deities, however, only plays a very sub-ordinate role here. The brows are equated with Isis and Nephthys, the throat with Anubis, the lung with Nephthys, and the esophagus with Anubis. Most common are descriptions of precious materials such as gold in reference to the throat, the spine, the abdomen, the knees, and the fingers; lapis lazuli in reference to the upper body, the hair, and the eyelids; carnelian for the buttocks and breasts (nipples), and faience for the shoulders. The mention of salve for the head and eye paint for the edges of the eyelids points in a similar direction. With some body parts, beauty, firm-ness, and functionality are emphasised; for example shining for the face, blackness for the locks of hair, breath for the nose, gazing at the Eastern Mountain for the eyes, reciting the *ma'at* for the lips, intelligent speech for the tongue, firmness for the breast, arms, and legs, joy for the heart, devotion for the muscles, guidance for the toes, and a knife-like sharpness for the nails. Finally, there are comparisons that are oriented on the form or function of a body part, some of which seem quite puzzling: the cheeks are compared with carriers of the sacrifice, the teeth with the mouth of the ring-neck snake, the vertebrae with cobras, and the hands with jugs. Then there are cosmic comparisons such as that of the jaw with the starry sky, the abdomen with heaven, and the navel with the underworld. In any case, it is clear that the weight of the transfiguring description has shifted from the beyond to the here and now, from the world of the gods to the world of the visibly present. The embalming ritual proves to be the framework for presentation – the "place in life" – of a transfiguring, glorifying discourse of the body which continues in the love songs more or less without interruption. The connection between these two apparently vastly separate worlds is formed through the lamentation of Isis, who transposes the transfiguring magic formula of the embalming priest into the language of longing.

Macrocosm: The World as the Body of God

The other area into which the idea of the body in embalming extends is theology, or – what is essentially the same thing in ancient Egypt – cosmology. In addition to the presumably ancient concept, according to which the gods arose out of the body

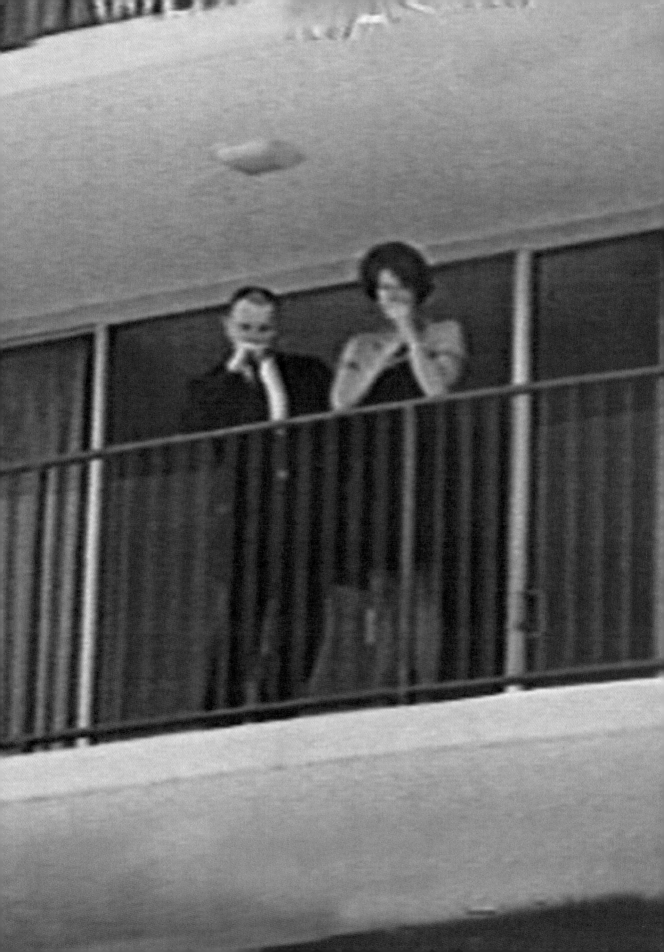

of Atum and together represent the body of the original God, in the late second millennium the idea of the Earth god develops, whose body is the world, whose eyes are the sun and moon, whose breath is the air, and whose secretions are the Nile.[14] This idea of God evidently represents a response to the radical monotheism of Akhenaten of Amarna. Akhenaten proclaimed that there is only one god, the sun, on whose work in light and time everything else depends. This teaching is countered by the Theban theologians of the Ramesside period by the doctrine of an all-encompassing God, from whose world body light, air, and water flow, as the powers that vitalise and animate everything. This God is called upon in the hymns of the Ramesside period in the following manner:

> His body is the ancient ocean,
> and inside it the flood of the Nile
> that brings forth and keeps alive all existence.
> His breath is the breath on every nose."[15]

> You created yourself as the sun of the day
> and as the moon of the night.
> You are the Nile that keeps humanity alive,
> and the air that allows throats to breathe.[16]

In a magical text of the 7th or 6th century, an all-encompassing God is invoked:

> from whose nose the air comes,
> in order to quicken all noses,
> who rises as the sun to illuminate the Earth,
> from whose secretions the Nile flows,
> in order to nourish all mouths.[17]

In a Ptolemaic inscription, it is said of Amun:

> His sweat is the Nile,
> his eyes the light,
> his nose the wind.[18]

and Greek magical texts turn to the God:

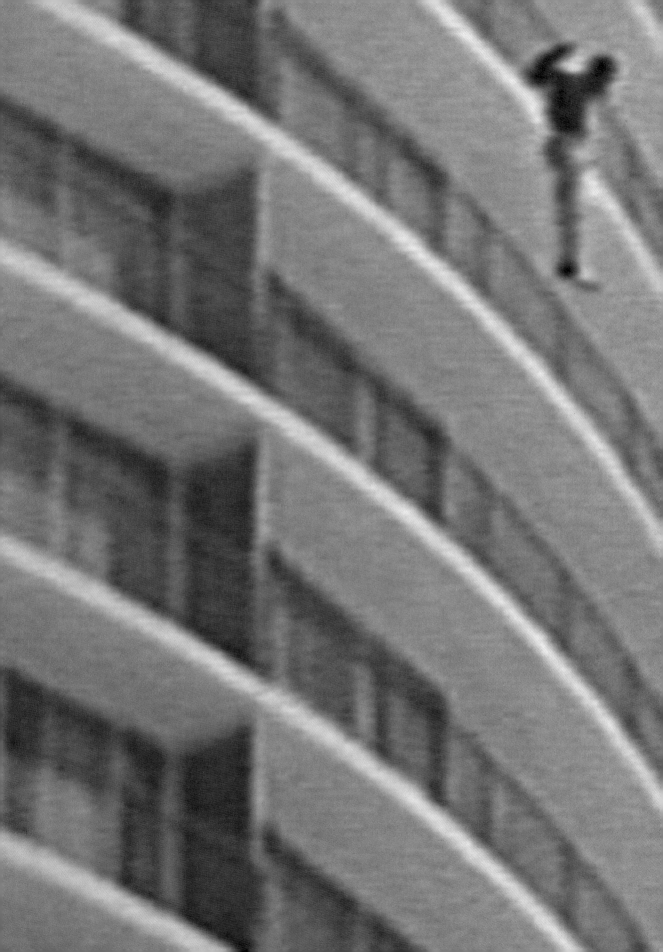

whom sun and moon obey,

as his tireless eyes which light the pupils of human eyes,

whose head is heaven,

whose body the firmament,

whose feet the Earth

and that which is around him, the water,

agathos daimon,

you are the ocean, maker of all good things and provider of humankind.[19]

André-Jean Festugière called this concept of God "le dieu cosmique" and established its meaning in the different religious and philosophical tendencies of late antiquity, such as Neoplatonism, Stoicism, and Hermeticism. The Egyptian precursors, which reach back into the Post-Amarna period and are themselves influenced by the ancient body symbolism of embalming, remained closed to him. In the framework of embalming, the Egyptians learned to think of the body as a world – as the divine world – and of the world as a body. On this foundation, it was only a small step to the idea that the visible cosmos is the body of a single, all-encompassing, invisible deity which manifests itself as the cosmos.

Egypt as the Limbs of the Body of Osiris

Within the scope of the same metaphor which conceives the world as the body of a god who animates it, a semantics develops in the Osiris religion of the Late Dynastic period which postulates the dismembered and embalmed body of this god as a symbol of the unity and integrity of the land of Egypt in the sense of a geographical, political, and cultural identity. Because this semantical view developed in a historical situation in which this identity was extremely endangered, the rites of collecting and embalming of the scattered Osiris limbs at the same time also perform an act of cultural memory, such that here the embalmed body appears especially clearly as an expression of memory and continuity – in this case of the country and not of the person. This idea of Egypt as the mummified body of Osiris is alive in different rituals. One of these rituals is the so-called "sacrificial dance" of the Egyptian king. Here we see a ritual run which is to be understood as the symbolic expression of the sovereign's taking possession of the country. In the Greco-Roman period, this run takes on a further meaning: it is now considered the performance of a mythical episode, that of Isis' search for Osiris' limbs, torn apart by Seth and scattered about the entire land.[20] In his ritual run, the king symbolically hastens through the land and gathers the *membra disiecta* of the slain Osiris, in order to then piece together the

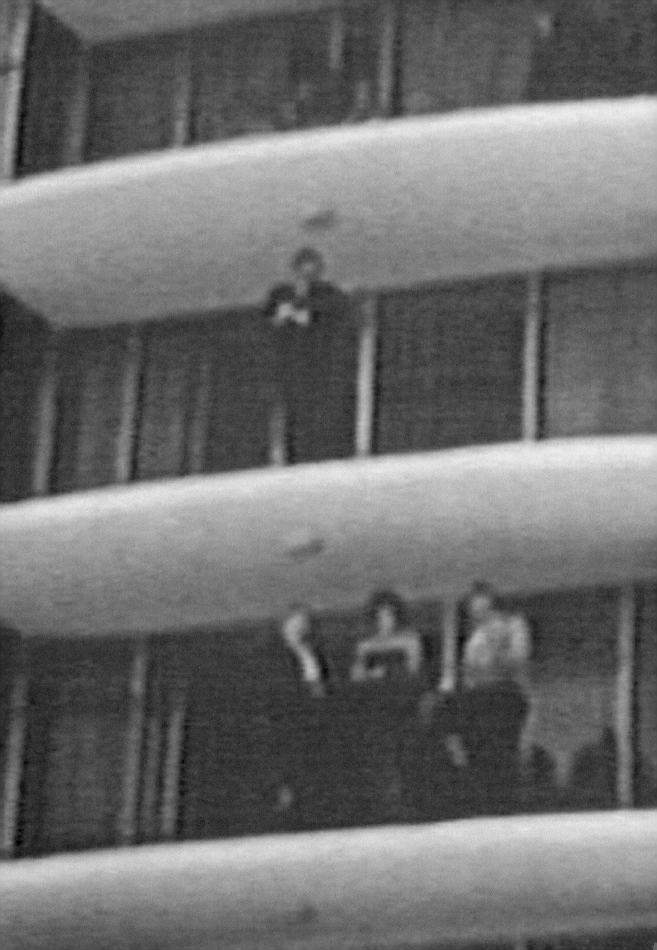

body of the god and, with it, the land of Egypt, restoring it to an animated whole once again. Precisely the same meaning is also connected to the rite of "pulling the chests". Arno Egberts collected together all of the evidence of this rite in his dissertation at the University of Leiden (1993), and was able to prove that in the accompanying texts of the Greco-Roman period, pulling the chests takes on the meaning of collecting, embalming, and storing the limbs of Osiris.[21] The semantics of embalming is extended in the Late Dynastic period to a wide spectrum of very different rites. Above all, however, it refers to the political dimension, particularly in a situation of a deep political and cultural crisis – the Macedonian foreign rule. Greek-dominated Egypt is equated with the torn body of Osiris, slain by Seth, in order to piece it together once again in the symbolic form of the ritual.

The most important of these rituals are the "Osiris Mysteries". They are celebrated at the end of the month Khoiak and represent the highest Egyptian holiday of the Late Dynastic period. The month Khoiak marks the end of the annual flooding of the Nile and the beginning of sowing. Here, the seed is "buried" in the earth, in order to be "resurrected" in a new growing season. That is the agrarian meaning of the rites, whose symbolic interpretation, however, goes far beyond this rustic origin. Nevertheless, a "Seed-Osiris" stands at the centre of the rites, a kind of miniature Adonis garden in the form of a wooden box shaped like a mummy and filled with garden earth and barley.[22] The period of celebration begins with the preparation of this grain mummy – that is, finding and embalming of the scattered limbs of the slain Osiris, which are ritually united and animated – and ends after the solemn burial of the seed mummy with the resurrection of Osiris (the celebration of the "erecting of the Djed pillar") and the accession to the throne of Horus, his son and avenger. The myth that lies at the base of this celebration and which Plutarch is the first to relate in coherent form is a variation of the embalming myth and a transposition of embalming onto a macrocosmic and political level. Just as the embalming ritual reintegrates the *membra disiecta* of the lifeless body to a new, animated whole which is capable of living, so do the Khoiak rites reintegrate the *membra disiecta* of slain Osiris to a whole which represents the country of Egypt. The reunited body of the god, reorganised into an animated whole, forms the symbol for the desired final form of Egypt as a political and cultural unity which is realised in this ritual. The forty-two limbs of Osiris, which in this festivity are collected, united, and reanimated, correspond to the forty-two provinces of the country.[23] The myth relates that Seth-Typhon not only slew Osiris, but also dismembered his corpse and scattered the individual body parts over the entire country. It was assumed that each province held a special body part of Osiris as its central secret and holiest relic. In the "Canopic

procession", part of the Khoiak celebration, the individually personified provinces bring forth their own characteristic body part in a Canopic jar in a solemn procession in order to reassemble the body of the god.[24] It is a water ritual; the water in the Canopic jar is drawn from the Nile, which symbolises a body part of Osiris. In the corresponding texts is written: "I bring to you the forty-two cities and provinces that are your limbs; the entire land has been founded for you as a place for your body" or "the forty-two provinces are your limbs".[25]

Thus, the Egyptians modelled the dismembered body of Osiris according to the multitude of the provinces, in order to represent and reinstate the unity of the land in the ritual of uniting the limbs. In this ritual and in the embalming of Osiris, the unity, wholeness, and integrity of the land of Egypt are simultaneously celebrated. As has already been mentioned, this turn to the political is characteristic for the situation of late Egyptian culture, when the country lost its political independence and fell under foreign rule, first by the Persians and then by the Greeks and Romans. During this time, the unity, holiness, and permanence of the land are invoked in many texts and rituals. This act of searching, collecting, and assembling together – which is not only performed annually in the Khoiak rites but is also set down as the foundation of meaning for all kinds of other rituals, and in which the Egyptians continuously assure themselves of the endangered identity and integrity of their culture – is something which one is compelled to link with the English concepts 're-collection' and 're-membering', which correspond to the German words *Erinnerung* and *sich erinnern*, but which, in their basic etymological meaning, signify nothing other than 'collecting together again' and 'assembling together again'. In the case of this socio-political image of the body, it is not a metaphor or fable, as in the legend of Menenius Agrippa, but rather a compulsory model and symbol of the religious, historical, and political identity of Egypt. The body of Osiris is a body with history, and it is this history which is remembered in the ritual of its reassembly, its re-memberment. The death of Osiris and the accession of Horus to the throne are political myths. The god Seth not only embodies the cosmic, but also the political powers of chaos: the Assyrians, the Persians, the Greeks, and finally, the Romans.

The Greeks and Romans were deeply impressed by these mythical images and rites. Lucian and various church fathers mention the cult of the body parts; Diodorus Siculus extensively discusses the tradition of Osiris' dismemberment and of Isis' search. Horace, however, to whom the winged words *disiecta membra* can be traced, is not thinking of Osiris, but of Orpheus. To be more precise, he calls it "disiecti membra poetae", the limbs of the torn poet, that is, of Orpheus, whose body has been torn apart by the Thracians.[26] Plutarch, on the other hand, refers in his writings

on Isis and Osiris to the myth of dismemberment and reassembling, and gives it a philosophical turn. Osiris becomes *Logos*, the reason that connects and controls everything, the context of meaning of the world, the truth. Plutarch derives the name Isis from the Greek words *isemi* and *eidenai*; she is the goddess of wisdom and of knowledge, or rather of the striving for knowledge, for the verb *iesthai* ('to hasten to') is also contained in her name. This tirelessly hastening movement towards knowledge and truth is represented as the tireless search for the scattered limbs of a dismembered Osiris. Plutarch interprets this search as an allegory of the uncompletable philosophical project of the search for truth. Seth-Typhon is the enemy of philosophy "who is conceited, as his name implies, because of his igno-rance and self-deception. He tears to pieces and scatters to the winds the sacred writings, which the goddess collects and puts together and gives into the keeping of those that are initiated into the holy rites" (Chapter 2, trans. Frank Cole Babbitt).

> [I]t is not, therefore, out of keeping that they have a legend that the soul of Osiris is ever-lasting and imperishable, but that his body Typhon oftentimes dismembers and causes to disappear, and that Isis wanders hither and yon in her search for it, and fits it together again; for that which really is and is perceptible (*noeton*), and good is superior to destruc-tion and change. The images (*eikones*) from it with which the sensible and corporeal is impressed, and the relations (*logoi*), forms (*eide*), and likenesses which this takes upon itself, like impressions of seals in wax, are not permanently lasting, but disorder and dis-turbance overtakes them, being driven hither from the upper reaches, and fighting against Horus, whom Isis brings forth, beholden of all, as the image of the perceptible world. (Chapter 54)

The body of Osiris is declared here to be the *Logos* or the context of reason and meaning of the world in the mode of its sensual perceptibility, which here, down below, always only appears in a torn, scattered, and fragmented state. Isis is the embodiment of philosophy, which is concerned with collecting the countless pieces of this dismembered context of reason and meaning of the world, and reassem-bling them into the integrity of a cosmos. This search for the dismembered Osiris has, in Plutarch, become the search for truth which can never entirely be had in this world; it remains constantly threatened by dismemberment and is, at the same time, an object of relentless human longing.

BODY, TEXT, AND TRANSCENDENCE
Aleida Assmann

What has become of the *membra disiecta* in Western tradition? There is hardly any-
thing that corresponds to the ancient Egyptian theory and practice of embalming,
aside from curious exceptions such as the mummification of communist leaders of
state (Lenin and Mao) and the newer techniques for the conservation of the dead
body by means of freezing or plastination. Instead, the opposite of the restitutively
collecting process of mummification has been at the centre of Western culture,
at least since the Renaissance – namely the anatomy of dismembering, separating.
Perhaps one could even say that in Europe since the Renaissance, anatomy has
assumed the central location of that cultural construction of the body which
embalming held in Egypt. In Europe since the Renaissance, the dissection of dead
bodies became a cultural practice which was led by a new drive for knowledge.
Here, the issue at stake was primarily visibility and directness. The truth lay hidden
under the skin, and it could be tracked down by cutting open and dismembering.
At the centre of these actions was the sense of sight. The concern was to open up
that which had been previously hidden and to make it immediately evident and visi-
ble to all. Anatomical operations were carried out in so-called anatomical theatres,
round buildings with a dissection table in the middle and gradated rows of seats all
around it, which were built all over Europe in the second half of the 16th century.[27]
Since the end of the 15th century, one could attend the anatomical demonstrations
as a spectator; tickets were sold and the price rose when a female corpse was up
for dissection.[28] A scientific drive for knowledge and popular curiosity entered
into an unproblematic marriage. Anatomy, with its dissection and dismemberment,
became a paradigm of a brilliantly clear, visually evident form of representation
which was also applied to other areas of experience. This explains the popularity
of the concept in the early era of printing, even for book titles that had nothing to
do with medicine and the human body.

What, then, does this difference between the reassembling embalming of Egypt
and the dismembering anatomy of Europe tell us about the cultural construction of
the body? The first thing that stands out is the contrast between placing the high-
est value on and devaluating the dead body. In Western tradition, the body loses its
integrity and identity in death. These qualities then turn into something else: the
disembodied soul or spirit. There are no parallels in the Platonic or Christian Western
world for the amazing continuity which the Egyptians constructed between the
living person and his or her "final form" as a corpse. On the contrary, death was

EXODUS

dramatised here as a boundary that separates body and soul, creating a dichotomy which is exceptionally full of consequences for cultural semantics. The body became the personification of all that which is subject to destruction; its existence is teleologically bound for decay and dismemberment. On the other hand, the soul or the spirit became the personification of everything indestructible, unified, intact. The body had no chance for duration; the prerequisite for this was the separation from the body, or, in other words, transcendence. Egypt, with its love and care of the body, appears to have been a culture without transcendence. Where the body, even after death, remains the carrier of identity and integrity, there is no place for bodiless concepts and immaterial ideas.

From this standpoint of a confrontation between Egyptian and European cultural semantics and body construction, Plutarch's text is especially illuminating because it relates the ancient Egyptian myth of Osiris, Seth (= Typhon), and Isis in such a way that it turns into a confirmation of transcendence and an illustration of Western metaphysics. Osiris receives an indestructible soul and a destructible body; non-sensuous, enduring concepts turn into sensuous images subject to decay; the world is divided into an upper region of bodiless eternity and a lower region of bodily decay. We will return to the later reception of this Egyptian myth at the end. Before that, a few more lines of connection between Egypt and Europe should be developed.

Jan Assmann's text demonstrates several entirely different imaginative complexes which are all marked by the ancient body symbolism of embalming. Here is the "idea of the body as a 'body corporate' of cooperating limbs", behind which the termination of such a cooperation stands as its shadow. The Egyptian fable wound up in the treasury of motifs used by poets since the Renaissance via Livy. In *Coriolanus*, Shakespeare brought onto the stage Menenius Agrippa, who seeks to pacify the rebellious citizens with the fable. One of these citizens immediately understood the principle of the body as body corporate, and counts off, half jokingly, the allegorical equation of human with political bodies:

> The kingly crowned head, the vigilant eye,
> The counselor heart, the arm our soldier,
> Our steed the leg, the tongue our trumpeter (1.1.116–118)

The stomach successfully defends itself against the accusation of its parasitic existence. He explains to the limbs, which are addressed as "my incorporate friends", that the (social) organism is a system of never-ending interdependence. The fable

Every outburst of energy generates disloca-
tion. This dislocation may be chaotic, or
reveal a harmonic unfolding, like a wave. In
either case, the displaced mass has only
two foreseeable outcomes: either to crash
violently into annihilation, or to dissipate
quietly in a less agitated field. What can
not be foreseen is how the energy gener-
ated by the forcedly displaced will return
back to perform its revenge, whose name
is history.

Jeder Ausbruch von Energie führt zu einer
räumlichen Verschiebung. Diese Ver-
schiebung kann chaotisch sein oder, wie
eine Welle, von einer harmonischen Entfal-
tung zeugen. So oder so gibt es für die ver-
drängte Masse nur zwei vorhersehbare
Möglichkeiten: Entweder wird sie mit einem
lauten Knall vernichtet, oder sie löst sich
leise in einem weniger bewegten Feld auf.
Was sich nicht vorhersehen läßt, ist, wie die
von dem zwangsweise Verdrängten erzeugte
Energie zurückkehren wird, um es zu rächen
– und der Name dieser Rache ist
Geschichte.

appeals to group loyalty; the dense structure of the overall context tolerates no individual actions.

In Shakespeare, there are further references to the theme of dismemberment and reassembling of body parts in other areas as well. In *Antony and Cleopatra*, he places in the mouth of the Egyptian queen words which remind one of the original God Atum, the "dieu cosmique". The body of this Earth god is "the world, its eyes the sun and moon, its breath the air, and its secretion, the Nile." Grieving over the dead Antony, the image of her lover appears to Cleopatra in a dream in the guise of the Egyptian Earth god:

I dream'd there was an Emperor Antony: [...]
His face was as the heavens, and therein stuck
A sun and moon, which kept their course, and lighted
The little O, the Earth. [...]
His legs bestrid the ocean; his rear'd arm
Crested the world; his voice was propertied
As all the tuned spheres [...] (5.2.76–84)

This mythical figure from late antiquity might have reached the humanists of the European Renaissance and Shakespeare via hermetic traditions such as the first cosmic Adam of Judaism, Adam Cadmon. Here, it seems especially plausible since it is an Egyptian woman who produces this vision of a *dieu cosmique* as a hypertrophic dream image of her deceased lover.

The type of descriptive song which separates the body of the beloved into individual parts and declines it through from top to bottom was immensely popular in the European Renaissance. This typical form of the Oriental love song, which has its archetype in the Song of Solomon, turns up again in Provençal literature and is stylised by Petrarch into a form which became compulsory for following generations of poets. Countless examples attest to the unusual popularity of the *blazon*, as this erotic song of description is called in Europe. This popularity, however, also led to a certain satiety. Once again, Shakespeare can be cited, who quotes the old pattern of the *wasf-blazon* in his 130th sonnet, giving it a parodistic turn:

My mistress' eyes are nothing like the sun;
Coral is far more red than her lips' red [...]

By thoroughly negating the standardised comparisons and discrediting them as "false compare", he signalises the exhaustion of an ancient convention of description now colliding with the new literary norm of "authenticity". In the 1980s, the Petrarchan pattern of description of feminine beauty collides with yet another norm, namely that of feminist literary criticism. The "dismemberment" in the service of an individualising description and glorification was examined from the perspective of gender as a "chopping up" of the female body in the medium of poetry, as an expression of the morbid fantasies of male poets. What already belongs in this context, however, is a Greek anecdote handed down by the painter Zeuxis. Zeuxis had been commissioned to make a statue of the goddess Aphrodite. In order to carry out his task, he asked for a selection of the most beautiful Athenian women to model, so that he might assemble in his sculpture the various features, every one of which was only individually present in each living person. Despite a certain similarity, this story completely breaks with the imaginative abilities of the collecting and assembling Egyptians. While the Egyptians were interested in a healing reassembly of the limbs, in a "restitutio ad integrum" of the body, which they carried out in practice in the technique of embalming and in language in the liturgy for the dead, the Greek anecdote is about the representation of the idea of absolute beauty. This, however, cannot be found in any individual, but rather transcends all earthly manifestation. The dismemberment and renewed assembling of Zeuxis produces something in the medium of art which nature cannot offer; art surpasses, transcends nature.

This logic of transcendence has become extraordinarily important for Western art theory, which purports that the whole is more than the sum of its parts. This "more than" contains the thought of the transcendence of the material, the substantial, its transformation into a new unity and a new substance. The new unity and new substance is that of the artistic work, which develops in co-evolution with the aesthetic demand for innovation and the consciousness of authorship.[29] Horace, who spoke of the "disiecti membra poetae", transposed the body of Orpheus which had been torn apart by the Thracian women into the poet's verses, which are exposed without protection to dispersal and decay. Horace's fear is overcome by the establishing of artistic work in a canon, which both makes it into a taboo and preserves its unity. This clarifies a difference between the Egyptians and the Occident: the concern for unity and integrity, which the Egyptians projected onto their own bodies, is now projected by artists since the Renaissance onto the unity and integrity of their works. They are not concerned with a final form of a bodily restitution, but rather with the final form of the unity of the work as a canonised text corpus.

This thought can also be summarised as follows: the value that the embalming Egyptians placed on the composition of their corpses is equivalent to the value that the canonising and canonised authors since the Renaissance placed in the composition of their literary works. The embodiment and paradigm of the text corpus was the Holy Scripture, for which a new hermeneutics was postulated in the mid-16th century. Matthias Flacius Illyricus (1520–1575) published a *Clavis Scripturae Sacrae* in 1567, in which he carefully develops the analogy between text and body and makes anatomy the principle of his art of reading.[30] After having recommended to the reader that he read the body of the text in its entire form, he continues:

> Thirdly, you must keep the layout and structure of the entire book or work in your mind. And you must observe very attentively which are, so to speak, the head (*caput*), the breast (*pectus*), the hands (*manus*), the feet (*pedes*), etc. Thereby you may judge exactly how this body is made, how it includes all these limbs, and in which way so many limbs or parts together comprise this one body, which is the agreement, harmony, or relationship between the individual limbs among one another or to the whole body, and especially to the head.[31]

Here, again, the anatomising gaze is apparent in contrast with the embalming gaze. The issue here is not the pious assembling of fragments for which the goddess Isis stands, but rather knowledge, the logic of the context, and the comprehensive understanding of the whole.

At this point, I would like to return to Plutarch, who was the first to cross these two aspects of burial and knowledge in his version of the Egyptian myth by making the collecting Isis into a seeker of truth and an imparter of wisdom. The English poet John Milton referred to Plutarch's interpretation of the Egyptian myth in a speech which he delivered in 1644 to the English parliament in defence of freedom of the press. Before he deals with the myth in detail, there is an Egyptian allusion in his text which refers to the embalming ritual:

> Books are not absolutely dead things, but do contain a potency of life in them [...], a good Book is the precious life-blood of a master-spirit, embalmed and treasured up on purpose to a life beyond life.[32]

This formulation confirms once again that the Egyptian obsession for embalming the body is "replaced" by the Western obsession for establishing books in the canon.

Immortality continues to be aspired to; however, it is no longer won through the conservation of the body, but rather through the conservation of the products of the mind. In the age of printing, the human dream of immortality is renewed and the book becomes its surest guarantor. The corporeal immortality of the Egyptians is thereby translated into a spiritual immortality whose material medium is writing. In the context of Milton's speech, the taboo or the sacralisation of the (good) book – and not only of the Bible, which was already always qualified as being holy – became the most important argument for his frontal attack on censorship. He equated the repression of books with the murder of a human being, and adds another sentence which brings the lesser cultural meaning of the body in comparison with the spirit to expression: "[He] who kills a Man kills a reasonable creature, God's image; but he who destroys a good Book kills reason itself, kills the image of God, as it were in the eye."

Milton found the story of Isis and Osiris in the edition of Plutarch's *Moralia*, published in 1572 by the humanist Stephanus. Plutarch tells the story of Typhon, who followed the trail of a boar and by the light of the full moon came upon the wooden coffin of Osiris. He tore the corpse of the deceased into fourteen parts and scattered them throughout the land. When Isis heard of this, she set out in search of Osiris' limbs. She finally found all the parts, with the exception of the member *par excellence,* which had been thrown into the water and gobbled up by a fish. Isis replaced the missing member of the deceased with an artificial imitation. The fact that Osiris and Isis were able to conceive their common son Horus posthumously by means of this prosthesis is left out by Plutarch.[33]

Plutarch's text is an extended ethnographic commentary of the Egyptian myth. The learned apparatus which he constructs is, however, less important here than a second version of the myth which he included in his introduction. The text is dedicated to Clea, a priestess of Delphi, who is described as a seeker of wisdom. Inspired by her, Plutarch transforms, or, more precisely, spiritualises the Egyptian myth into a Hellenic story which only includes Isis and Typhon as protagonists who carry on a struggle between truth and falsehood. Plutarch builds a bridge between Egypt and Greece by means of etymology:

> For Isis is a Greek word, and so also is Typhon, her enemy, who is conceited, as his name implies, because of his ignorance and self-deception. He tears to pieces and scatters to the winds the sacred writings, which the goddess collects and puts together and gives into the keeping of those that are initiated into the holy rites [...][34]

A description of the initiated as worthy recipients of such wisdom begins at this point. What qualifies them over the others is above all their asceticism; body and spirit, sensuousness and truth are brought into stark contrast by Plutarch. He relates that their

> consecration, by a strict regimen and by abstinence from many kinds of food and from the lusts of the flesh, curtails licentiousness and the love of pleasure, and induces a habit of patient submission to the stern and rigorous services in shrines, the end and aim of which is the knowledge of Him who is the First, the Lord of All, the Ideal One.[35]

The Greek fable differs markedly from the Egyptian myth. Whereas Typhon is an embodiment of lies and ignorance, and thus an enemy of the truth, Isis herself is not yet the divine manifestation of truth here, but rather initially the protector and priestess of truth who stands in direct contact with the lord of the universe. Then, however, it says that those who approach her shrine in devout posture can secure knowledge and understanding of the world.

The role of Isis remains ambiguous. She vacillates in Plutarch between being a priestess and a goddess of truth. With her rise to the position of ruler of the universe, a sex change of the highest deity comes about in late antiquity, which the 18th century then emphatically reconstructed.

Milton adds his version of the Egyptian myth to the series begun by Plutarch. He takes over the Greek interpretation of the story as a struggle not for the reconstitution of the body of Osiris, but for truth.

> Truth indeed came once into the world with her divine Master, and was of perfect shape most glorious to look on; but when He ascended, and His Apostles after Him were laid asleep, then straight arose a wicked race of deceivers, who as the story goes of the Egyptian Typhon with his conspirators, how they dealt with the good Osiris, took the virgin Truth, hewed her lovely form into a thousand pieces, and scattered them to the four winds. From that time ever since, the sad friends of Truth, such as durst appear, imitating the careful search that Isis made for the mangled body of Osiris, went up and down gathering limb by limb still as they could find them. We have not yet found them all, Lords and Commons, nor ever shall do, till her Master's second coming; He shall bring together every joint and member, and shall mould them into an immortal feature of loveliness and perfection.[36]

As Plutarch before him, Milton also transforms the actors of the story. Truth plays a major role for him as well, this time in the form of a virgin who is clearly contrasted with Isis, the loyal spouse and mother. This virgin has less to do with Isis than with

FORMATION

Osiris, whose role she assumes. Furthermore, in the translation of the Egyptian myth into an English allegory, a sex change again takes place: the destroyed body of Osiris becomes the destroyed body of a virgin.[37] The role of Isis is replaced by the philosophers and seekers of truth who attempt to recover the pieces scattered far and wide and to reassemble them. In marked contrast to Plutarch, Milton's project of the search for truth remains never-ending. There is no mention here of the initiated who are committed to truth, who watch over and preserve it; instead, every form of delimitation and termination of the search for truth is thoroughly condemned. The true role of Isis – and here a sex change occurs as well – belongs to the Messiah, who alone, at the end of all time, collects the fragments and fits the truth into a perfect and whole form.

The most important difference between Plutarch's and Milton's versions of the story is revealed in the contrast between an antique culture of secrets and a modern culture of the public. Plutarch's Typhon tore the truth into pieces and scattered them to the winds. The word 'scatter' took on a positive sound in the era of book printing, as the printing press guaranteed an entirely new form of reproduction and dissemination of literature and, along with this, helped spread truth. Milton favoured a printing which was unrestricted by license carriers and censorship as a motor for unconditional publication and democratisation. Printing, which is coupled with the project of the never-ending search for knowledge, is also a motor for progress, whose pull and dynamism arises in the orientation towards a goal which itself has been withdrawn. For Plutarch, Typhon represents the profanation of truth; this is the typical problem of a culture of secrets. In contrast, Milton fights against the restriction and limitation of truth, a problem which only poses itself in a culture of the public. Both make use of a form of an ancient Egyptian myth which they vary for their own purposes – removed, however, from its original content, from the concern for the integrity of the dead body, which was the motivating force behind the extraordinary cultural achievements of ancient Egypt.

1. K. Sethe, *Zur Geschichte der Einbalsamierung bei den Ägyptern und einiger damit verbundener Bräuche*, protocol of the Prussian Academy of Sciences, Berlin 1934; S. Sauneron, *Rituel de l'Embaumement*, Cairo 1952; J. C. Goyon, *Rituels funéraires de l'ancienne Égypte*, Paris 1972, 11–84; Fr. Dunand and R. Lichtenberg, *Le momies et la mort en Égypte*, Paris 1998. Embalming was naturally not accorded to every Egyptian from the pharaoh to the fellah with the same degree of elaboration. Whereas the king and the highest officials presumably

Its force field is sometimes discreet, some-times anamorphic, and other times explic-itly precise. In each case, bodies trapped within a formation capture with crystal clarity the contradictory tensions moder-nity has to resolve for the maintenance of its greatest invention – the monadic sub-ject, oscillating between the mirage of indi-viduality and the call of the mass. That such tension is managed by detailed regu-lation of individual motions within a larger collective body shows just how modernity's project is, first and foremost, a gigantic choreographic effort, in the most literal sense.

Ihr Kraftfeld ist manchmal diskret, manch-mal anamorphisch und manchmal ganz entschieden genau. In jedem Fall erfassen die Körper, die in einer Formation gefangen sind, mit kristalliner Klarheit die gegensätz-lichen Spannungen, die die Moderne auflösen muß, um ihre größte Erfindung aufrechterhalten zu können – das monadi-sche Subjekt, das zwischen dem Trugbild der Individualität und dem Ruf der Masse hin und her schwankt. Daß diese Spannung durch die detaillierte Regulierung individu-eller Bewegungen in einem größeren kollek-tiven Körper unter Kontrolle gehalten wird, zeigt, in welchem Maße das Projekt der Moderne vor allem ein gigantisches choreo-graphisches Unternehmen ist – im buch-stäblichen Sinn.

spent the full seventy days in the embalming chambre, the fellahs certainly had to make do with a hint of embalming similar to the Catholic last sacrament of extreme unction. The Egyptians were masters at creating minimalistic, shrunken forms, and if they had to, could reduce expensive building, art, and cult forms to mere hints. The idea of a procedure that lasted seventy days and that each and every person – in whatever abbreviated form – could look to as a transitory stage towards posthumous continuity became fused, however, with the concept of embalming as a cultural institution, at least in the classical and late eras of Egyptian history.

2. While alive, a person lives on Earth, but not in the beyond, which, in the Egyptian imagination, manifests itself in a threefold way: in heaven, in the underworld, and in the Earth's interior. Only within the framework of cult rituals can a person connect with the areas beyond. After death, the reverse is true: he then lives in heaven, in the Earth's interior, and in the underworld, and can enter into a connection with this world within the framework of rituals and holiday celebrations. This form of existence is substantially richer than during life, when one is limited to this world.

3. I am referring here to a lecture which the Heidelberg archaeologist Tonio Hölscher held on the Greeks' image of the body.

4. W. R. Dawson, "Protection of Parts of the Body", *Aegyptus* 11, 1931, 26f.

5. S. H. Altenmüller, "Gliedervergottung", in *Lexikon der Ägyptologie* II, Wiesbaden 1976, 624–627. A certain systematics can, however, be recognised. Nearly all great gods of the ennead of Heliopolis are included in the list: Re, Shu and Tefnut, Geb and Nut, Isis and Nephthys; Seth, Atum, and Osiris are missing. Yet this can be easily explained. Atum and Osiris are death itself, and Seth is the mythical murderer of Osiris, who as such is closed out of the pantheon of the new body. In addition, there are Horus and Thoth, as well as Anubis, Upuaut, and the children of Horus – typical gods of embalming.

6. *Sonnenlitanei*, ed. Hornung, 215–217; see Erik Hornung, *Das Buch der Anbetung des Re im Westen*, vol. II, AegHelv 3, 1976, 88f.; see Jan Assmann, *Liturgische Lieder an den Sonnengott*, Munich 1969, 348. E. Brunner-Traut ascribes to the contrary interpretation in her book *Frühformen des Erkennens. Am Beispiel Altägyptens*, 2nd ed., Darmstadt 1992, 71–81. She asserts that the Egyptian, as all other pre-Greek or pre-"axial-age" cultures, were incapable of comprehending the body as an organic unity, and could only see it as a composite or aggregate of individual parts. "The body is assembled together from a number of parts, 'knotted, tied together'; it is more or less that which we call a jointed doll." (72). This form of understanding, which comprehends a form not as a whole in its organic context, but rather assembles it together from many single parts or single views, is what E. Brunner Traut calls "aspective". The thought of "playing together", of cooperation which I am interested in, is something she rejects explicitly.

7. A. Erman and H. Grapow, *Wörterbuch der ägyptischen Sprache* III, 2nd unrevised reprint, Berlin 1957, 357.18–358.2.

8. Livy, *Ab urbe condita libri*, 2, 32; Plutarch, *Vita Coriolani*, 6; see: H. Gombel, *Die Fabel vom "Magen und den Gliedern" in der Weltliteratur*, Halle an der Saale 1934; E. Brunner-Traut, *Frühformen des Erkennens. Am Beispiel Altägyptens*, 2nd ed., Darmstadt 1992, 71f.

9. As quoted by E. Brunner-Traut, *Altägyptische Tiergeschichte und Fabel. Gestalt und Strahlkraft*, Darmstadt 1964, 40f., 56. On the text, see Frank Kammerzell, "Vom Streit zwischen Leib und Kopf", in S. Lief, ed., *Mythen und Epen* III, TUAT III.V.III, 1995, 951–953.

10. On the form of the Oriental descriptive song and its ancient Egyptian origin, see Alfred Hermann, *Altägyptische Liebesdichtung*, Wiesbaden 1959.

11. Song of Solomon 4: 1–7; see O. Keel, *Deine Blicke sind Tauben. Zur Metaphorik des Hohen Liedes*, Stuttgarter Bibelstudien 114/115, 1984.

12. Papyrus Chester Beatty I, I, 1–6; quoted from Michael V. Fox, *The Song of Songs and the Ancient Egyptian Love Songs*, Madison 1985, 52; see A. H. Gardiner, ed., *The Library of A. Chester*.

13. Book of the Dead 172, German trans. Erik Hornung, *Das Totenbuch der Ägypter*, Zürich 1979, 351–358 (excerpts). O. Keel, in reference to E. Hornung, has already indicated the proximity of this text to the descriptive song of romantic poetry (note 11), 28f.

14. See Jan Assmann, *Re und Amun. Die Krise des polytheistischen Weltbilds im Ägypten der 18.–20. Dynastie*, Freiburg (Switzerland) 1983, 250–263.

15. Pap. Leiden I 350; see Jan Zandee, ed., *De hymnen aan Amon van Papyrus Leiden I 350*, Leiden 1947, 98–101; see also Assmann, *Re und Amun*, 251f., no. 3.

16. Ostrakon Wien 6155 + Cairo CG 25214; see G. von Vittmann, *Wiener Zeitschrift für die Kunde des Morgenlandes*, 72, 1980, 1–6; see Assmann 1983 (note 14), 252, no. 4.

17. Serge Sauneron, *Le papyrus magique illustré de Brooklyn* [Brooklyn Museum, 47.218.156], New York 1970, 23, pl. IV, fig. 3.

18. Document VIII § 65c; see Otto Firchow, ed., *Urkunden des ägyptischen Altertums, VIII: Thebanische Tempelinschriften aus griechisch-römischer Zeit aus dem Nachlaß von Kurt Sethe*, Berlin 1957.

19. Papyri Graecae Magicae XII, 238–245, ed. Karl Preisendanz; see Hans Dieter Betz, *The Greek Magical Texts in Translation*, 2nd ed., Chicago 1992, 162.

20. Hermann Kees, *Der Opfertanz des ägyptischen Königs*, Leipzig 1912, 90–100.

21. Arno Egberts, *In Quest of Meaning*, Leiden 1993.

22. E. Chassinat, *Le mystère d'Osiris au mois de Choiak*, 2 vols., Cairo 1966 and 1968; S. Cauville, *Dendera. Les chapelles Osiriennes*, 3 vols., Cairo 1997.

23. Fundamental on this subject: Horst Beinlich, Die *"Osirisreliquien". Zum Motiv der Körperzergliederung in der altägyptischen Religion*, Wiesbaden 1984. Regrettably, Laure

Pantalacci's dissertation, *Recherches sur Osiris démembré*, Thèse de Doctorat de III.e Cycle, Université de Paris-Sorbonne, 1981, remains unpublished to this day and was not available to me. See also L. Pantalacci, "Sur quelques termes d'anatomie sacrée dans les listes ptolémaiques de reliques osiriennes", Göttinger Miszellen 58, 1982, 65–72.

24. Beinlich 1984 (note 23), 80–207 and 272–289.

25. Ibid., 208f.

26. Horace, *Satires* i.4, 62: "[non ...] invenias etiam disiecti membra poetae" ("thus you [never] find the limbs of a torn poet"). The limbs of the torn poet are the words and thoughts that remain when verse, rhythm, and composition are changed, by which, despite the destruction of the poetic form, one can still recognise the true poet in his choice of words and creative fantasy. It is possible that Orpheus, Linos, Osiris, Dionysos, and whatever other god or other hero of whom the myth of dismemberment was told, in themselves had nothing to do with each other. In the imaginative world of antiquity, however, these myths blended into each other.

27. In Montpellier 1556, in London 1557, in Ferrara 1588, in Basle 1589, in Leiden and Padua 1594. More recent studies on the anatomical perspective: Barbara M. Stafford, *Body Criticism. Imagining the Unseen in Enlightenment Art and Medicine*, Cambridge, Mass. and London 1991; Deborah A. Harter, *Bodies in Pieces. Fantastic Narrative and the Poetics of the Fragment*, Stanford 1996; David Hillman and Carla Mazzio, eds., *The Body in Parts. Fantasies of Corporeality in Early Modern Europe*, London and New York 1997.

28. William S. Heckscher, *Rembrandt's Anatomy of Dr. Nicolaas Tulp. An Iconological Study*, New York 1958.

29. For this new aesthetic in the Renaissance, see Aleida Assmann, "Die bessere Muse. Tradition und Innovation bei Sir Philip Sidney", in Walter Haug and Burghart Wachinger, eds., *Zum Begriff der Originalität in der frühen Neuzeit*, Fortuna Vitrea, Tübingen 1993.

30. Dilthey called Flacius the founder of the new hermeneutics. I thank Mathias Pozsgai for the hint on Flacius.

31. Matthias Flacius Illyricus, *De ratione cognoscendi sacras literas – Über den Erkenntnisgrund der Heiligen Schrift*, Latin-German parallel edition, trans. and preface Lutz Geldsetzer, Reihe Instrumenta Philosophica, Düsseldorf 1968, 91f.

32. John Milton, "Areopagitica", in *Milton's Prose*, ed. Malcolm Wallace, London 1963, 280.

33. Plutarch, *Moralia*, Loeb Classical Library, 21, 45–47.

34. Ibid., 352, 9.

35. Ibid.

36. Milton, "Areopagitica" (note 32), 311.

37. One is tempted to see here the premonition of a motif that would become an obsessive theme especially in the 19th century: the death of the beautiful woman. See Elisabeth Bronfen, *Over Her Dead Body: Death, Femininity, and the Aesthetic*, New York 1992.

Choreography As a Cenotaph:
The Memory of Movement

Gabriele Brandstetter

One has to dig up the dead, over and over again [...] the future only arises out of a dialogue with the dead. – *Heiner Müller*

Movement is a factory of the fact that you are actually evaporating. – *William Forsythe*

Rainer Maria Rilke published his collection of poems *Sonnets to Orpheus* in 1923 with a dedication of a special kind. He constructed the text as a cenotaph, "written as a monument for Vera Ouckama Knoop"[1]. The memorial commemorates a young dancer who died of a mysterious disease in 1919 at the age of nineteen. She stopped dancing, her body changed, and she sought movement in other forms – in music and in drawing. It was "as though the dance denied her were still finding its expression, ever more quietly and discreetly", wrote Rilke to Margot Sizzo on 12 April 1923. But this cenotaph which the texts represent is not only meant for the deceased dancer. Much more, the sonnets – in the name of the mythical singer capable of moving even the dead with his song – refer as an epitaph to the death of dance itself. They put writing, as memory and as a lament on evanescence, in place of the moving body. The poetry invokes that empty space which has divested itself of dance – a vacuity which, for this very reason, is called "the unheard-of centre":

You still knew the place where the lyre
lifted sounding – : the unheard-of centre.[2]

Under the sign of the mythical invoker of the dead, Rilke's *Sonnets to Orpheus* demonstrate what choreography intends: the description of that space which has

always been in the process of expelling the body's movement. Seen in this way, choreography is a form of writing along the boundary between presence and no longer being there: an inscription of the memory of that moving body whose presence cannot otherwise be maintained. Choreography is an attempt to retain as a graph that which cannot be held: movement. On the one hand, 'choreography' means the writing of movement as notation; on the other hand, it also refers to the text of a composition of movement. Choreography, as the writing of and about movement, as preserved memory, thus always includes something of a requiem. It is precisely this memory which designates the Orphic: as a space between life and death. This space between the material and the immaterial world opens and closes by means of the gesture of turning, by the torsion of the body which "holds open the door to the grave"[3]. The fact that working with movement – the placing of steps and their transition in placement – also includes entering these interspaces and that choreography places and erases traces of memory has deeply engraved itself on the modern consciousness. Rilke's poetic phenomenology of these processes gives an idea of this.

The works of contemporary choreographers such as Meg Stuart, Xavier Le Roy, and William Forsythe are also particularly imbued with a reflection on the fleeting quality of dance and of the fragmented traces of memory which, at the very most, allow themselves to be gathered up as vestiges and translated into another text.

William Forsythe – vestiges of whose dance pieces I shall present, from my own memory, over and over in what follows as a leading thread in my argument – has been engaged by these questions more, perhaps, than any other contemporary choreographer. In *Limb's Theorem* (1990), a fragmented interspace is opened up as a theatre of the memory of movement. The dancers move on a stage kept so dark that the audience can only partially perceive the bodies. The contours and three-dimensionality of the forms are further blurred by the precise handling of the lights. The lighting conditions influence perception in such a way that the imagination adds the invisible, whose absence we feel in the forms and movement. In these borderline areas of the perceptible, seeing becomes insecure; the corporeality of the forms is porous and the line of the figures of movement is interrupted. Light and shadow cause anamorphic distortions.

As the title suggests, the choreography postulates a theorem on limbs. Not a complete theory, but rather something like a hypothesis on the body and its parts. The human figure cannot be grasped as a whole. Instead, it constantly eludes its stable form – in movement and through movement. The body thus appears divided into parts, or dis-membered, to then become reassembled, or re-membered in the

viewer's reconstructive perception. The entire text of the piece constantly formulates and then refutes other versions of this theorem on the organisation and disorganisation of the limbs. The programme booklet is part of this choreographic theorem as well. It contains text fragments by Aldo Rossi and Ludwig Wittgenstein: philosophical reflections on the subject of perception and imagination, and on the idea of the fragment. Printed on rough, recycled paper, the typefaces are set in justified blocks of text printed as a negative image – white on black (the play of light and shadow on the stage translated onto paper), paler on every successive page, and with headings skewed in such a way that the layers of print gradually overlap. There is hardly any differentiation between (back)ground and (typographic) figure, and the body of writing slips into an indistinctness which is analogous to the figures of the dancers themselves. The blocks of text which embody the memory of writing – a memorial to the perception of movement – themselves move within a (scriptorial) space in which they fade and are superimposed to the point of illegibility, whereby a process of overwriting is set in motion: It is a kind of choreography on paper as a palimpsest. The justified blocks of text in the programme booklet are interspersed with empty pages – that is, with paper surfaces that are not inscribed, but rather incised (the verb 'to write', like the Greek word *graph*, originally meant 'to cover with writing' as well as 'to scratch' or 'to incise'). Geometric figures, lines, circles, acute angles, and curves are punched into the paper like the floor plan of choreographic notation. They jump up as the page is turned, suddenly taking on a spatial form.

The programme booklet keeps posing a set of basic questions in choreography, the same questions as those addressed on the stage: the continuity of movement and the identity of bodily form. Choreography – as a sketching of paths, as cartography – is "folded" into these pages. In this way, the programme booklet brings to view a virtual mise en scène of the shifting of letters: the emancipation of writing from the principle *scripta manent* into the fleetingness of movement in space. "Fragment," reads the text fragment by the architect Aldo Rossi, "*frammento* means a small chip which has broken out of a larger body", and he goes on to ask whether an accumulation of fragments, rather than being termed a mere "rubbish heap", should not actually be called the "city of the future".

What William Forsythe's choreography takes up on and makes tangible in different forms and frameworks – on paper and on stage – are highly abstract questions concerning the space and time of movement and the never more than fragmentary traces which survive as its memory. And this investigation itself, like the framework provided by the title, takes place in an interspace: in a form of the concept of Orphic, stemming from Rilke's mythical poetics and translated into late 20th-century

thinking. As well as meaning 'extremity', the word 'limb' (deriving from the Latin *limbus* = 'hem' or 'edge') also designates the form of the circle and arc in instruments used for measuring and drafting angles. Thus *Limb's Theorem* – the choreography in the book and the performance on the stage – could be read as experiments with instruments of figural measurement and engraving: with the precision technology of figure placement and spatial delineation. At the same time, the fragility and unpredictability of this kind of work become apparent.

'Limbus', with its completely different meaning of 'hem' and 'border zone', is closely related to 'limbo', which refers to the realm between heaven and hell – that sphere in which, according to the Christian faith, deceased unbaptised children linger: Dante's *purgatorio*. 'Limbo' – the region that Christ descended into – means a heterotopia comparable to the passage between Hades and Earth that Orpheus passed through in his search for the dead Eurydice. Finally, another level of meaning enters the programme of *Limb's Theorem*, one that also illuminates the complex context of (in-between) space, movement, and memory from another angle: from the perspective of neurophysiology. The technical term 'limbic system' denotes the zone in the brain which – as the superordinate integrative system – is responsible for the organisation of human behaviour. Perception and memory of movement in reading and writing – this is all we are doing – always produce this interspace after the fact: a limbo of moving bodies and an epitaph of choreography.

Cartography – Notation and Memory of Movement

Perhaps at the very beginning of all memory, as a mythical memorial to movement, there was the labyrinth: Ariadne's dance floor. The Palace of Knossos was created by Daedalus as a labyrinth, in the centre of which the Minotaur was enclosed. And Ariadne received the thread which helped her find the way out of the labyrinth. The floor plan of the labyrinth was the spatial figure of a loss of orientation in movement and, at the same time, the location of a sacrificial ritual. The repetition of these paths – in a dance which redirects disorientation back into an order which can be defined cartographically – also invokes the dead. It is spatial notation which transforms the threat of death into a symbolic act through the memory of the sacrificial victim (those human sacrifices brought to the Minotaur), for the victim's body disappears in the centre of the labyrinth. In dance, this *corpus* of the victim is absent. Memory alone retains the spatial pattern, the design of the choreography.

All memory is spatial. Choreography, as notation and as a cartography of movement, is a means of retaining the memory of movement – alongside other, more recent recording systems such as photographic images, film, video, and electronic

media. But how does the memory of movement translate into writing? And how can the traces of kinetic memory be pursued in a process that never runs in a linear and progressive manner, but rather develops an anticipatory power in its oscillation between remembering backwards and forwards? But conversely, perception would also be impossible – as the results of neurological research studies tell us – if the brain did not already keep memories readily available at all times.[4] "I'm always touching the latest action with the new thing I'm doing," remarked the dancer and choreographer Saburo Teshigawara, "but the stream is not a line that you draw behind you as in skiing. That's in the past, whereas our stream in dance is always already in the future."[5] In this process of remembering movement "in the future", images are always being erased and replaced with others. In his phenomenology of memory, Henri Bergson emphasised the way in which the perception of movement and the dissection of the remembered images of movement work together: "You sub-stitute the path for the journey, and because the journey is subtended by the path you think that the two coincide. But how should a *progress* coincide with a *thing*, a movement with an immobility?"[6] According to Bergson, images of memory and imag-inative contents interlock, exchange places in such a way that memory no longer imagines our past alone: "In truth, it no longer *represents* our past to us, it *acts* it [...]"[7] Memory becomes agent, player, and director. Memory choreographs the recog-nition of movement.

A look back in history reveals that this intricate connection between the memory of movement and the *imagines* of imaginative power already was of primary impor-tance in the choreography of the Renaissance. One of the earliest dance treatises of the period, written by Domenico da Piacenza, emphasises that *memoria* and *fan-tasma* are inseparably linked in the choreographic process. And Domenico finds an appropriate image for this:

> Note that fantasmata is a physical quickness which is controlled by understanding the
> misura first mentioned above. This necessitates that at each tempo one appears to have
> seen Medusa's head, as the poet says, and be of stone in one instant, then, in another
> instant, take to flight like a falcon driven by hunger.[8]

The moment that the image of movement is fixed in the memory is expressed through metaphors of stiffening and falling: as petrification through Medusa's gaze and as the sweeping dive of a hungry falcon. In these images, fissures of movement are cut into the memory process – transitional zones, intervals between individual sequences of movement. The *fantasmata* denote moments of rest, like taking a breath. They

open that meaningful instant in which the (remembered) image arrives at the moment of quiet and of the keeping still of the body, encompassing the movement altogether in the figure. In this pictorial evocation between the past and the future, the *fantasmata* offer a reflection of the *memoria*. The movement is completed in stillness, the procedural memory is overlaid by the anticipatory memory. Because for choreography, the art of memorising means far more than committing the patterns of movement and paths to memory. Much more, it is the visualisation of the entire process in each respective moment of movement: as though one were imagining an image, a choreographic map.

Thus, along with the theory of memory in dance, the search for a system of notation for movement also began. Shortly thereafter, writing became the cultural archive of dance; notations of choreography were developed and formulated in treatises by dance masters at Italian courts. What remains are peculiar scores: spatial and temporal notations which codify and record movement by means of figures showing floor paths and ciphers symbolising the directions for carrying out these movements. The mnemonic system of dance consisted of figures, names, and numbers. Writing thus reconstructed that which has always disappeared when the body moves – as a system, as an ordering of the uncontrollable. It is true that the body is absent in these texts, but it has no place in the memory script of these notations; bodily movements, the posture of the head, or the turning of the torso were not transferred into signs – this remained for later systems of notation.

Not until the end of the 19th century did the body begin to be accounted for significantly in the process of memory and theories of memory. The "phantasms" which permeate the memory of the body, together with the remembered and excluded images, henceforth appear subordinate to another dynamics of movement, that of the dynamics of the subconscious. They no longer mark the turning point of stillness and the transformation through remembered and anticipated memory, but rather appear as foreground images concealing the repressed, dislocated, and unreachable memories within the crypt of the subconscious.

> One has to let the phantasms play close up to the bodies: against the bodies, because they adhere to them and project onto them, but also because they touch them, cut through them, regionalise them, and multiply their surfaces; and, in like manner, outside the bodies, between which they play their game according to laws of transference, turning and moving unknown to them. The phantasms do not carry the organisms on into the imaginary; they topologise the materiality of the body.[9]

Starting with Freud, this topologisation of the body and the occupation of the map of the body by phantasms which follow dynamics of remembering and forgetting inaccessible to the consciousness became a new subject in 20th-century cultural science. Memory became a problem case.

William Forsythe demonstrated that this "problem case" could also be handled playfully. His choreography *Artifact* (1986 version) contains a dictionary of those concepts that form a kind of matrix of the composition: a thesaurus of those elements of speech taken out of the archive and made current as dance. One of these concepts is the word 'remember'. A text woven out of this concept is worked into the choreography in a long sequence of paradoxical twists on remembering and forgetting: "Remember the story" and "I forgot the story about you [...] remember, remember [...] remember"[10]. Remembering and not remembering, forgetting and that which cannot be remembered are continuously being invoked by means of voice and body: "They will never remember where. They always forgot which. They never remember how [...]". And in the course of this choreography, which portrays remembering as concrete poetry and which summons up the moving anagrams of body parts and spoken parts as a spatial puzzle, forgetting itself is, finally, programmed as well: Which viewer is able to remember the exact formulation of the words spoken, the phrases of movement? Writing about it, as is the case here, for example, always requires the archaeological collecting of traces, the fragmentary reconstruction using the few remaining written and pictorial documents.

The Computer: Saver of Memory and Archive of Movement?

At the end of the 20th century, the question arises anew as to how the memory of body movement can be saved. Which means of storage offer the possibility of repeating, of reproducing the sequences of movement, and what does this mean for cultural tradition? For a history of the moving body? Can video documentation replace writing? And what changes do programmes that electronically simulate body movement bring about? Or even the development of programmes by researchers of artificial intelligence, who, conversely, carry on the observation of human movement with computers, thereby contributing to the perception of movement?[11] A matrix for producing choreographies still intended for the stage – as with Merce Cunningham? Or will the computer become the comprehensive storage place for the vocabulary of movement and the precise medium for the recording of performances in the future? William Forsythe uses a specially designed computer programme which he developed in conjunction with the Institute for Visual Media of the Centre for Art and Media Technology Karlsruhe in this way. This CD-ROM, in extended form and with

G-FORCE

commentary, is now available to the public as an archive of movement as well as a document of certain choreographies, such as *Self Meant to Govern* (1994). Elements of the dance alphabet which Forsythe has developed with his dancers are stored in this digital archive and can serve as an aid to the dancers' memories. The CD becomes a sort of cyberprompter. But at the same time, this choreographic archive also offers a freely available inventory of movement material which can be called up on the computer screen by dancers and non-dancers alike as a scheme configured by the program or permanently encoded. The aim is a school of *analytical* seeing, as the subtitle announces, *A Tool for the Analytical Dance Eye*.[12] Besides the didactic function as an "interactive school of dance", there is the level of multimedia documentation, and finally, the level of media and corporeal transformation which Forsythe especially emphasises. The dancers' work takes place in training, and also, as in *Self Meant to Govern*, in the interaction on the stage: in the improvisations with those code elements which the computer supplies as random material. The choice and the activation of elements of movement from this basic storage catalogue does not occur in the form of a mimetic transferral, but rather in a translation which always transforms: not as an edition of the choreographic texts, but rather in the working out of variant material for improvisation. *Improvisation Technologies* is the title of this storage of movement on CD-ROM.

In this way, the stage work of choreography consists of up-dating computer-supported mnemotechnics for each performance. The dancers are agents of the pre-existing technologies of memory, and this should not at all be understood negatively, in the sense of pure "user" pragmatics, because Forsythe's dancers are also involved in the development of an alphabet of movement: as co-programmers of mnemonic devices. Moreover, it is interesting to note that Forsythe assumes that a kind of memory is inherent in the kinetic sphere itself: "your kinesphere functions as a memory [...]"[13] The concept of the kinesphere, which Forsythe has adopted from the expressive dancer and founder of kinetography, Rudolf von Laban, designates the field of movement that lies within reach of the body, a kind of invisible spatial mantle that Laban drew in the form of a crystal – the icosahedron. This transparent, crystal representation of the kinesphere is, so to speak, the core of the cybermemorial. Yet while the kinesphere and kinespheric memory remain bound to the body, the movement memory stored in the CD-ROM is "excorporated". Storing and remembering are separated from the body, released from their tie to the body through various intermediate operations, and made virtual in the Net. In this way, the effects that develop out of this extended ludic region for the relationship of body and space overlap. This has been welcomed from all sides and with nearly naive trust in the

He thought of himself as matter: mass, surface, density, opacity. He thought of himself as measurable: height, weight, age, pulse. He thought of himself as structure: bones, ligament, muscle, cartilage. He thought of the world as pure force, against which he would collide. Once, he thought the world had turned purple; it was only his eyes flooding with blood. He always looked like a child after each experiment. He was constantly being photographed.

Er betrachtete sich als Materie: Masse, Oberfläche, Dichte, Lichtundurchlässigkeit. Er betrachtete sich selbst als meßbar: Höhe, Gewicht, Alter, Puls. Er betrachtete sich als Struktur: Knochen, Bänder, Muskeln, Knorpel. Er betrachtete die Welt als reine Kraft, gegen die er prallen würde. Einmal dachte er, die Welt sei purpurrot geworden, doch es waren nur seine Augen, die sich mit Blut füllten. Nach einem Experiment sah er immer aus wie ein Kind. Er wurde ständig photographiert.

expansion possibilities of the prosthetic body in virtual space. The "transhuman" re-embodiment of the moving body in cyberspace perhaps marks a further station in the instrumentalisation process of cultural history, in the development of technologies which Michel de Certeau termed "the apparatuses of incarnation". From another perspective, the body memory in virtual space comes across as being paradoxical. Isn't the multimedia, electronically-linked archive of movement on CD-ROM an extended form of writing? The body of William Forsythe, the system's author, is enclosed within this storage chamber. His body? Or rather his simulation, in perfectly reproduced movements from Forsythe's "lecture demonstrations", which allow every trace of movement to appear as a graphic image on the computer screen? Transported into cyberspace via scanner, this is precisely what this "memory-body" documents from the movement archive: the disappearance of the body. Enclosed within the virtual theatre of memory as in a sarcophagus ('sarcophagus' means 'meat eater'), the edifice of the digital storage of memory raises itself above the empty space of fleeting dance; choreography – transcription – as the epitaph of dance.

Disturbance in Balance – Chance and Memory
Kafka, who once said that he wasn't a good swimmer, speaks of the memory of "not swimming":

> I can swim like the others, only I have a better memory than the others, I have not forgotten
> my former inability to swim. But since I have not forgotten it, my ability to swim is of no
> avail and I cannot swim after all.[14]

Can we unlearn our ability to execute skilful, acquired movements (apart from disturbances of the brain and of the nervous system)? Can we remember the status of "not being able" to carry out a movement after the fact? And can we arbitrarily forget what has engraved itself in the procedural memory of the body – complex, automated movements such as swimming, riding a bicycle, or simply walking?

Through a reflection of this kind on the apparently self-evident nature of movement and its remembering repetition, the concept of 'going' or 'walking' (gehen) has become interesting for the modern period. Neurologists and researchers of artificial intelligence today ask how, taking the interconnected language and movement processes as an example, 'going' is represented in the brain as an image of movement: What does the image that Marc Johnson called "The Body in the Mind" look like? And how are the metaphors of the verb 'to go' mentally reconstructed – for example, the saying 'that goes against the grain with me'? Not only science, but also

dance poses hypotheses on going or walking. For in the final analysis, dance is the art form of placing steps (pas). Thus, the discovery of walking – simply walking – as the embodiment of movement and its transitoriness also becomes an occasion for self-reflection in choreography. Rilke emphatically writes in his *Sonnets to Orpheus*, dedicated to the deceased dancer, that dance is the "transposing / of all transience into stepping".[15] But one could respond to Rilke by slightly changing his words, since at the same time the perception of movement becomes the "dismantling of all movement within the stepping". For with the development of chronophotography, that form of media technology located somewhere between photography and film, its prominent inventors Marey and Muybridge did nothing else but indeed arrest the division of the movements of walking or running into infinitely long sequences of individual images that fix every phase of the temporal process and transfer it into diagrams. From 1867 onwards, Marey developed recording machines that tran-scribed step sequences that cannot be followed with the naked eye (for example, a horse's gallop) into bar diagrams. He called these records of movement "synoptical notations" after the type of musical score, "the type of music" whose sounds had been "written by the horse himself".[16]

Walking becomes the paradigm of "Postmodern Dance", which, as it is known, no longer wants to be 'dance', yet nonetheless reformulates dance as performance. Merce Cunningham and the group of his pupils that met in the Judson Church Theatre worked on such concepts of *events* as 'non-dance'. Can a dancer walk as a non-dancer does? And when does walking – simply walking and nothing more – become definable as choreography? Douglas Dunn was asked in an interview: "Does walking down the street come close to your idea of what dancing is about?" – And the answer was: "As an analogy, yes [...] on the one hand, the connection to order – the streets, the traffic lights, and regulations, etc. – and, on the other hand, the complexity, because all those different intentions find their way in and around each other."[17]

As an everyday activity, walking becomes a pattern of choreography as cartogra-phy: an act of describing paths of motion and their crossings; nothing less than a mapping brought forth by a deliberate choreography led by chance. And this chore-ography is not the transcription of a previously written pattern of movement, but rather a movement of reading and writing in one. Michel de Certeau thus termed the connection between walking and spatial notation a game of tactile perception and of kinesic acquisition. "The play of the steps is a formation of spaces [...] they can-not be localised, because they create the space itself. They are just as intangible as Chinese letters, the contours of which the speaker sketches with a finger into his

palm."[18] Walking is a mode of reading and writing chronotopical maps whose points are read together in movement – a script which renders invisible the very process that made it possible. Every script of movement replaces and occupies, just as the motion of writing and reading itself does, and becomes a trace that takes the place of praxis.

Can this everyday practice – walking – be turned around into a process which goes beyond the ordinary? Could this movement be "unlearned" by observing the failures with microscopic precision in a close reading? Then walking would always also be a kind of falling. The self-evident coordination of the limbs in motion contains, in the moments of transition, an element of disorder. Laurie Anderson wonderfully formulated this paradox of disturbance in the apparently ordered movement of walking:

> You're walking [...] and you don't always realise it but you're always falling. With each step [...] you fall. You fall forward a short way and then catch yourself. Over and over [...] you are falling [...] and then [you] catch yourself. You keep falling and catching yourself falling. And this is how you are walking and falling at the same time.[19]

Contemporary dance theatre works with precisely this. The peculiarity and precision of its work with the body is rooted in a fundamental mistrust in the self-evident processes of known movements – whether these are virtuoso dance steps, mechanised working movements, or schematic acts of communication. In William Forsythe's work with the body, for example, the processes of dissolving of fixed patterns result from an exact observation of the codified steps and poses of the *danse d'école*. Gaps and dislocations are allowed into these patterns – like a weaving error in a fabric or dropped stitches in a knit pattern. For this, an exact knowledge and analysis of the traditional systems of movement are required – whether they be the code of classical ballet, the tradition of folkloristic dance, or the stylised pattern of steps in Japanese No theatre. "Reading *anew* that which has been handed down means interpreting it 'incorrectly'."[20] That would mean making the code of classical ballet "lively in an incorrect way" – as Forsythe comments on his manner of "reading" in an interview. The triumph of ballet lies in its virtuoso techniques of antigravity and the accompanying celebration of equilibrium. Such an "incorrect" interpretation could now, as with Forsythe, consist in making the falling out of this balance – disequilibrium – the subject of work with the body, instead of the breathtaking balance. The illusion of floating on point, which constituted the ballerina's aura in the 19th century, is henceforth broken, for the slipping out of the

precarious pose of the arabesque is not avoided, as is the case in classical ballet, but instead becomes the source of a continuation of a movement, the form of which stems from the surplus of energy released by the fall and by the still uncertain goal of this falling movement. The figure of this "released" arabesque is therefore not pre-drawn, but rather produces itself in an unmanageable process of movement. The breathtaking experience of the virtuoso control of the body in perfect balance – *The Vertiginous Thrill of Exactitude*[21] – makes room for another, equally breathtaking experience: playing with the disturbance of balance, with the loss of control. This is an experience which, in Forsythe's words, finally signifies dissolution, "letting yourself evaporate":

> The more you can let go of your control and give it over to a kind of transparency in the body, a feeling of disappearance, the more you will be able to grasp differentiated form and differentiated dynamics [...] You try to divest your body of movement, as opposed to thinking that you are producing movement. So it would not be like pushing forward into space and invading space – it would be like leaving your body in space.[22]

Is the disturbance of balance that moment in which we forget a learned movement – at least for a moment? And can this experience – and also the movement spontaneously unfolding out of it – be brought about voluntarily? Stumbling, falling ... these certainly allow themselves to be conventionally represented in pantomime, precisely as "disturbances", as failures in motion; the long tradition of this type of representation in theatre, and not only in the area of comedy, provides enough examples of this. But how does one make falling out of the order of equilibrium the object of dance, without just simply acting it out? Does it work, on the other hand, as a "skilled" demonstration of such disorganisation, so that the impression arises with Forsythe's critics of a "virtuoso limp", or, as with Meg Stuart, of a "corporeal stutter"?

Such questions do not only apply to the "paradox of walking as falling", but rather to the paradox of body representation in general. Phenomenological observations of these forms of being – between stability and lability, between the unconscious "being a body" and the reflexive "having a body", between standing and falling – concentrate on the anthropological side of kinaesthesia. Referring back to Husserl and Merleau-Ponty, the philosopher Bernhard Waldenfels asks: "What does a world look like in which a 'free fall' is possible which says more than just a coincidence or accident? What does a world look like in which bodies are looking for places to land, without already feeling solid ground beneath them?"[23] Man was already described in Kant's anthropology as a being possessing a disturbance in balance, as though he

were standing "on the edge of an abyss".[24] Man's upright gait carries its lability along with it, in a physiological as well as metaphorical sense, a lability "which comes to expression in different forms of the lapse. Only he who (or that which) can stand can also fall over. Falling represents here an extreme possibility. In falling, we touch the boundaries of our being. In falling over or falling down, we enter a movement that slips out of our control. The body slips out of itself."[25]

The body which precisely in its loss of control "slips out of itself" finds itself in the status of not knowing which prefigures the emancipation from ingrained traces of the memory of movement. Not a point zero of knowledge or a complete forgetting, but a virtual limbo between bodily knowledge and lack of knowledge, between control and the failure of the controlling factor. This interval holds the potential of "another movement", in which the known and the repeatable simultaneously contain the turning point of unlearning – a feature which opens the possibility for unknown, "foreign" movement. This has nothing to do with the aesthetic concept of alienation, nor is it about a masquerade of the familiar and the conventions related to this. Whereas the politics of alienation are based on a change that grows out of an enlightenment concerning difference (a dialectic process which still holds onto the old, the own as the object of criticism), change arises out of the lapse seemingly without a directive and without a stated goal. For this reason, it is not the alienated vestment that corresponds to the phenomenology of the lapse, but rather the attempt to rid the body of (its) movement (as Forsythe says, "to divest your body of movement"). The type of the 'new', of the foreign that can arise out of this (because it is always only a possibility – a possibility which can also be missed) is emerging: in the best case, it is a form of surprise, of surprising oneself. As Douglas Dunn said, "Surprise [...] I'd like to know what dance would look like if the dancer didn't know what he was going to do next."[26]

This thought of a surprise through a movement not deriving from the repetition of the known or from a predictable sequence (as, for example, with functional movement in work or sports) is what characterises the principle of improvisation. The idea of an entirely spontaneous movement which is unique and thus unrepeatable has a long history in anthropology and in aesthetics. It is linked to the fantasy of a primordial, expressive power of human motion *preceding* all language and all social disciplining and located beyond all regularisation. In contrast to this is the knowledge that the movement of the body, however much it runs within codified channels, can never be reproduced in a perfectly identical way. To be precise, every repetition of a remembered movement is overlaid with interferences of the (inner and outer) perception of the moment, and is therefore a bodily work of memory which adjusts the

image of movement of the moment according to the image in the memory in a repetitive process of "similar dissimilarity". How, then, should improvisation be understood? As a bodily movement determined by chance, and not deriving from a specific code of movement? And in what way could the paradox of the (intentional) forgetting of all kinds of patterns of movement stored in the memory be solved? Even as a dance movement concept – such as in "Contact Improvisation", founded by Steve Paxton, or in the choreographed improvisational pieces of Meg Stuart, Amanda Miller, Jonathan Burrows, and William Forsythe – the concept of 'improvisation' denies exactly those layers of memory which are fixed within certain systems as codified movement and are readable as such. Improvisation defines itself as movement arising out of a lack of rules, as a "non-code" driven by emotions or by chance. Are the general forgetting and unlearning that are the prerequisites here – the prescribed lapse in memory – conceivable? Does not the fact that improvisation workshops exist – as well as "Improvisation Technologies" – suggest that the "unlearnable of unlearning" is also being built into a pedagogic framework and that the "lack of rules" of improvised movement is itself being translated into patterns? Certainly, for a movement which in a strangely foreign way has cut off every reference to known and recognisable bodily motions is perhaps "virtually" imaginable. But would it be readable? It would probably still be read and made legible upon being transferred into the contexts of its representation. In this way, however, it would attain that very effect which improvisation achieves at best: rendering familiar patterns of movement meaningless – a ReMembering capable of occurring precisely in that lapse within a smooth memory of movement. In this way, improvisation does away with the "cease-fire between choreography and dance", shifts the weight from the fixation – the cenotaph of choreography – to the event of movement of the dancing body whose complexity cannot be reproduced: "The purpose of improvisation is to overcome choreography, to come back to what dance was originally."[27]

What level of abstraction do the experimental orders of movement reach in the modern period? Has the deconstruction of frequently-used images and codes of movement indeed reached the boundary of unreadability? The deeper and the more precisely one penetrates into a movement – 'walking', for example – the more abstract it becomes. Is this choreographic microanalysis a reflex reaction to the increasing tendency towards minimalism and abstraction of Western society? Must one then be "at least as abstract as the stock market", as the choreographer Mary Overlie said, "in order to be really creative today"?[28]

Have the body's *Pathosformeln*, those "formulae of expressing extreme passion", disappeared in 20th-century dance, as they have in art? Do the expressive gestures

HAILSTORM

that were certain to be easily decoded still exist? Body images which are legible as the language of emotion, which "speak" directly and conjure up that other movement: the movement of the soul?

They have not disappeared; they can be found in other areas of our culture, having departed from art. Cannot grand gestures of tumultuous enthusiasm or the *Pathosformel* of falling to one's knees with the hands raised to the heavens be seen today in soccer stadiums, instead of in churches and exhibition spaces? But it is not just the dislocating of body images in the topography of Western culture; the images of the body and their expressive movements have become transformed – their shape deformed as though under an immense pressure, their movements distorted and chopped up, proffering no tribute to an already known ideal of beauty and grace. These bodies unleash another fragile and threatened beauty, however, in the process of their "ReMembering"; an unforgettable contact with foreign movements and body images reveals itself to the gaze that does not shy away from taking a closer look.

It is the borderline situations of the body in motion whose imposition grows out of a strange hybridity. The hypermobility of the body reveals an impression which is nearly impossible to comprehend: beauty of vanishing form – a "poetry of disappearance" – in the rejections and punctual deformities of movements that risk the unexpected. That also means, particularly for the viewer, casting a glance into the chaos, into a process of the confusing of (body) parts, which can be read and collected only at a certain price: The task of memory – that double ReMembering – is divided among those moving and those watching the movement. And this process thus always becomes a journey of remembering through the phantasms of one's own body history. And is this landscape not also marked by deformity? By misunderstanding and misreading, which – in the limbo of subjective memory – rebuilds the rules of language and allows a world of spirits to arise out of it? It is as though the ideas in our body memory could no longer get rid of the memory of a history of damages.

One such story is told by Walter Benjamin in his *Berlin Childhood around Nineteen-Hundred*:

> In an old children's verse, a character called Muhme (Aunt) Rehlen appears. Because I didn't know what 'Muhme' was, this being became a spirit for me: the 'Mummerehlen' [...] 'I want to tell you something about the Mummerehlen.' The little verse is distorted, and yet the entire distorted world of childhood is contained izn it."[29]

On the edges of everydayness, unsuspected shadows and colours vibrate continuously with unique intensity and cadence. In the half-lit rooms of the world, a luminous beat lulls the scopic field, bathed by the hailstorming aura of the televised era. Content is overcome by form, form overflows into impression, impression dilutes into lightning flashes. Television dances its magic inscription beyond the retina, on walls. It delivers not facts, but pulse.

An den Rändern der Alltäglichkeit vibrieren unablässig unvermutete Schatten und Farben von einer einzigartigen Intensität, in einem einzigartigen Rhythmus. In den halbdunklen Räumen der Welt lullt ein rhythmisches Leuchten das Gesichtsfeld ein, das von der hagelsturmartigen Aura des Fernsehzeitalters überflutet wird. Die Form siegt über den Inhalt und schwappt über in die Impression, die Impression löst sich in Lichtblitzen auf. Hinter der Netzhaut, an Wänden tanzt das Fernsehen seine magische Einschreibung. Es liefert keine Fakten, sondern einen Puls.

Distortion – mishearing and misreading – is the poetic core of a story whose spirits cannot be driven from memory. Writing appears in place of that false movement which makes something beloved be absent – which is the story of Orpheus – and which makes the subject's loneliness apparent. Writing, thus ends Benjamin's story, is the epitaph of those movements which have always been disguised in the memory by distortion. "Had I even just once had a glance of the not-yet-distorted," wrote Benjamin in 1932, "I would have been consoled for the rest of my life."[30]

1. Rainer Maria Rilke, *Sonnets to Orpheus*, trans. M. D. Herter Norton, New York and London, 1942, 13.

2. Ibid., 125.

3. This is how Rilke describes the death of Vera Ouckama Knoop in a letter to Witold Hulewicz on 13 November 1925.

4. See Wolf Singer, "Zur Selbstorganisation kognitiver Strukturen", *Gehirn und Bewusstsein*, ed. E. Pöppel, Weinheim 1989.

5. *Das Gedächtnis, Theaterschrift*, no. 8, Brussels 1995, 202.

6. Henri Bergson, *Matter and Memory* (1896), trans. N. M. Paul and W. S. Palmer, New York 1919, 248.

7. Ibid., 93.

8. Domenico da Piacenza, "De arte saltandi et choreas ducendi. Dela arte di Ballare et Danzare", quoted in D. R. Wilson, *Early Dance Circle, Sources for Early Dance, Series 1: Fifteenth-Century Italy*, Cambridge 1988, 8f. Italian original: "[...] e nota che fantasmata / e vna presteza corporalle laquale e mossa cum lo intelecto dela mexura dicta imprima disopra facendo requia acadauno tempo che pari hauer ueduto lo capo di meduxa / como dice elpoeta / cioe che facto el motto sij tutto di piedra inquello instante / et ininstante mitti ale / como falcone che per paica mosso sia segonda la riegola disopra [...]"

9. Michel Foucault, in Gilles Deleuze and Michel Foucault, *Der Faden ist gerissen*, Berlin 1977, 26.

10. See Christel Römer, "William Forsythe's *Artifact*. Versuch einer Annährerung durch Sprache", *William Forsythe. Tanz und Sprache*, ed. Gaby von Rauner, Frankfurt am Main 1993, 27–46.

11. See Stefan Wachter, "Maschinensehen. Das Erkennen menschlicher Bewegungen", *Form und Zweck*, no. 16, 32–40.

12. William Forsythe, *Improvisation Technologies. A Tool for the Analytical Dance Eye*, ed. Centre for Art and Media Technology Karlsruhe, Ostfildern 1999.

13. William Forsythe in the programme booklet for *Eidos:Telos*, ed. Städtische Bühnen Frankfurt, Frankfurt am Main 1995, 39.

14. Franz Kafka, *Wedding Preparations in the Country and Other Posthumous Prose Writings*, trans. Ernst Kaiser and Eithne Wilkins, London 1954, 327.

15. Rilke 1942 (note 1), 105.

16. Quoted from Marta Braun, *Picturing Time. The Work of Etienne-Jules Marey (1830–1904)*, Chicago and London 1992, 28.

17. Sylvère Lotringer, *New Yorker Gespräche*, Berlin 1983, 59f.

18. Michel de Certeau, *Kunst des Handelns*, Berlin 1988, 188f.

19. Quoted in *Parallax*, ed. Städtische Bühnen Frankfurt, Frankfurt am Main 1989, 13.

20. Felix Philipp Ingold, *Das Buch im Buch*, Berlin 1988, 112.

21. As Forsythe titled one of his smaller pieces (1996), with which he paid reverence in his slightly ironic way to this fascination for ballet.

22. Forsythe 1995 (note 13), 33.

23. Bernhard Waldenfels, *Sinnesschwellen. Studien zur Phänomenologie des Fremden*, vol. 3, Frankfurt am Main 1999, 217.

24. Immanuel Kant, *Mutmasslicher Anfang der Menschengeschichte*, quoted in Waldenfels, ibid.

25. Waldenfels, 219.

26. Lotringer 1983 (note 17), 55.

27. Forsythe 1999 (note 12), 25.

28. Lotringer 1983 (note 17), 132.

29. Walter Benjamin, *Berliner Kindheit um neunzehnhundert*, Frankfurt am Main 1987, 59.

30. Ibid., 60.

Bending towards the Breaking Point:
The De-Formation of Dance and Mannerist
Images of the Body

Gerald Siegmund

1. The Dance of Images

Strange things happen in Renaissance paintings in the course of the 16th century: Figures lose their attachment to the ground and start to float. Their bodies become contorted like elongated snail shells. They appear to tumble from their frames and reach for the viewer with fingers spread, while they simultaneously appear to hover towards him on their backs. Where traditionally linear perspective guided the viewer's gaze and provided a mirror of nature, suddenly an empty centre prevails. In *Descent from the Cross* (1526–28) by the Florentine painter Jacopo da Pontormo, this is embodied in a white cloth. The vacant, sad stares of its figures seem to push their way out of the painting. Glances remain unreciprocated. Due to extreme criss-crossing, the direction of the gazes is lost in a vague nowhere which gives the painting an anxious and troubled character. While the three figures in the foreground still balance or kneel on the tips of their toes, bringing their bodies into a precarious equilibrium, the men and women behind them no longer have any attachment to the ground. Reductions in size due to perspective, which creates the impression of spatial depth, is abandoned to a great extent. The firm shape of bodies and that of the picture's perspectival construction become evasive and fluid; it appears as ephemeral as the shape of a cloth fluttering in the wind. The coincidental, that which has no duration and certainly no symbolic significance for the history of salvation, is suddenly and miraculously found in the centre of the painting. The small figure of Jesus in the lap of the *Madonna with the Long Neck* (c. 1534–40) by Parmigianino (a painter from Parma who was a follower of Raphael in Rome) almost tumbles onto the floor and out of the painting, but just manages to cling to Mary's dress. As the title of the painting indicates, the figure of Mary is oddly proportioned. Not only her neck, but also her

Jacopo da Pontormo **Descent from the Cross**, c. 1526–28
Florence, Santa Felicita, Capponi Chapel

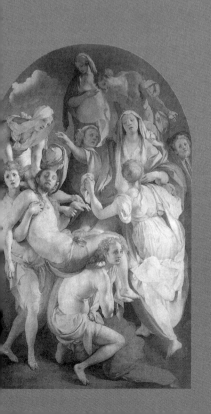

hands and fingers are exceptionally long. These elongations and contractions distort the correct mimetic representation of space and figure and throw proximity and distance off balance. In the bottom right corner of the picture, behind Mary's throne, the space opens into a strangely stagelike exterior where a prophet who is hardly larger than the hem of Mary's dress stands with a scroll in front of a column as though he were in a completely different space altogether. Parmigianino's *Self-Portrait in a Convex Mirror* (c. 1523–24) rolls the space into a ball, while the painter's right hand, his "instrument", appears anatomically enlarged in the foreground, as if its importance for the act of painting were meant to be highlighted self-referentially. Once again, no view of nature is provided. The window has shrunk to an insignificant triangle on the left edge of the medallion-like painting. The views of nature are blocked or become stage sets, such as the one in *Gabrielle d'Estrées and her Sister* by an anonymous artist of the Fontainebleau school, in which two topless women sit in a bathtub as if in a theatre box and pinch each others' nipples with dainty fingers. Pictorial spaces are arranged in endless succession in the background. The times when artists turned to nature to depict its shapes and colours and give them a perfect order on canvas seem truly over. The painter's gaze now falls on other paintings. Art defines itself as artifice and as the unfolding of an inner, subjective idea, as opposed to an objective, mimetic one. Beauty is no longer found primarily in the objects provided by nature, but in the imaginative power of the artist, in an eidos not present in nature.

The four paintings that I have briefly described are filed under Mannerism by art history. Mannerism, with its characteristic dissolution and multiplication of perspectival spaces, contraction and elongation of body parts and their contours, as well as the choreographic mobility of its figures and the twisting of their bodies to the breaking point, represents a rejection of the Renaissance ideal of harmonious composition. Deformation and defiguration indicate an altered relationship of art and artists with the world that they are, after all, meant to depict and recreate. I would first of all like to summarise the crucial academic positions on these changes in order to then derive a position of my own from them. In my view, Mannerism does not represent a phenomenon of crisis, but rather the culmination of the pictorial rhetoric of the Renaissance that leads to art's autonomy as text.

Starting from such a structural definition of the term, I will attempt a "mannerist" conceptionalisation of one tradition within modern dance, one that focuses primarily on questions of structure rather than of content. My attempt is motivated on the one hand quite naively by the problematising of space, body, and movement as central concepts of dance. On the other hand, the re-emergence of typically Mannerist figures

Parmigianino **Self-Portrait in a Convex Mirror**, c. 1523–24
Vienna, Kunsthistorisches Museum

Parmigianino **The Madonna with the Long Neck**, c. 1534–40
Florence, Galleria degli Uffizi

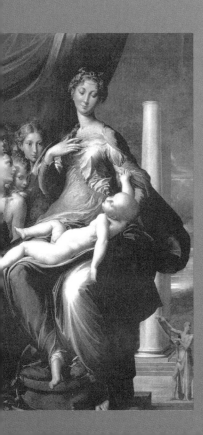

such as the arabesque and the *concetto* seems significant to me, since they shape
the role of the body in 20th-century dance as image-text. In this context, Mannerism
is an attempt to re-establish the conceptual space of resemblance with its Platonic
and metaphysical implications, despite the awareness of its failure, and thus an
attempted reactivation of cultural memory that contains submerged knowledge of the
world. Yet it also appears as a self-assessment of dance, its means, and ultimately
its rejuvenation precisely through the decomposition and deformation of established
models. These models are frequently derived from the archives of the visual arts,
the body-images of which accompany the development of dance.

2. On the Theory of Mannerism

Ever since Walter Friedlaender started in 1914 to analyse the stylistic features of
the first generation of Mannerists such as Pontormo, Rosso, or Parmigianino, the
Mannerist period from 1520 to approximately 1620 and its cultural context have been
examined and evaluated continuously.[1] The function and relevance of the term
'Mannerist' are objects of controversy to this day. For Ernst Robert Curtius, Mannerism
is characterised by rhetorical excess and an artifical and affected manner of expres-
sion. Mannerism is a recurring stylistic feature from Classical Antiquity to the present
day, a term devoid of "all content for art history" that "merely indicates the lowest
common denominator for all literary tendencies that are opposed to the Classical, be
they pre-Classical, post-Classical, or simultaneous with any form of the Classical."[2]
Consequently Mannerism is neither bound to a particular century nor to a specific
artistic genre. Following Curtius, Gustav René Hocke regards Mannerism as a "primor-
dial gesture of humankind".[3] In contrast to Curtius's history of style that removes
individual works of art from their historical context, Arnold Hauser's social history of
art sees Mannerism as being closely linked with the social, political, and psychologi-
cal conditions of its time. Terms such as 'alienation' and 'narcissism' are regarded as
crucial for an understanding of Mannerism, since they express a deeply-felt crisis
of the individual in a time of social upheaval. The division of society into Refor-
mation and Counter-Reformation that found its first drastic expression in the Sack
of Rome in 1527 plunged people into a fundamental insecurity that emerged in art
as an "opposition against the merely instinctive, a protest against everything purely
rational and naively natural, an emphasis on the inscrutable, problematic, and
ambiguous".[4] Therefore the "hour of birth of modern man" is not so much represented
by the Renaissance, but by its aestheticised collapse in Mannerism. John Shearman
opposes both the stylistic and socio-historical universalising of the phenomenon in
his study, *Mannerism*. Mannerist artists neither rebelled against their models nor did

they express unresolved social or psychological tensions in their paintings. Their style must be understood as a sui generis style, as a "stylish style" that aims for "refinement" and is just as perfect as that of the Renaissance.[5]

The term *maniera* was first used in art history in Giorgio Vasari's *Le vite de' più eccelenti pittori scultori e architettori.* There it is nearly synonymous with 'style', be it the style of a period or that of a particular painter. Yet already in Vasari's description of individual styles, there is tension in the use of this term: between the imitation of nature and stylisation, and between 'beautiful manner' and 'more manner than imitation of nature'. Supported by the idea of a rebirth of art in the Renaissance, perfection that exceeds that of Antiquity is achieved in Vasari's contemporary, Michelangelo. Yet surpassing established art with a *maniera moderna* was only possible when the learned imitation of nature of the 15th century made way for a greater freedom of the artist: "to attain greater beauty and artistic perfection of style, or *bella maniera*, defined as the modification of nature by skillful abstraction and inner idea."[6] In Michelangelo's work, this inner idea apparently struck the right balance between the observation of nature according to the laws of optics and an abstraction deriving from the study of other works of art. Yet in their attempts to surpass their model, painters who imitated Michelangelo were constantly in danger of losing the balance in favour of an exaggerated *maniera*. If, on the other hand, they stayed too close to Michelangelo, they were merely imitating, that is, they were only painting in the 'manner' of Michelangelo and had failed to add anything new to art. In both cases *maniera* has negative connotations.

In Vasari's biographical sketches, it seems at first glance that Mannerism is also regarded as a symptom of decline – like everything that comes after Michelangelo. Yet the poignancy of the concept lies in the simultaneity with which the *maniera* creates and destroys perfection, that is, the harmony of proportions. The link lies in the idea of *disegno*. Starting with Leon Battista Alberti's treatise *De Pictura* (1435), *disegno* in the shape of *historia* – the composition – becomes the central tool in the elevation of the painter from craftsman to a god-like artist.[7] According to Alberti, a picture is composed of surfaces, limbs, and entire bodies, the harmonic arrangement of which inspires joy and pleasure in the viewer. The ultimate aim of the composition is "copia et varietas rerum", the utmost variety and vividness of postures and colours.[8] Yet here, too, this abundance threatens to develop into Mannerism, for Alberti's text is immediately compelled to limit this freedom of composition once again: "But I would have this abundance not only furnished with variety, but restrained and full of dignity and modesty."[9] The threat of the uncontrollable, of a surplus of signs, lies in the rhetoric of the construction itself.

Because for Alberti, as for Vasari, composition is nothing but a cut-up, a montage of the most beautiful things that nature can offer the eye. Alberti writes: "Therefore, excellent parts should all be selected from the most beautiful bodies, and every effort should be made to perceive, understand and express beauty."[10]

Against this background Mannerism itself seems to be composed like a "classical", harmonious Renaissance painting. A change in focus enables the viewer to shift his gaze from the objectifiable figure to its development, and thus to the seams of construction that are always already inscribed in the perfect figure. Mannerism brings to its logical conclusion the rhetorical structure of pictorial composition with its aim of creating affects by fearlessly developing its possibilities and forcing them into the open. Decomposition of perspective and deformation of bodies are thus neither components of a style of its own nor stylistic constants that indicate the dissolution after a Classical period. Instead they assume the structure of a deconstructive negativity that is always inherent in each expressive statement and the space-time of which it distorts and unhinges.

Erwin Panofsky relates Mannerism to the subject and its relation to the world. While Alberti's artist of the Renaissance regards himself as a craftsman whose idea derives from observation, an idea in which subject and object and spirit and nature are equivalent, the relationship of subject and object becomes problematic with the advent of Mannerism.

> During the Renaissance the Idea concept, not yet consistently reasoned out and not too important in art theory, had helped conceal the gap between mind and nature. During the Mannerist period it served to reveal it: the forceful stress on the artistic personality pointed directly to the problem of "subject" and "object". But at the same time the Idea concept made it possible to close up the gap by reinterpreting "Idea" in its original, metaphysical meaning; for this metaphysical meaning resolves the opposition of "subject" and "object" in a higher, transcendental unity.[11]

The awareness of a rift between subject and object for the first time brought artistic creation into the consciousness as an autonomous process independent of mimesis and thus makes its theoretical legitimation a necessity. Mannerism, according to Panofsky, is the first proper theory of art. At the same time, this emerging autonomy has to be secured and integrated into the divine order via a Neoplatonic concept of the artistic idea as divine spark, as "scintilla della divinità" that enables the subject to become creative in the first place.[12]

What did this 'idea' of Mannerist creation consist of? Michel Foucault describes

G. B. Bracelli **The Actors**, 1624
From Gustav René Hocke, *Die Welt als Labyrinth.*
Manierismus in der europäischen Kunst und Literatur,
Reinbek 1987

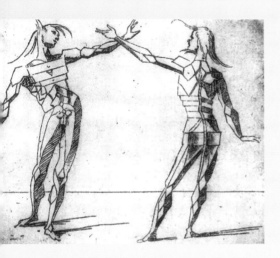

the discourse of the Middle Ages as well as that of the Renaissance as a conceptual space of resemblance. Things enter a meaningful relation with each other through their proximity in the world (*convenientia*), the connection of things that are spatially separated but related to each other like a mirror and its reflection (*aemulatio*), as well as through analogies and sympathies that make them resemble one another and guarantee the meaningful closure of the world picture.[13] Joachim Küpper, with reference to Foucault, calls the discourse of the Renaissance the first stage of dissolving the idea of resemblances which had structured thinking since the late Classical period, as resemblances able to accept the proximity of many dissimilar things that are regarded as equally valid – without taking into account their formerly binding theological context. He sees (literary) Mannerism as the second stage of dissolving in which the modelling of the world – that was still possible in the Renaissance in the shape of plural, alternative worlds – is completely abandoned in favour of an explicit and self-justifying artistry of stylistic means. Mannerism thus becomes the purposeless art of art.[14]

This form of producing resemblances is evident in the *Wunderkammern*, the Mannerist collections of curiosities, such as the ones created by Rudolf II in his palace in Prague or by G. B. della Porta, the founder of a secret academy who collaborated with Rudolf II in the search for the philosopher's stone by means of alchemical experiments, in his house in Naples. Such collections of curiosities or art chambres united in one space dried animal corpses, precious gems and metals, mechanical devices, crafted and found objects – in short, everything that appeared bizarre, grotesque, or strange. Collected in distant places, the objects assumed merely because of their spatial proximity a relation of resemblance that established the order of things like a microcosm – without, however, basing this collection on a rational system of taxonomy and classification, as later supplied by the conceptual developments of Classicism. One may assume that since even such strange objects as the horn of the unicorn – which was known not to exist – entered the *Wunderkammern*, the chambres represented the conscious attempt at reactivating an already problematic order of resemblance: a "no longer" that nonetheless still claims validity by any possible means, and a "not yet" that gains its productivity from its intermediate position.

The concept of resemblance will be retained in the following as a theoretical guideline for Mannerism. This implies a removal of the episteme of resemblance from its historical context of Renaissance, Mannerism, and Classicism or Baroque, and its re-evaluation as a structural possibility that, once established, remains available at all times. With the emergence of Modernism, resemblance in the context of art is brought back to life as an attempt at renaturalising life and art. In its wake, traditional

cosmological models in the context of the dancing body and its relation to space are reactivated, at a time when they no longer play a part in the production of knowledge in the industrial age. This will become evident in the works of Loïe Fuller and Oskar Schlemmer. For the period after 1960 that one may heuristically call Postmodernity in dance, as Sally Banes does, the Mannerist moment of self-assessment and self-dissociation of the dancing body moves into the foreground as the very renewal of dance, similar to the oversized right hand in Parmigianino's self-portrait. William Forsythe and Meg Stuart will provide evidence for this. The further structure of the present essay thus follows the two dominant stylistic figures of Mannerism: the arabesque as pictorial composition (Fuller, Forsythe) and the combination of the *concetto* as a textual strategy (Schlemmer, Stuart), both of which are articulated through the body in motion. This distinction – which is not really one since text always weaves itself with the dancing body into a picture, while the picture always unravels itself into text – is introduced for the sake of clarity. Both figures address different sides of the same phenomenon of rhetorical overfulfilment and overabundance; a further reason why they must not be understood as opposing terms. My attempt to create analogies between such seemingly remote areas as 16th-century art and 20th-century dance via the common *tertium comparationis* of a body-text-image, of combination and arabesque, admittedly follows a Mannerist thought experiment itself, one that might for this very reason yield surprising results.

3. Anamorphosis: The Dynamic Space

Linear perspective as an ordering principle of pictorial composition already dissolves with Parmigianino's illuminated, elongated right hand. A correct perspective that would re-establish balanced proportions in the portrait can only be attained if the viewer positions himself at an acute angle to the painting's surface. The best known example of such a use of distortion, or anamorphosis, is Hans Holbein's painting *The Ambassadors* (1533). It depicts two powerful young men: Jean de Dinteville, French ambassador at the English court, and his friend Georges de Selve, the future bishop of Laveur. On the table between them are symbols of their power and their various interests: Terrestrial and astronomical spheres, additional astronomical and geometrical measuring devices, and an opened Lutheran hymn-book represent the perfect order of the world, the connection of science and art, and the harmony of cosmic and terrestrial spheres, with man as the privileged point of convergence. Yet on the floor in the foreground of the painting, an elongated object materialises like a stroke that seems to cross out this order once again. If one walks to the left side of the painting, the distorted anamorphic smudge is revealed as a skull that inscribes

in the world of the two men a further world that only becomes visible through the viewer's movement. Holbein's technique permits two realities to occupy the same space, although the observer is incapable of grasping both of them at one glance. They occupy the same pictorial space and yet belong to two different orders that question their mutual status in the manner of a picture puzzle or even exclude each other. Holbein's picture is, in a literal sense, a movement away from the representation of the world towards a sphere that only flares up at the borderline between the background and foreground of the painting, a borderline that the viewer must approach in order to realise it. Similar to Orpheus's experience during his escape from the netherworld, only the backward glance – the look over the shoulder or the reversal of the gaze – makes the invisible visible in the dissolution of the represented form.[15] This alternative space can only be experienced fleetingly and through movement. The space metamorphoses and tilts with the movement. The space is bound to it the movement and in this way opens up multiple and varying spaces.

Anamorphosis results from the dot-by-dot projection of an image from a straight plane onto a tilted one from one point of view. Such an anamorphic process provides the structure for William Forsythe's full-length ballet *Alie/n A(c)tion* that was performed for the first time in the Schauspielhaus Frankfurt on 19 December 1992. Already the Mannerist combination of the letters in its title plays on the idea of 'alien' in multiple ways: those that might arrive one of these days from outer space or foreign countries, alienation, an alien nation, as well as a lie in action, that is, a structure that unfolds from within and only signals its reference to the world as an effect, as a lie. "Ent-World-ET", an ironic allusion to Steven Spielberg's famous extraterrestrial, is scribbled onto the backdrop of the empty stage that continues to change shape during the first part of the ballet as long wooden benches are constantly rearranged on it. What remains is the movement of the dancers. The basic theme of the alien, projected onto the spatial and temporal paradigm of the stage, mainly concerns their spatial orientation that is rendered confusing and strange when several ordering systems overlap in the same space. The basis of the distortions is provided by Rudolf von Laban's icosahedron that envelops the human body and its radius of movement as a kinetic sphere. Laban's three levels with their twenty-seven corner points and twenty planes serve, on the one hand, as means of orientation and as a plaything for each of the ten dancers in the first part. Through unusual combinations of space and body points, they create strange movements that appear to have shifted out of their axes, out of balance, and thus out of form. On the other hand, the complete three-dimensional model is projected onto the stage floor in an anamorphic distortion in such a way that a diagonal movement towards

the upper right no longer needs to be executed as such, but can be replaced by a dancer merely pointing towards the corresponding spot on the floor.[16]

"Our body is the mirror through which we become aware of ever-circling motions in the universe with their polygonal rhythms", writes Laban in the introduction to his theory of space and harmony, *Choreutics*, and thus highlights the cosmological basis of his theories of space and movement.[17] "We should never forget that every gesture and action of our body is a deeply rooted mystery [...] It was thus that tumbling or standing on the head could once have been a sacred play."[18] In the teachings of harmony the link between man and universe is expressed, analogous to Leonardo's drawing of a man harmoniously surrounded by a circle, as a connection mirrored in the human body and soul. Each seemingly banal movement, such as a somersault, carries the traces of its spiritual origin, even when culture has long become oblivious to it. Laban's theory of harmony – a theory that he significantly tried to put into practice with choruses – therefore reminds us of forgotten knowledge by postulating a resemblance that became irrelevant as a generator of knowledge when thinking shifted to processes of individualisation and interiorisation.

In Forsythe's piece, the metaphysical content of the moving shape in space becomes an ironic allusion to the science fiction film *Alien*, a film that is used to generate new and different movement. The supernatural and alien elements that humans encounter in outer space are presented as a video on a screen on the right side of the stage. Alone or in groups, the dancers approach this screen in order to relate what they see on it. A further system of generating movements consists of transferring gestures from the flat surface of the screen to the space of the stage with the help of Laban's system of orientation while simultaneously twisting them, lifting them onto a different plane, or leading them in a different direction. Forsythe uses various ruptured and integrated ordering systems (a computer eventually joins film and the icosahedron as a third principle) to overfulfil that which Laban – who did not believe in the existence of a (metaphysically) empty space – defined as space: "[... S]pace is a superabundance of simultaneous movements."[19] By turning every point in the body into a potential centre of movement, Forsythe also creates a multitude of icosahedra that anamorphically distort and shift Laban's "original" and project it back onto the dancer's body itself. Forsythe's anamorphoses of order generate multiple dynamic spaces both in and with a body bent out of joint, precisely by not rejecting the rhetoric of theories of space and harmony, but by thinking them through to their logical conclusion.

Athanasius Kircher **Metaphor Machine**, 1624
From Gustav René Hocke, *Die Welt als Labyrinth. Manierismus in der europäischen Kunst und Literatur*, Reinbek 1987

for manu
facturing
desire

INVENT

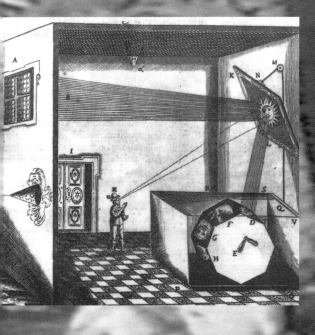

4. The Arabesque: The Dynamic Image

"The body is in movement from beginning to end" (*dal suo principio al suo fine mobile*) and within it proportion has no "perfect location" (*luogo perfetto*) wrote Vincenzo Danti in his *Primo libro del Trattato delle perfette proporzioni* in 1567, thus establishing pure movement as the ordering principle of Mannerist paintings.[20] In Cornelis Cornelisz's painting, The *Fall of the Titans* (1588–90), tumbling male bodies can be seen whose muscles appear grotesquely overemphasised – even in the small figures in the background. Nonetheless, the viewer does not have the impression of a downward movement. Individual Titans are indeed shown falling head first; others, however, hover upright and even seem to push their way into the upper space of the picture, as if trying to defy gravity. The heavy bodies are further counterpointed by the butterflies, symbols of lightness, that have landed on the Titans' genitals or thigh, their open wings forming an analogy to the tousled hair. The figures' extended limbs enter a literal network of bodies, a grid pattern of varying density woven out of subtly shaded body parts, that extends into the aperspectival depth of space like a flowing cloth. Bodies that are twisted around themselves, twisted bodies that are interwoven to form a picture: Cornelisz has shaped his grotesque figures into arabesques.

With the advent of Mannerism in the 16th century, the arabesque leaves behind its original function as a decorative element in framing devices and enters the painting itself, thereby toppling the "hierarchy of picture and ornament" and producing an oscillating effect between foreground and background, an emphasis on surface that cancels the meaningful content of images and texts by making one collapse into the other. Employed in the designing of religious texts in Islamic culture, the arabesque sanctifies texts and in its pictorial capacity permits writing to achieve the status of the transcendental signified.[21] The arabesque becomes the structural metaphor for a self-transforming and self-reflexive text.

For dance at the turn of the 20th century, the American music hall artist Loïe Fuller has become the epitome of such a self-weaving image-text. With costumes made of metre-long stretches of silk that she moved around her body on two rods and supported by clever lighting that illuminated her costume with electric light filtered through coloured glass, she dissolved her body as a sign and a producer of signs in the rhythm of pure movement. Light and costume dematerialised her in their mutual interplay, by continually immersing her in ever-changing and never static or clearly identifiable shapes. Already Stéphane Mallarmé regarded her

Calligraphic Text by Johann Neudörffer
From *Eine gut Ordnung und kurzer Unterricht*, Nuremberg 1538, after
Gustav René Hocke, *Die Welt als Labyrinth. Manierismus in der
europäischen Kunst und Literatur*, Reinbek 1987

for making the world a smaller place

Interruption	Unterbrechung
Conditioning	Konditionierung
Recording	Aufnahme
Individual	Individuum
Vibration	Vibration
Pastime	Zeitvertreib
Evolution	Evolution
Advertising	Werbung
Speed	Geschwindigkeit
News	Nachrichten
Safety	Sicherheit
Work	Arbeit
Planning	Planung
Leisure	Freizeit
Fission	Spaltung
Freezing	Einfrieren
Codifying	Kodifizieren
Impulse	Impuls
Instant	Sofort

Serpentine Dance not as the dancing body of a woman, but rather as a "textile text"[22], as a cipher for his idea of a pure poetry of hermetically closed signs without semantic reference.[23]

The abstract patterns woven by the cloth that circle around an empty centre and continue to evolve from within the structure itself without referential connections as "absolute arabesques" are shapes that Loïe Fuller created in imitation of organic nature.[24] *Serpentine Dance, Lily Dance, Fire Dance, Dance of the Butterflies, Clouds,* and *Waves* were meant to express emotions via the detour through nature and its organic forms. More precisely, they were meant to evoke an idea in the mind of the spectator that falls back on the image of the elements in nature.

> To impress an idea, I endeavour, by my motions, to cause its birth in the spectator's mind, to awaken his imagination, that it may be prepared to receive the image. [...] I have motion. That means that all the elements of nature may be expressed.[25]

Since Fuller "has motion", she is capable of expressing images of nature, a nature that is, *mutatis mutandis*, movement and nothing but movement. The arabesque that is in itself insignificant becomes the privileged figure of metamorphosis, of mutability, the protean principle of the permanent transformation of matter, all the way to the idea. The principle thus gains a Neoplatonic underpinning. The fact that this knowledge – that is not primarily tied to the individuality of the dancer as a psychological character – continued to haunt, in trivialised shape, popular forms of theatre such as the music hall (Fuller had gained her first insight into the effects of combined lighting and fabric when she performed a hypnotism sketch in a satire about a quack on Broadway) also deprived Fuller of critical recognition. As late as 1926, John Schikowski refuses to acknowledge her merit in his study of the history of dance. Influenced by Expressionist dance, he accuses her of failing to express an "immediate" psychological experience.[26] He therefore sees Fuller in opposition to what he perceives as the "sweeping political, economic, and cultural change" after the First World War and thus in conflict with the dominant knowledge of the time and its expression in art.[27]

Pure autonomous movement in Loïe Fuller's work remained clearly bound to a Mannerist relation of resemblance between choreographic movement and nature, a relation founded on the idea of the image. Schikowski calls Fuller's dance "an architectural ornament or a beautiful carpet" and thus remains undecided as to whether her dance is flat like a carpet or three-dimensional like a building.[28] Fuller's abstract weaving of organic patterns of movement into a figure

for peeking
behind the
curtain of
nature

of image and text returns in William Forsythe's work without its metaphysical connections, albeit with altered implications concerning the importance of space. The drawings of the Italian artist Giambattista Tiepolo provided the model for *Hypothetical Stream 2* (first performed in Frankfurt on 30 January 1998). Forsythe attached vectors to the depicted clouds and angels that were meant to indicate ways in which the individual figures might escape from their cluttered captivity in space.[29] During the performance, however, Tiepolo's models are not projected onto the backdrop of the stage. Despite its religious content, the model only serves to liberate movement. It de- and recomposes itself on the stage, spatialises and distorts itself in a different art form that picks up and reformulates the lines of movement inherent in the drawings. The twenty-five minute piece, designed for nine male and female dancers who are rarely on stage together, is characterised by continually changing formations. De-formed, the dancers of a septet re-form to a quartet and a trio, or a quintet and a duo, until eventually a solo, two duos, and a trio remain. The principle of spatial change and transition continues into the movements that follow the principle of twisting and turning in all imaginable ways, be it around one's own body or around the supporting and tangential limbs of the partners. Hooked into extremities or joints such as elbows and knees, a knitted linking of limbs and bodies develops as a text that continues to write itself, but one that can also be observed spatially across the empty stage in the synchronised rotation of arms. Despite the linking, the individuality of the bodies is retained, since these observe different speeds at different times, all the way to a standstill in the image. The movement continues in ever-changing and yet self-sufficient configurations – for which reason the piece seems to start in a random location and seems to suddenly come to an end in an equally random location.

5. Rules of Combination: The Rhetorical Body

In contrast to the previous section, the focus in this section is not the weaving, shapeless movement of the arabesque, but the approximation of the body to the "still point of the turning world" where T. S. Eliot locates dance in his poem "Burnt Norton", by combining its functional elements. In his poetic treatise *Il Cannocchiale Aristotelico* of 1655, Emanuele Tesauro describes this ingenious thought experiment that is founded on the principle of metaphor as the discovery of dissimilar similarities: "trovando in cose dissimigliantile le simiglianze."[30] Similar to the telescope of its title that moves distant things closer to the eye of the observer, the poet creates astonishment and admiration for the *mirabile* he produces. The aspect of finding images thus gains an element of supposed manic

for weaving
the web

excess of resemblance as well as of the taming of the alien or dissimilar in the assimilating image.[31] Guiseppe Arcimboldo, painter at the court of Ferdinand I in Vienna from 1562 on and later at the court of Rudolf II in Prague, composed his famous portraits out of books, fruit, vegetables, grains, sea creatures, and other animals that he assembled to form a human face. As Roland Barthes states, all these elements already possess a function and meaning of their own before they enter the structure of the picture.[32] Arcimboldo thus quotes rhetorical elements that he combines in new ways to create a metaphorical resemblance between nature, culture, and man – the glorified ruler – through the contiguity and super-imposition of dissimilar objects, such as the pillars of a bridge or a set of teeth. Objects are transformed by selection and combination of distinct elements on the canvas of the body. The movement does not take place primarily in space, but in the body as space that consequently starts to open up new and miraculous con-nections of meaning.

The choreographer Oskar Schlemmer, with his background in painting and sculpture, continued to explore this approach in Modernism with his sculptural costumes. In doing so, Schlemmer does not take the body as his starting point "in order to slowly sculpt dance out of it", but instead starts "from the form, from a formative idea" that he then attempts "to realise through the body".[33] The human body is transformed by means of costumes that give three-dimensional shape to the laws of space. For his "choreographic mathematics" Schlemmer develops four types of stage costumes in 1924, each of which expresses the laws of and pathways through space in relation to the human body. Some of them, such as the technical organism of circular and rotation movements, had already been used in his *Triadic Ballet* of 1922. The relation of the dancer to the cubic space that surrounds him leads to "ambulant architecture", the functional laws of the human body in their relation to space lead to the "marionette", the dancer's lines of movement in space approach the technical organism, and the signs of expression that connect him to the metaphysical order lead to dematerialisation.[34] Schlemmer therefore primarily pursues the abstract idea of a universal order from a subjective idea that shapes the objective order of space and time. He makes the fleeting lines of movement of a body in space visible by indicating them on the costume. In doing so, he removes them from transient time and projects the successive and spatially heterogeneous onto the simultaneity of a single body. In consequence, this body disintegrates optically into several congealed and col-lated temporal stages. The making visible of pathways in space and their projec-tion back onto costumes leads to an overdetermination of the natural figure, to its

for chang
ing the
scale of
war

deformation and defiguration in line with the mathematical logic of its movement. "One might imagine the development of costumes as the filling of the space with a soft material in which the stages of the choreographic movement solidify in negative shape."[35] The costume, as the negative of the choreographic pathways through space, overdetermines the body with the rules of a universal order in whose centre is positioned man himself who mirrors these rules once again through his movement in space. Schlemmer's constructivist figures, in which movement congeals into shape while the body itself becomes space, make reference to the schematic figures of Albrecht Dürer and Ehard Schön, a fact that Schlemmer himself acknowledges. But one can also recognise links with the architecturally organized machine men of Luca Cambiaso and Giovanni Battista Bracelli, figures that no longer disguise the implicit laws of construction of human beings behind a mimetic shape, but foreground their concept – like Schlemmer.[36]

Without the metaphysical content of Schlemmer's ordering schemes in space and time, the body returns in contemporary dance as the space of combinatory possibilities in Meg Stuart's work. The American choreographer pushes to its limit the physical self-reflexion of dance that already occupied Schlemmer. In the first section of *Splayed Mind Out*, her co-production of 1997 with the video artist Gary Hill, three entangled bodies are dumped on the stage floor in flickering strobe light. The light chops up the images of the bodies, the borders and outlines of which have in any case become blurred. A head starts to roll back and forth, an arm is extended, a leg dangles over a chest, the foot attached to it is shaken by a hand as if it were a hand itself and the leg an arm. In this body composed of separate bodies, both assume a different position than the regular anatomic ones. The foot even changes its role as contact point of the upright body with the floor when in proximity to the hand. In a later sequence, a female dancer puts her head on the fold of her partner's stomach as if she were resting her chin nonchalantly on a window sill. While in Forsythe's work hybrid physical connections dissolve immediately after their creation in order to twist through the space as arabesques, in Meg Stuart the reconstructed, bent, and broken bodies remain immobile for seconds, sometimes minutes. Her grotesque bodies thus unite in one hyper-body that becomes the memory landscape for stories a single body is incapable of telling.[37]

In *Appetite*, a piece that was created in 1998 in collaboration with the visual artist Ann Hamilton, Stuart once again makes the limits of the body and its transgression her dominant theme. A dancer stuffs the white cloth that previously covered the stage into his blue overalls, as if he greedily wanted to devour the

Ehard Schön **Schematic Figures** 1534
From Gustav René Hocke, *Die Welt als Labyrinth. Manierismus in der europäischen Kunst und Literatur*, Reinbek 1987

r firing

hot

started the

space race

entire space. A female dancer rests motionless on a chair, while her partner pulls cushions, blouses, and dresses from her costume. While in Oscar Schlemmer the pathways through space and figures in space enveloped the body, in Meg Stuart objects or memories hide under the skin and deform the image of the body. The two artists approach the visual limits of the body from different angles – Schlemmer from within and Stuart from without – in order to uncover surprising potentials of movement by dissolving them.

Novelty arises from the combinatory sequences of distinct rhetorical figures – circle, spiral, cube, Schlemmer's joints, and Stuart's head, arm, and leg – that are arranged according to the principle of montage of distant or separate realms of imagery or function. In this context one ought to recall the three rows of Schlemmer's *Triadic Ballet* that was performed by three dancers, a ballet that continually reshuffles the diverse spatial costumes in different successions according to its own internal logic. The metaphorical principle that is labelled by 17th-century rhetorical treatises as the phenomenon of *ingegno, argutezza,* or *concetto* surprises the intellect with subtle and ingenious discoveries that the consciousness of the observer or listener cannot categorise. Although Tesauro as well as Balthasar Gracian and Matteo Pellegrini always take literature as their point of departure, they also apply their object of investigation, the ingenious metaphor, to pictorial and scenic – that is, corporeal – representations.[38] "And in this brief moment of rupture, the body, too, as if in sudden ecstasy, remains numb, petrified, without movement or speech", claims Tesauro's *La filosofia morale.*[39] Through these decorative, ornamental "gestures of the mind" develops a gap in the flow of objects, a hiatus that leaves both the bodies of the dancers and that of the audience frozen into a stunning picture.

6. No Longer and Not Yet

Whereas the two positions of early Modernism erase the body and its signs, Postmodern choreographers insist explicitly on corporeality. Loïe Fuller removes the figure through an arabesque devouring of interior and exterior, and Oskar Schlemmer transcends the body through the combinatory "folding" of spatial stereometry. In contrast, William Forsythe de- and recomposes the ballet rhetoric of the upright body with the aid of Rudolf von Laban's choreutics and achieves bodies that are plural both in space and time. Meg Stuart in turn combines body parts in surprising ways until they form a single hyper-body. They all attempt to design new body images in dance that generate new possibilities of movement through resemblances (to nature, the mathematical cosmic order, the system of

for invent
ing ways of
distributing
stress

ballet, the system of the individual body parts and their functions and memories). Independent of psychology, feeling, and character, they achieve choreographic abstraction and self-reflexion by not merely highlighting specific compositional rules, but by fulfilling them in all their consequences and thus driving them towards a deconstructive hypertrophy.

At the start of the present essay we defined Mannerism historically as a time of no longer and not yet, but its structural implications and formal principles achieve a new significance today beyond the debate on Mannerism as a precursor of Modernism. In an age in which the archives of our cultural memory are opened wide through electronic media and information technology, everything can be combined with everything in a modern *Wunderkammer*, everything can be transformed and thus potentially assimilated. The problems arising from this set-up for the philosophical concept of a self-determined subject are well known. Dance, whose privileged instrument is the body, is today confronted with a body that can no longer be taken for granted. While we have an idea of our body only as an image from the start of our development, dance exploits the possibilities of making images of the body visible and of generating new ones. It thus secures its potential against its material disappearance in cyberspace. It explores its capacities by producing resemblances as self-resemblance that mirrors, doubles, and points beyond dance in order to ascertain its very existence.[40] In its return to Mannerist procedures, dance has pursued a double strategy ever since Modernism. On the one hand, it serves its historical as well as structural self-assessment and self-reflexion. On the other hand, it permits – through the productive breaking-up of the body as the pliable material of dance – a perspective towards the future in which body images and concepts of movement can be checked and developed in their resemblance to other arts and media.

1. Walter Friedlaender, *Mannerism and Anti-Mannerism in Italian Painting*, New York 1957.

2. Ernst Robert Curtius, *Europäische Literatur und Lateinisches Mittelalter* (1948), 11th ed., Basel and Tübingen 1993, 277.

3. Gustav René Hocke, *Die Welt als Labyrinth: Manierismus in der europäischen Kunst und Literatur* (1957, 1959), reprint, Reinbek 1987, 271.

4. Arnold Hauser, *Der Manierismus: Die Krise der Renaisssance und der Ursprung der modernen Kunst* (1964), reprint, Munich 1979, 13.

for invent
ng the
nterrup
ion

5. John Shearman, *Mannerism*, Harmondsworth 1967.

6. James M. Mirollo, *Mannerism and Renaissance Poetry*, London and New Haven 1984, 14.

7. Leon Battista Alberti, *On Painting and On Sculpture: The Latin Texts of "De Pictura" and "De Statua"*, ed. and trans. Cecil Grayson, London 1972, §33, 71: "The great work of the painter is the *historia*".

8. Ibid., §40, 78–79.

9. Ibid.: "Sed hanc copiam velim cum arietate quadem esse ornatum, tum dignitate et verecundia gravem atque moderatam."

10. Ibid., §55, 98–99: "Ergo a pulcherrimis corporibus omnes laudatae partes eligendae sunt. Itaque non in postremis ad pulchritudinem percipiendam, habendeam atque exprimendam studio et industria contendendum est."

11. Erwin Panofsky, *Idea: A Concept in Art Theory* (1924), trans. Joseph J. S. Peake and Victor A. Velen, Columbia 1968, 84.

12. Ibid., 86.

13. Michel Foucault, *The Order of Things*, New York 1994, 17–25.

14. Joachim Küpper, *Diskurs–Renovatio bei Lope de Vega und Calderón*, Tübingen 1990, 230–304.

15. The related negation of the subject of self-consciousness cannot be discussed here. See the chapter on anamorphosis in Jacques Lacan, *Die vier Grundbegriffe der Psychoanalyse*, 3rd ed., Berlin and Weinheim 1987, 73–126. For a historical-materialistic view see Stephen Greenblatt, *Renaissance Self-Fashioning*, Chicago and London 1980, 16–27.

16. Gerald Siegmund, "Improvisationen, die ins Auge springen", *Frankfurter Allgemeine Zeitung*, 18 June 1999.

17. Rudolf von Laban, *Choreutics*, ed. Lisa Ullmann, London 1966, 26.

18. Ibid., 54.

19. Ibid., 3.

20. Quoted from Daniel Arasse and Andreas Tönnesmann, *Der europäische Manierismus 1520–1610*, Munich 1997, 410.

21. For a cultural and historical differentiation and the meaning of arabesque and grotesque see Susi Kotzinger, "Arabeske-Groteske: Versuch einer Differenzierung", *Zeichen zwischen Klartext und Arabeske*, ed. Susi Kotzinger and Gabriele Rippl, Amsterdam and Atlanta 1994, 219–228.

22. For this concept see Erika Greber, "Textile Texte", *Wortflechten, Kombinatorik und poetologische Reflektion*, Constance 1994.

23. On the phenomenon Loïe Fuller see Gabriele Brandstetter and Brygida Maria Ochaim, *Loïe Fuller: Tanz, Licht-Spiel, Art Nouveau*, Freiburg im Breisgau 1989.

for intro
ducing a
wireless
world

24. Ibid., 145.

25. Ibid., 94.

26. John Schikowski, *Geschichte des Tanzes*, Berlin 1926, 129: "Was the virtuosity with which she brought the rapidly changing floods of colour into correspondence with her body not just a simple music hall trick?"

27. Ibid., 126.

28. Ibid., 130.

29. Gerald Siegmund, "Wenn ich choreographiere, bin ich Auge mit eingebautem Ohr", *Frankfurter Allgemeine Zeitung*, 29 January 1998.

30. Emmanuele Tesauro, *Il Cannochiale Aristotelico* (1655), reprint of edition of 1670, Bad Homburg et al. 1968, 266.

31. For a related area of the fantastic see Renate Lachmann, "Trugbilder. Poetologische Konzepte des Phantastischen", *Etho-Poietik*, ed. Bernhard Greiner and Maria Moog-Grünewald, Bonn 1998, 179–201, here 185.

32. Roland Barthes, "Arcimboldo oder Rhétoriqueur und Magier", *Der entgegenkommende und der stumpfe Sinn*, Frankfurt am Main 1990, 136–154.

33. Oskar Schlemmer, "Missverständnisse", *Schrifttanz*, vol. 4, no. 2, 1931, 27–29, here 29.

34. Idem, "Mensch und Kunstfigur", *Die Bühne im Bauhaus* (1925), ed. Walter Gropius, reprint, Berlin and Mainz 1965.

35. Idem, "Tänzerische Mathematik", *Der Tanz in dieser Zeit*, special edition 3/4, Vienna 1926, 124; on the relation of three-dimensional costume and space see Gabriele Brandstetter, "Intervalle: Raum, Zeit, Körper im Tanz des 20. Jahrhunderts", *Zeit-Räume*, ed. Martin Bergelt and Hortensia Völckers, Munich and Vienna 1991, 225–269, here 238–240.

36. Compare Dirk Scheper, *Oskar Schlemmer: Das Triadische Ballett und die Bauhaus-bühne*, Berlin 1988, 266, 337; Hocke 1987 (note 3), 125–146.

37. On the relationship of body and space in Meg Stuart compare Gerald Siegmund, "Bild und Bewegung. Manierismus als Grenze des zeitgnössischen Tanzes", *Grenzgänge: Das Theater und die anderen Künste*, ed. Gabriele Brandstetter et al., Tübingen 1998, 231–241; Siegmund, "Von Monstren und anderen Obszönitäten: Die Sichtbarkeit des Körpers im zeitgenössischen Tanz", in press.

38. Tesauro 1655 (note 30), 10–13.

39. Tesauro, *La filosofia morale*, Turin 1670, quoted in Klaus-Peter Lange, *Theoretiker des literarischen Manierismus*, Munich 1968, 90.

40. Compare Gerald Siegmund, "Zwischen Bild und Bild: Tanz als Bestandsaufnahme heutiger Existenz", *Programmbuch Wiener Festwochen* 1999, 33–43.

Translated by Rainer Emig

for training
the mind's
eye

for patent
ing 1,093
inventions
and mech
anizing
light

JITTERBUG

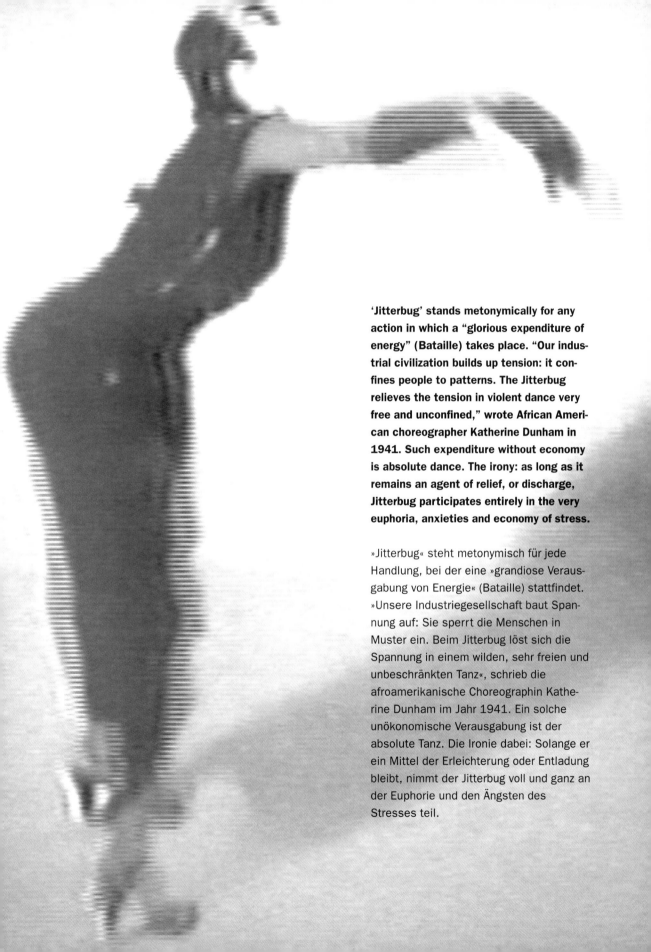

'Jitterbug' stands metonymically for any action in which a "glorious expenditure of energy" (Bataille) takes place. "Our industrial civilization builds up tension: it confines people to patterns. The Jitterbug relieves the tension in violent dance very free and unconfined," wrote African American choreographer Katherine Dunham in 1941. Such expenditure without economy is absolute dance. The irony: as long as it remains an agent of relief, or discharge, Jitterbug participates entirely in the very euphoria, anxieties and economy of stress.

»Jitterbug« steht metonymisch für jede Handlung, bei der eine »grandiose Verausgabung von Energie« (Bataille) stattfindet. »Unsere Industriegesellschaft baut Spannung auf: Sie sperrt die Menschen in Muster ein. Beim Jitterbug löst sich die Spannung in einem wilden, sehr freien und unbeschränkten Tanz«, schrieb die afroamerikanische Choreographin Katherine Dunham im Jahr 1941. Ein solche unökonomische Verausgabung ist der absolute Tanz. Die Ironie dabei: Solange er ein Mittel der Erleichterung oder Entladung bleibt, nimmt der Jitterbug voll und ganz an der Euphorie und den Ängsten des Stresses teil.

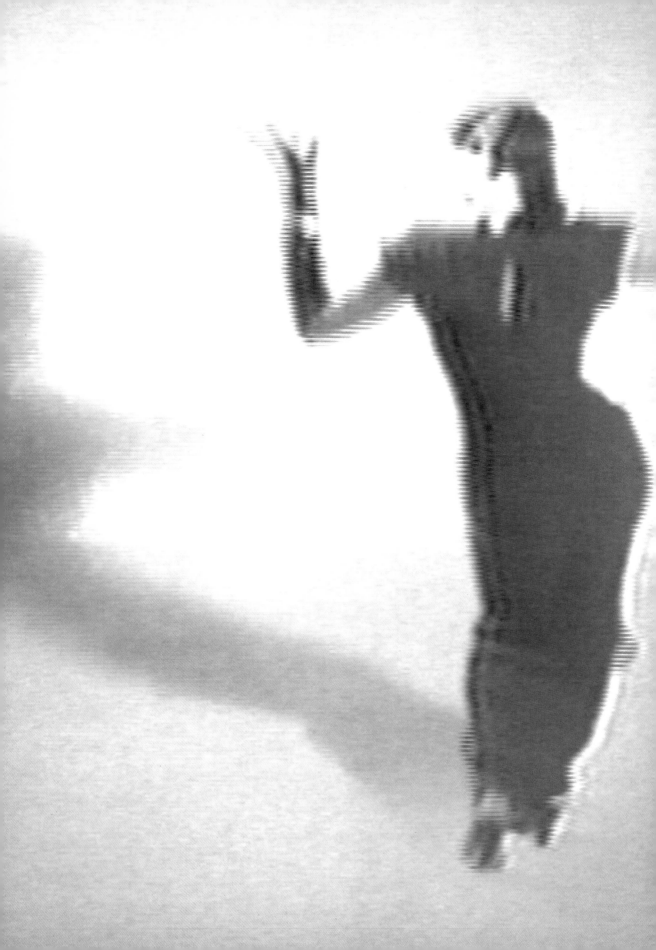

KAROSHI

Mr. H, age 42.
A truck driver for 11 years. His
annual working hours totalled
5,700 hours. In 1994, following
his usual shift, Mr. H died of
acute myocardial infarction.

The link between capital and the body lies
in the capacity of each to maintain con-
stant output, and to increase this output in
moments of crisis. When output falters,
both the market and the body risk a per-
ilous shock, whose consequences include
cardiac arrest, distress, or major capital
drainage. The danger may be fatal. Output
is the life cycle and the vicious circle of any
stress-inducing system. Failure to sustain it
becomes the system's natural selection
process.

Das Bindeglied zwischen Kapital und Körper
besteht darin, daß beide fähig sind, einen
konstanten Output zu produzieren und
diesen Output in kritischen Momenten zu
erhöhen. Wenn der Output stockt, laufen
sowohl der Markt als auch der Körper
Gefahr, einen gefährlichen Schock zu erlei-
den, der unter anderem zu Herzstillstand,
Notsituationen oder größeren Kapital-
abflüssen führen kann. Die Gefahr kann
tödlich sein. Der Output bildet den Leben-
szyklus und den Teufelskreis eines jeden
Streß erzeugenden Systems. Die
Unfähigkeit, ihn aufrechtzuerhalten, wird
zum natürlichen Ausleseprinzip des Sy-
stems.

Mr. I, age 26.
An employee of a major insur-
ance company. For several years,
Mr. I had been staying at the
office late into the night. He
became seriously ill several times
during his tenure with the com-
pany. In May of 1997 he died
suddenly of chronic overwork.

Mr. B, age 24.
Worked for a large electrical appliance manufacturer on product development. One day in 1995, Mr. B suddenly disappeared. He was found dead several months later with the following letter:
"These last 10 months I have become exhausted both mentally and physically. I moved in an attempt to better the way I live, but even though I had spacious surroundings, I had no time of my own, so all that space meant nothing…I'm sorry how this will affect those I leave behind, but if I just abandon everything, I'll never be tired again."

Mr. D, age 54.
An employee in the sales promotion section of a major product company. He worked late on weekdays and rarely took a day off on weekends or holidays. Because he was too busy to spend time with his wife, she used to sit on a chair outside the bathroom and talk to him while he was taking a bath. Mr. D died in 1998 of a cerebral hemorrhage.

LOGO

Each day, the average Western citizen sees, assimilates, and recognises 16,000 different logos. These are so many light-houses guiding us in our experience of the world. As graphic equivalent of the compass and as modern derivative of medieval heraldry, the logo first of all tells us where we stand. Its inscription on every landscape recasts space as site of perpetual recognition. Its presence on every piece of garment recasts subjectivity as tribal.

In westlichen Ländern sieht, verinnerlicht und erkennt der Durchschnittsbürger pro Tag sechzehntausend verschiedene Logos. All das sind Leuchttürme, die uns bei unserer Wahrnehmung der Welt leiten. Als graphisches Äquivalent zum Kompaß und als modernes Derivat der mittelalterlichen Wappenkunst sagt uns das Logo vor allem, wo wir stehen. Seine Einschreibung in jede Landschaft macht aus dem Raum einen Ort beständigen Wiedererkennens. Seine Präsenz auf jedem Kleidungsstück definiert die Subjektivität neu als eine Art Stammeszugehörigkeit.

MENGELE

He used us as if we were animals, like mice. We were the guinea pigs

We were always naked during the experiments. We were marked, pa:

We were asked to bring in blankets to the women who were being gi

Mengele was trying to change the color of our eyes. One day, we wel

He bound my breasts to keep me from nursing. My child is crying fr

Mengele once put a needle in my arm—only the needle, not the syrin

One day, my twin brother, Tibi, was taken away for some special exp

I was chosen along with other women to receive injections in our mc

Later he told me that he had survived by dreaming at night of consu

ere the mice. We couldn't resist. We were his prisoners. — Lea

neasured, observed. Boys and girls were together. It was all so

ocks in order to find out how much strain a person could take. After

eye-drops. Afterwards, we could not see for several days. We

ger. She wants to be fed. I chew a tiny piece of bread and place it in

od started spurting out. He calmly placed the blood in a test tube.

ts. Dr. Mengele had always been more interested in Tibi. I am not

lips. Mengele was there, watching us. A few days later, the heads

ge meals, and that this had given him the strength to face the star-

Huber and Judith Barnea

demeaning. There was no place to hide, no place to go. They compar

the experiments we would bring the women out and put them on the

thought the Nazis had made us blind. — Hedvah and Leah Stern

my child's mouth. My breasts are full of milk. I am swollen from it u

Then, he gave me a sugar cube. — Solomon Malik

sure why – perhaps because he was the older twin. Mengele made se

of most who got shots swelled up. They disappeared. I was lucky. M

vation of the next day. Nourished on dreams. — Sheila Cohn Dekel

ry part of our body with that of our twin. The tests would last for

hat would take them to Birkenau. None of them survived. We took

neck. Every day, Doctor Mengele comes to enjoy himself by look-

erations on Tibi. One surgery on his spine left my brother para-

did not puff up. — Magda Bass

hours. And Mengele was always there, supervising. — Eva Mozes

out bodies, one after another. After a while, death was like breathing

ing at this spectacle. — Ruth Eliaz

lyzed. He could not walk anymore. Then they took out his sexual or

— Ernst Michel

.fter the fourth operation, I did not see Tibi anymore. I cannot tell

you how I felt. It is impossible to put into words how I felt. They had

away my father, my brother, my two older brothers—and now, my

twin. — Moshe Offer

Permutations between thresholds of horror and thresholds of the socially acceptable are: imaginable but impossible; unimaginable but possible; imaginable and possible; unimaginable and impossible. When all four are in operation, it is the thresholds themselves that require revision – not because they have gone beyond their own conceivable limits, but because the limits have been introjected into the system's core. In the case of violence and horror, it is clear that a revision of their "exterior nature" to the boundaries of society is in order – for their "unimaginable impossibility" is nothing but the masking of the quiet routine of the system.

Zwischen den Schwellen des Grauens und den Schwellen des gesellschaftlich Akzeptierbaren gibt es folgende Kombinationsmöglichkeiten: vorstellbar, aber unmöglich; unvorstellbar, aber möglich; vorstellbar und möglich; unvorstellbar und unmöglich. Wenn alle vier anwendbar sind, müssen die Schwellen selbst überprüft werden – nicht etwa, weil sie über ihre eigenen denkbaren Grenzen hinausgegangen sind, sondern weil die Grenzen in den Kern des Systems introjiziert wurden. Im Fall der Gewalt und des Grauens muß offensichtlich überprüft werden, inwieweit sie »außerhalb« der Grenzen der Gesellschaft liegen – denn ihre »unvorstellbare Unmöglichkeit« ist nichts anderes als die Maskierung der lautlosen Routine des Systems.

NOISE

Modernity's process of individuation fore-grounds character, the unique voice, the opinion. Thus, a cacophony of the self slowly takes shape. As each voice begets a new voice, the old communal chorus becomes a fragmented mass of soloists, each singing a unique song, each filling up the air with a competitive urge to out-solo every other voice. Amidst the apparent noise, however, a vibrating force har-monises each soloing voice; a word cen-tripetally summons the noisy soloists into the chorus line of progress: money.

Der moderne Individuationsprozeß stellt den Charakter, die eigene Stimme, die Meinung in den Vordergrund. Dadurch bildet sich allmählich eine Kakophonie des Selbst her-aus. Weil jede Stimme eine neue gebiert, wird aus der alten Gemeinschaft des Chors eine zersplitterte Masse von Solisten, von denen jeder ein anderes Lied singt und die Luft mit dem rivalisierenden Drang erfüllt, alle anderen Stimmen zu übertönen. Doch inmitten dieses scheinbaren Lärms gibt es eine vibrierende Kraft, die alle diese Solo-stimmen harmonisiert; ein Wort ruft die lärmenden Solisten zentripetal in die Reihen des Chors des Fortschritts: Geld.

The Human Touch: Towards a Historical Anthropology and Dream Analysis of Self-Acting Instruments

Allen Feldman

Gentlemen, I have just heard myself play!

– Rachmaninov in 1923 upon hearing a piano roll of his music on a player-piano.

Introduction

The diagram of an automated water organ, designed by the famous 17th-century polymath Father Athanasius Kircher, features miniature dancing and labouring human automata. His design also deploys a right/left polarity. The right side of the water organ stages automata of blacksmiths working at their forges, hammers in their hands. The left side is ornamented with grotesque human figures dancing under the shadow of a gigantic skeletal figure – death, whose presence in the tableau marks this scene as the dance of death allegory. On the right side of Kircher's water organ we thus have a depiction of orderly labouring bodies and on the left disordered bodies in a state of possession and somatic displacement. The entire diagram proffers a semi-automated musical instrument, akin to the idea of a perpetual motion machine and marked by mini automata run by clockwork mechanisms, also animated by hydraulics. These polarised bodies, in turn, express different relations to automatism – regulated labour and mimetic possession by an Other. The very syncretism of the iconography and the diversity of functions invested in the water organ indicate that automated musical instruments can evoke many other issues about bodies and instruments beyond musical performance. The bifurcated design uses once familiar demonic iconography of the Medieval period to introduce strange and innovative 17th-century technology. In turn, the technical form now actualises the demonic or the phantasmagoric as a mechanised spectacle, and therefore, as a secularised profane experience. Therefore any historical inquiry into automated musical

instruments will have to take into account a general history of technology and its cultural grammars, and in turn examine performance culture – as it relates to automated music – from the standpoint of material culture. For it is both the embodiment of musical instruments and mechanisation of human bodies or, in other words, musical and labour performance that is at issue here.

Kircher's drawing introduces an iconography that reoccurs throughout the subsequent history and cultural reception of automata and automata-like machinery in the formative periods of modernity. His automated water organ is part of a long lineage of cultural/engineering experiments to produce sound and musical instruments that required minimal human intervention, and in some cases minimal skill and performance. In turn, these mechanical instruments anticipated, paralleled, and consistently aestheticised technological transformations occurring in the increasingly autonomous techno-economic sphere that drove the formation of European modernity.

The imagery of the dance of death and possession in relation to the mechanical and the automatic evokes bodies possessed by repetitive action and by a mimetic relation to an Other. This tableau further implies that the mimetic relation between the human body and the automaton is reversible: the body and the machine can exchange forms of agency, thus the imagery of regulated labouring bodies and possessed disordered bodies on a semi-automated man-made device. The skeletal imagery of the dance of death figures also bears horological symbolism in which in as much as death implies the mastery of time over the human body, the musical automaton, a proto-perpetual motion machine, incarnates a human conquest over time. The death imagery in Kircher's instrument implies that automata, as vehicles through which humanity is meant to master time, master humanity instead. The self-acting machine thus subordinates the human world to a new temporal regimen governed by what Adorno and Benjamin termed "second nature" because of its historical character.

This constellation of tropes, clustered around the figure of the automaton, crosscuts several centuries of technological imagining in many European societies and points to a cultural memory that transcends any particular invention or utility. Indicative of the simultaneous cultural investment and anxiety associated with automatism, with bodies altered by mechanical possession, is Foucault's 20th-century analysis of Bentham's late 18th-century social automaton – the Panopticon, which was entirely constituted out of the machinery of flesh and bones, social norms, and human agents rather than of gears and flywheels. Bentham's original design and Foucault's subsequent appropriation of it both engage expectations and tensions

over automatism appropriate to the cultures and epochs in which they respectively wrote. Bentham used not only a machine model but also a self-reproducing machine model to conceive the fabrication of social hierarchy and training in a penal institution. In turn, Foucault speaks in reference to Bentham's Panopticon, to the central anxiety provoked by automatism – mimetic possession:

> A real subjugation is born *mechanically* from a fictitious relation [...] He who is subjected to a field of visibility and who knows it, assumes responsibility for the constraints of power; he makes them play spontaneously upon himself; he inscribes in himself the power relation in which he simultaneously plays both roles; he becomes the principle of his own subjection.

Here automatism, in the particular form of autopunition, is posited as both the ideological desire and functional goal of institutional hegemony. Power is autonomised when the penal machine is mimetically reproduced within the body of the inmate. The political subject is forged as a human automaton by the mechanisation (institutionalisation) of agency. In the 1920s in *History and Class Consciousness*, Lukács also identified the mechanised moulding of the human body and personality by the Fordist assembly line as culturally threatening. Foucault, like Lukács, treats this mechanical mimesis as the interiorisation and miniaturisation of both command positions and subordinate positions. The miniaturisation of dominant/subject and subordinate/object postures in the same body, human or mechanical, is axial to all agents or instruments that *act upon themselves in order to re-enact the Other.*

A Brief History of Clockwork Instruments

Automatic musical instruments are musical instruments that play a fixed program of music, which may or may not be reprogrammable depending on the technology being deployed. Since the 15th century the majority of these instruments used clockwork mechanisms and are in effect musical automata incarnating one musical sound-making ability or another. Their development has to be viewed within the wider of field of automaton technology even though these instruments do not always represent or recreate entire human bodily capacities but only specialised functions and abilities. Further, the development of musical automata follows an incremental iconic distancing from the human body as a whole as the design of these machines moved away from explicitly anthropomorphic imagery – humanoid musician figures – to more specialised capacities encased in increasingly abstracted mechanised bodies that fulfil human tasks like musical performance without preserving any anthropological iconic resemblance. The idea of the automaton in the

machine age shifts from the replication of humanity as iconic model to the reduction and decomposition of the anthropological into prescribed functions, tasks, and duties – which is why I view the automaton, even the musical automaton, as a disciplinary instrument and a vehicle of social norms about the disposition of the body.

The basic mechanical principles and techniques that comprise the clockwork musical instrument have been extant since the late Roman Empire. This involved the transmission of motion through a toothed wheel device. The Antikythera horological instrument, salvaged from a Greek ship sunk in the 2nd century BC, had brass gear wheels and equilateral teeth for the indication of the positions of the sun and moon. Hero of Alexandria, in the 1st century AD, described devices that used a weight drive combined with tooth wheels. Many horological instruments from this period up to 1300 were dependent on hydraulic power. Clockwork automata were also advanced by the development of spring drives from the 15th century onward, and by the application of rotary fan devices as air brakes that regulated motion and speed, which can be traced back to 1300 AD. The bellows technology used in aerophonic musical automata can be traced to the 3rd century BC with Ktesibios's invention of the manually playable organ using a piston pump and a hydro-pneumatically controlled air reservoir. The evolution of bellows technology from Vitruvius's design of organs with double alternating piston pumps at the beginning of the Christian era to the 18th century resulted in the gradual reduction of the manpower needed to pump the bellows. Programmed musical instruments can be documented as early as the middle of the 9th century AD in Baghdad where the three Musa brothers designed an automatic flute player in which music was programmed on a rotating cylinder. By the late 16th century all the diverse technology required for the manufacture of musical and other automata were in place: weight/water/spring drive; toothed wheel transmission; the air brake; wind supply by hydra-pneumatics or bellows; preprogrammed music for a diversity of idiophonic, aerophonic, and chordophonic devices.

The technological history of automata in pre- and early modernity was bound up with the development of horology. Time-keeping technology and automated musical mechanisms required the same forms of tooth wheel transmission, hydraulic or air-driven power sources and air brakes to slow down or regulate the motion of wheels. This is most evident in the striking clock where a bell or gong indicates the time acoustically with weighted mechanisms which insure that different strokes are administered in accordance with changing hours. The fusion of horological devices and musical automata is identifiable in a wide variety of instruments from the 15th century onwards; these include turret clockwork with bell music and astronomical showpieces with bell and/or organ music. By the 16th century there was a wide

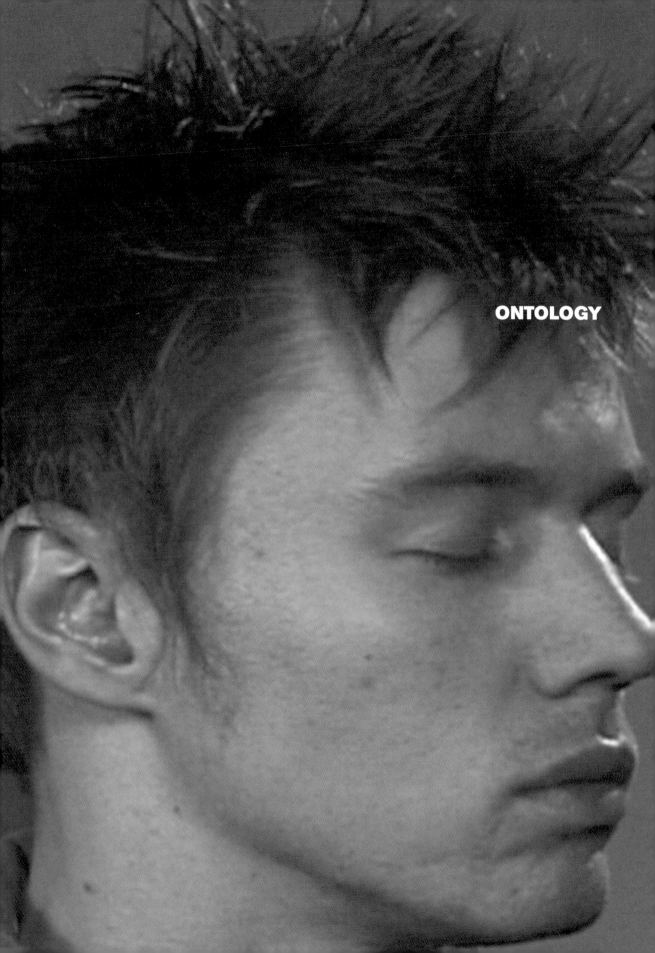

ONTOLOGY

variety of free-standing musical clocks, wall clocks, and table clocks with music performed by bells, pipes, and strings. As Robert Fludd, a 17th-century theorist and designer of automata wrote:

> [...] thus it becomes possible to have music without a musician or action of any living being: it will be splendid, graceful, and an impressive marvel for those partaking, or in the presence of a festive meal to hear unexpected music without the presence of any moving being from some corner of the dining hall.

The seminal theoretical works on musical and related automata were published in the early 17th century: Salomon de Caus's *Les Raisons des forces mouvantes* (1615), Robert Fludd's *Utriusque cosmi maioris scilicet et minoris metaphysica, physica atque technica historia* (1617), Kircher's *Musurgia universalis* (1650), and Gaspar Schott's *Magaia universalis naturae et artis* (1657). These publications also introduced a pervasive pattern in the technological culture of automaton imagining: automaton fakes and forgeries. The intricate designs of Fludd and Kircher by and large are completely unfeasible in practice and exhibit a high degree of fantasy. None of the 17th-century works commented on the dynamics of the actual music to be played on these instruments.

By the 18th century, clockwork automata were integral components of "cabinets of curiosity" and "displays of ingenuity" that circulated among the courts, salons, and exhibition halls of Europe and were considered exemplary icons of Enlightenment reason, with their synthesis of artificial life, decorative and expressive arts, and scientific principle. This is the classical age of automaton design and craftsmanship as advanced by Jacques de Vaucanson (1709–1782), the Swiss father-and-son duo Pierre Jaquet-Droz (1721–1790) and Henri-Louis Jaquet-Droz (1752–1791), and Henri Maillardet (1745–?). The inventions of this group include simulated biological process like Vaucanson's digesting duck, singing birds, a wide range of musician and dancing androids, and automatic anthropomorphic writing figures. With the refinement of the inner mechanisms, there was a growing miniaturisation and diversification of the outward casings of musical and related automata. The 18th century also witnessed a shift in the performance spaces of the instruments from the church and court to the popular culture of the street. This shift in performance spaces culminates in the mid 19th century when musical automata were made and marketed for the domestic space as integral decor of the bourgeois parlour. Throughout the 18th and 19th century a remarkably wide range of musical automata was produced encompassing every possible category of musical sound including voice, piped and bowed

When constant desire to become another
becomes the stability of being, and when
this desiring being fuses intimately with the
plasticity of matter, then ontology becomes
synonymous with ecology.

Wenn das beständige Begehren, ein anderer
zu werden, zu dem wird, was die Stabilität
des Daseins ausmacht, und wenn dieses
begehrende Wesen eine enge Verbindung
mit der Plastizität der Materie eingeht, dann
wird Ontologie synonym mit Ökologie.

instruments, percussion, and plucked strings. By enabling displays of animated sound and movement, and through the application of the mechanical principles of these instruments to moving paintings and animated panoramas, clockwork instruments can be counted among the range of pre-cinematic devices.

Reversible Transcriptions

It is my contention that the technical development, iconography, and cultural mediation of automata, particularly clockwork musical instruments and related devices, constitute a coded and even allegorical discourse on the political-economic instrumentation of the human body. And Kircher's water organ, with its smithy androids, shows that the association of musical automata and labour is far older than the Enlightenment. Anthropomorphic technology both poses and presupposes normative notions of the body and its attendant activities and capacities. Social orders and institutions concerned with the technical design, production, and spectacle of automata are in effect speaking to the automatic social reproduction of bodily norms and power-laden models of the political and economic subject. As devices of entertainment and spectacle, musical automata are in effect engaged in the mechanical aestheticisation, consumption, and normative imaging of the body, its parts, and capacities.
In the case of 19th-century automata, musical and otherwise, I will suggest that these devices were vehicles for encoded statements about human labour in the age of mechanical reproduction. The aesthetics of the performing musical automaton was as much concerned with the mechanisation of the social actor, as with the fetishistic humanisation of technology.

The figure of the automaton is driven by the cultural-technical logic of mimesis and self-reproduction in time and space, and the central categories of automatism – the self-acting instrument, simulation, and delimited spatio-temporal replication – became both the axes of coercive economic practice, improvement and ideology, and a nightmarish imagery of a social order haunted by its own massive symbolic and instrumental investment in a mass-production apparatus. Industrial society emerges as a kind of meta-automaton, particularly when combined with the social force of commodification. Thus it is equally crucial to read the cultural investment in automata (in certain periods) as mediated depictions of the fears, hostilities, and resistances arising from the autonomous and thing-like functioning of social and economic structures. Seen from today's perspective as stranded historical objects, clockwork musical automata have imaginary, retro-utopian associations that connect them with that political archaeology which Benjamin, Bloch, and the Surrealists identified with the discarded commodity-artefacts of outmoded modernities. For the

Surrealists, such historically and economically discarded artefacts possess a latent power of social critique in their denaturing the cultural world of technical rationality.

It is my thesis that the somatic schema associated with 18th- and 19th-century musical and other automata are but a prelude to endowing economic actors with the semiotic, temporal, and imputed moral characteristics of the automaton. At the same time, the musical and anthropomorphic automata became central symbolic sites for a reversible transposition of agency between humanity and the machine for certain class strata. The pivotal mediating moment in the mimesis between the body and the automaton is their convergence under industrial capitalism as exchangeable commodities. Both automatism and commodity exchange involved the animation of the inanimate through the transposition of essential characteristics of human agency to the thing. Marx credited the commodity form with the functional characteristics of the automaton insofar as commodification transformed human relations into relations between self-directing things and because the closed circuit of commodity exchange appears as estranged and sovereign from all human intervention. Thus the commodification of automata carries a special frisson which is quite evident in the advertisements for musical automata, a central source for their cultural reception and conceptualisation. These ads cultivated a wish imagery of the automaton promoting its dream appearance and utopian promise in the spheres of both leisure and labour. Like most marketing devices they may have a significant rhetorical dimension; however their long history and narrative and iconic continuity, from the late 18th century to the first decades of this century, certainly reflect real consumer demand and personal identification with the promise of the automated music machine.

In the 19th century the mass production and marketing of automata, mainly in the form of clockwork musical instruments, music boxes, and related devices, gradually transformed these artefacts, from exotic side-show curiosities or court and scientific displays to domestic instruments of pleasure and consumption. I will suggest that what was pleasurable about the automaton performance and what was consumed was more than just the programmed music. The programmes and advertisements for automaton exhibitions and automata for domestic use contain an inventory of wish, of desired experiences sought from the musical automaton, that both generated and refracted the mass market for these devices. The ads indicate that the moral career of the labouring body under industrial capitalism intersected the moral career of the musical automaton, as a mechanical worker and aesthetic experience. This moral and semiotic convergence rendered the automaton a privileged and class-bound site for the symbolic display of technical imaginaries.

The Clockwork Automaton As an Archaeology of Labour and the Senses

One of the most renowned clockwork automata of the late 18th century was Vaucanson's digesting duck. The duck automaton ingested food fed into its mechanical mouth, digested or decomposed this matter with a stomach described as a "chemical laboratory", and eventually eliminated waste product from its rear. The duck was valued because it rendered the interior of its body and the digestive process completely visible; its mechanics were a performed schematic of a process that was usually hidden within the density of the human body. The mechanical performance of the duck was continuous with Enlightenment optics. The duck was an automated stomach, processing raw material and producing worked-upon matter. It was a labouring mechanism. In his prospectus for the invention Vaucanson wrote:

> [In the duck] matter is digested in the stomach conducted by pipes where there is a sphincter that lets it out [...] this is not perfect digestion that would produce nutrition for the animal [... but it] makes matter come out sensibly changed from what it was [... and] when wound up it performs all its different operations *without being touched any more* (emphasis added).

The duck implicitly mimicked and anticipated an automated factory in which both the process of labour and its habitat were fused. In this factory, none of the raw material was wasted as nutrients for the worker. In more ways than one the duck produces pure gross profit. Most importantly, the prospectus identifies a central attribute of the automaton that was eventually transformed into an important marketing strategy of the mass-produced devices seventy years later: the pleasure it offers visual appropriation and the mechanism's antithesis to tactile contact which encodes a complex discourse and cultural perception about labour and mechanisation.

The hybrid factory and alimentary imagery of Vaucanson's prospectus is re-encountered in the numerous advertisements for player-pianos, orchestrons, clockwork violins, mandolins, hurdy-gurdies, and their coin-operated cousins from the mid 19th century onward. The latter were fed coins into one orifice, producing music out of another orifice. In fact, the customers of the coin-operated music machine could realise a profit: after purchasing a specific amount of tunes he/she would receive an additional performance at no extra cost. But more importantly, in the advertisements of the period an essential and marketable component of the clockwork musical instrument – scientific, domestic, or coin-operated – was the exposure and spectacle of the internal gears, wheels, and springs within a miniature proscenium stage of glass casing usually framed by ornamented, carved wood termed "special bodies". As in Vaucanson's duck, it was crucial to visually witness the mechanical simulation of

bodily capacities and performance in process. The music produced provided valida-
tion of mechanical ingenuity as much as it provided aural pleasure. As an ad for the
Capital self-playing music box states:

> The entire mechanism is exposed to view, the action of the note projection on the star
> wheels, which in turn actuate the tooth of the Comb, can be seen which in this instrument is
> very interesting to the eye [...]

Visual edification here was not only concentrated on the culminating musical per-
formance but on the inner labour of the mechanical apparatus as a primary source of
aesthetic satisfaction and distraction. The clockwork musical instrument was a proto-
cinematic apparatus, a miniaturised factory in which the visual motion of machinery
was a novelty to be consumed. The economic references encoded in this spectacle
were further stressed by the one sensory capacity that was constantly minimised in
the ads for automata. As one 1820 ad for an automaton put it, the device runs "with-
out the aid of any confederacy [inferring human intervention and tactile contact ...]
it can never be out of order, neither heat, cold moist or dry can affect its regularity."
This automaton rang musical bells, drew a sword, fired a pistol, and played card
tricks. Another advertisement expands on this theme and declaims of an orchestron:
"the machine when once wound up performs all of its different operations without
being touched any more." We first encountered this virtue of the clockwork instrument
in Vaucanson's prospectus for his digesting duck – "when wound up it performs all
its functions without being touched any more". Still another ad for a player-piano
asserts: "with this instrument there is no strain on the muscle", thus firmly locating the
human role in the automaton performance on the side of leisure, not labour.

These devices progressively incorporated special attachments, mechanical hands
that were programmed to strike the keyboard. Later, in the reproducing piano-roll
instrument, foot devices were introduced to replicate the emotional expressions of the
original player who recorded the roll. Thus as player-pianos grew more sophisticated
in their construction, the barring of tactile contact was somewhat modified by a form
of touch that was infinitely more spiritualised, despite its mechanisation, than the
labour of running a machine. Thus in 1895 one ad for a player-piano states that with
the newly invented "expression pedals" the instruments now "possess the secret of
the human touch". The automaton now mimics internally what has been previously
expelled from the operation of its kind. And another ad declaims: "You supply the
expression and we supply the technique." Still another instrument, the Angelus, fea-
tured a "diaphragm pneumatic" that claims to replace the human finger:

The diaphragm pneumatic is the only means ever devised to give the human touch [...] the same firm but reliant and buoyant touch that characterises the human finger.

Other reproducing pianos now claim to simulate human emotions through the non-musician's manipulation of the "expression pedals" with the feet, thus leaving the hands free; but even here there was a need to minimise or obscure the act of physical contact with the expression pedals, so an ad for the Lyraphone declaims: "[...] this piano possesses a marvelous human touch needing only the addition of grey matter to be a sentient being." Here it is the instrument itself that simulates tactility and the work of performance; the player is disembodied as gray matter or brain and grafted onto this new mechanical "extra body". In this division of labour we glimpse a growing spiritualisation of the mechanical device to the extent that it can simulate human emotions and tactile contact through mechanical ingenuity. Other ads show family groups gathered around their player-pianos with dream bubbles depicting absent loved ones such as soldiers at foreign battlefields or the deceased elderly, a whole range of spectral visitations to the Victorian parlour including that of superstar musicians of the period, and exotic geographies and climes – images that marked the player-piano and the music box as a site for desire, imagination, and memory. However, the techniques of emotive implanting and evocation are carefully distinguished from any physical exertion to make the machine operate. The type of tactile contact promised in the advertisements that was required to make the machine emote was portrayed as qualitatively different from the process of labouring at a machine – a common practice in the industrial centres of the late 19th century which was associated with class stratification.

The spiritualisation of the clockwork musical instrument was furthered by its increasing miniaturisation which allowed its structural integration into the accoutrements of the domestic sphere of the 19th-century parlour. Thus clockwork sound-producing devices were built into ashtrays, furniture of all kinds, bookcases, and other shelf bric-a-brac. In turn these miniaturised devices, which were inserted in the corners and crannies of the heavily-furnished 19th-century parlour space, were programmed with different musical genres: sacred religious music, military and patriotic tunes, and light entertainment. The ads for these devices promoted these machines as scheduled mood-altering entertainment that could be wound up to play at different times of the day, altering the moral-emotional ambiance of the domestic space and explicitly automating the domestic habitus as a structure of feeling. The parlour, which by the mid 19th century had become an altar to the mass-manufacture of status goods, now featured aesthetic icons of imagined mechanisations that were once

proper to the factory – in the medium of the automaton, industrial production itself had become an object of consumption.

In the transition from curiosity to mass-produced commodity, the clockwork automaton was increasingly subjected to protocols of reception based on a sensory polarity between vision and touch – that is, between visual and auditory reception as a mode of consumption and automatism itself as material labour (metaphorised as mechanical tactility). The automata of the 18th and 19th centuries performed tactile acts upon themselves or upon external objects, but as performance artefacts their primary mode of apprehension was mediated by modes of sensory and physical distancing, if not detachment on the part of the spectator. The close association of the automaton device, particularly the musical device, with tactile action, was usually symbolised by a concerted disassociation of the audience of the clockwork spectacle from any exerted physical, that is, labour relationship with the machine. The musical automaton was not exactly a labour-saving device, rather it performed the spectacle of mechanical labour minus the human component – it was its own factory, worker, and product encompassed in a singular body. The adverts probably addressed an audience that had to be taught to *play* with machines, instructed on how to integrate machinery into their private and leisure lives, therefore the establishing of a kinship between consumer and product through anthropomorphic imagery and emotion. These devices symbolically relieved their audience from the burden of labour. Labour here became an aesthetic and visual consumption object through its automation. As mass-produced automata penetrated the sphere of everyday life, particularly the 19th-century domestic sphere and the parlour space, the visual-auditory/tactile polarity came to represent a class polarity between consumption and work. But to fully understand this symbolism, we must examine the moral career of mechanised labour in the same period that witnessed the mass-marketing of musical automata.

Exhausted Mechanisms

The advertising campaigns for the reproducing pianos and music boxes implicitly proposed the automaton as the resolution of what Anson Rabinbach in his book *The Human Motor* identified as a major contradiction and anxiety of the epoch: the tension between economic production and fatigue, which was disseminated throughout bourgeois culture far beyond the factory site and the economic sphere. According to Rabinbach, the production ideologies of the 19th century understood the physical limits of the labouring body, particularly the body under the stress and strain of industrial mass production, as a moral horizon that set the practical limits of civilisational progress. Fatigue had its physical, health-related, sexual, intellectual, and

aesthetic registers, and was discussed and depicted as a moral infirmity threatening the social order. Human breakdown in the factory space under industrial production was directly linked to wider social breakdown associated with urbanism, technology, and the experiential compression of commodity consumption – entire social orders could be subjected to exhaustion.

Further, fatigue was associated with the uncontrollable and involuntary release of irrational behavior and sexual drives that were antithetical to the public morality of the work ethic and the private morality of bourgeois decorum. Intensified labour on the factory production lines was seen to propel the worker into another destructive and irrational automatism – the descent into instinct and the release of inhibition – that was seen to be caused by mental and physical exhaustion resulting from sustained contact with industrial regimens. This discourse referred to the drinking spaces, sexual practices, and popular culture of the working masses in their off-work hours, a perceived social pathology that was continuously targeted for reformation through a variety of efforts such as temperance societies, sex-worker reclamation, religion, and in its way, as indicated by the clockwork instrument ads, the programmed music of the player-piano and mechanical music box. But well beyond this, it is obvious that the cultural imagining of a perpetual motion machine, which was technologically embryonic in the clockwork instrument and a central aspect of its social promise, must place these instruments at the centre of any epochal anxieties about economic, cultural, and anthropological fatigue.

Rabinbach's analysis provides a useful context for understanding the cultural fascination with an anthropomorphic machine that did not experience fatigue itself or impart it to its operator; a machine which only required the most minor of physical interventions to run and which could disseminate morally uplifting entertainment, both scientific and musical. This was obviously a class-bound discourse, and, though there are no statistics available on the economic strata of the consumers of domestic clockwork musical instruments, the advertisements present a bourgeois scenography of the instruments' targeted audience and its moral concerns. This imagery however could just as well have been targeted to the working class, as well as the middle class, precisely because of its status symbols and morally uplifting ideology.

Mechanical Therapeutics

Not coincidentally the reproducing piano and music box advertisements stressed their medical and mental benefits. These instruments and specific musical repertoires were prescribed for use in what one ad called "melotherapy": musical therapy

for a variety of nervous afflictions, including insomnia, dyspepsia, neurasthenia, and hysteria, the symptoms that were stereotypically associated with mental and physical exhaustion. As devices like expression pedals furthered the ascendant spiritualisation of the clockwork musical instrument, a new anthropology was being forged, coupling human feeling with mechanical tactility and banishing labour and its associated fatigue as moral deficits.

The contradiction between productive industrial labour as civilisational progress and physical-emotional fatigue as a psychosocial regression threatening that progress received an imaginary solution in the private space and in the cultural sphere of mechanised musical performance. The integration of human spirituality and emotion and the clockwork instrument was a utopian composite image and a symbolic reconciliation, and it is no coincidence that this coupling of "grey matter" and machine sentience seems mainly to occur in the privacy and security of the middle-class parlour far from the terrain of concrete class tensions and the physical stress of the factory floor.

The Clockwork Musical Instrument and the Colonial Subject

Many automata, musical and otherwise, were first encountered in the liminal space of the fair or carnival and were enveloped in dangerous and eerie atmospherics. Gustav Meyrink, author of *The Golem*, describes his encounter with an Orientalist panopticon with its "its jumpy breathless music and smoky oil lamps that flooded the tent." Through peepholes on walls decorated with red cloth, spectators could view a mechanical, moving panorama depicting the storming of Delhi or stand silently in front of a glass coffin in which an automaton of a dying Turk lay breathing heavily. This figure could open its lead-coloured eyelids to the sound of clockwork military music. Here the phantasmic atmosphere was fused with the specialised sensory reception of automata and the portrayal of automata as third world cultural and colonised others.

There was Kempelen's infamous automated chess player, a fake automaton, in which the berobed, bearded, and turbaned chess master was depicted as a Turk. There were the Swiss automata that depicted anthropomorphic, ape-like, Negroid fiddlers, or the automated, moving, and musical elephant mounted by a brown-skinned Hindu mahout. There was a whole series of Orientalist automata: soothsayers, magicians, and conjurers such as the Chinese magician sitting in a temple or a music box showing a magician in Persian dress flanked by two monkey musicians in Asiatic costume playing cellos and violin. There were the Arab tightrope dancer with black musicians playing drums; the Indian snake charmer who played clockwork

PRODUCT

music through a flute, the Negro dressed in slave garb; another Negroid narghile smoker, dressed in Egyptian costume, with exaggerated lips drinking a cup of coffee; an automaton of a westernised Negro being shaved; and that of a black crossbowman wearing nothing but a loin cloth made of palm leaves. These figures of external alterity were also complemented by subaltern figures internal to European culture. Women of diverse class affiliations were a common figure displayed in anthropomorphic automata; in addition there were shepherds and shepherdesses in antique dress playing flutes and pipes, the peasant potato eater music box, and a host of artisan figures representatives of a prior economic era or of currently outmoded economic/technological practice. But there were also automata that depicted scenes of contemporary working life, such as the automaton shoemakers, one having a quarrel with his wife, weavers, wood-turners, and finally automata that depicted the interior of entire factories with machinery and workers in motion.

What is the connection between the automaton – this mechanised spectacle, performer, servant – and the colonial and internal subaltern? Sir Richard Burton, explorer, ethnologist, and pornographer, may provide us with part of the answer. In a striking passage from one of his Afghan travelogues, Burton is put off by an Indian servant's servility. Burton suspects a fundamental and very disturbing mocking mimesis behind the Other's pseudo and stylised self-abasement to the colonial master, without acknowledging the master's own complicity in this imperial symbiosis. He concludes his contemptuous, yet anxiety-tinged assessment of his servant with these words:

> [...] a portly, pulpy Hindoo, the very type of his unamicable race, with a catlike gait, a bow of exquisite finish, a habit of sweetly smiling under every emotion, whether they produce a bribe or a kick; a softly murmuring voice, with a tendency to slinking; and a glance which seldom matches yours and when it does, seems not to enjoy the meeting. How timidly he appears at the door! How deferential he slides in, salaams, looks deprecating, and at last is induced to sit down! *Might not he be considered a novel kind of automaton, into which you transfer your mind and thoughts – a curious piece of human mechanism in the shape of a creature endowed with all things but a self?* (emphasis added)

Burton, who prided himself on his impersonation of natives and who participated in Sufi trance rituals, here stumbles upon the colonial mirror through the mimetic facility of the automaton. Orientalism here is the reciprocal insertion of the European and the Asian into a kitsch-like social relationship, into caricature and cross-cultural *trompe l'œil*. The subaltern as copy turns back upon the master (the model), the

Helmet	Helm
Telephone	Telefon
Turbine	Turbine
Conveyor belt	Förderband
Escalator	Rolltreppe
Money	Geld
Barbie	Barbie-Puppe
Television	Fernsehen
Electric chair	Elektrischer Stuhl
Dentist's chair	Zahnarztstuhl
Ambulance	Krankenwagen
Computer	Computer
Surveillance camera	Überwachungskamera
Velcro	Klettverschluß
Viagra	Viagra
Oncomouse	Onkomaus
Light bulb	Glühbirne
Uniform	Uniform
Car	Auto
Deodorant	Deodorant
Zoom lens	Zoomobjektiv
Remote control	Fernbedienung

latter's own projected self-hood, his own panoply and ornaments of mastery, the master's "mind and thoughts", and thereby opens up for Burton the complex cultural phantasmagoria of subversive mimesis and its sensory offense against the coloniser. The European project of dispensing mastery through the dispersal of its distaff body imagery onto nature, machinery, and the colonised is transformed in the mimetic mirror of both the serving machine and the subordinate native, as the latent power of the copy to echo, train, and to decentre mastery through the ironic art of imitation.

The new technology of the automata was passed into the culture and into perception with the aid of the exotic and the archaic; imagery that depicted antiquated historical periods and racial, ethnic, and class others that were contemporary representatives of pre-civilised or pre-modern realities which had been rapidly displaced by industrial culture and colonialism, both internal and external. More familiar exotica, the colonial and domestic subaltern, were used to broker the unfamiliar exotica – new technology and new affective relations to strange and novel machinery. Benjamin has discussed how the normalisation of new technology in the 19th century was consistently brokered with archaic imagery and antiquated exotica.

At the same time this process, in the case of musical and other automata, was enabled, as usual, by the depictive displacement of ethnic, racial, gender, and class others. Further, just as much as figures of alterity and icons of prior and already outdated cultural forms, personae, and practices were used to socialise the automata into contemporary everyday life, the imperial encounter was itself reciprocally mediated and politically neutralised by the mechanisation, incarceration, and consequent fantasy formation of the third-world Other in the structure and design of the automaton.

This procession of automated mechanism constituted a dream kitsch of overlapping historical faces and forms. It was as if the middle class could not conceive of its new material culture as an indigenous and emergent form; automaton technology had to be imagined as the re-enactment of anterior cultures, symbolic afterbirths of economic displacement on one hand and colonial displacement on the other. Through this masquerading of the automaton as subalterns of external and internal colonisation, several myth logics were put into play: the new technology of the automaton was aestheticised via the guise of tamed icons of the pre-industrial past and the contemporary "primitivity" of the colonial subject. These images of familiar and tamed exotica, their bodies parodied, pastiched, and mechanically subordinated, insulated the audience from the latent parricide and somatic substitution-duplication of the anthropomorphic machine. The body imagery of colonial and historical others that was grafted onto machine bodies and functions repressed the alterity of a transitive technological present and stabilised it in class perception. In turn, the performing

colonial subject is dehumanised and more firmly positioned as subaltern, based on his/her moral and physical analogy to the automaton as visual spectacle, labour-saving device, and epitome of servility and imitation.

Automata and Bourgeois Dream Space

The parlour space, in which these artefacts, curios, novelties of mechanised and miniaturised colonial and historical others were mounted and displayed also further explains their localised 19th-century meanings, for as Ernst Bloch informs us, the 19th-century parlour was a space of "gruesome [...] yet important dreams". For Bloch the 19th-century parlour was a hollow and spooky element of the last century, filled with a profusion of knick-knacks of a culture incapable of having its own form. Thus the culture "dreamed" in imitation of older European aristocratic cultures, peasant nostalgia, and Oriental and other third-world exotica. For Bloch this accumulated multicultural residue was "historical dust" that "gathered itself in decorative clouds" and from which arose a dream kitsch composed of all styles laid on top of one another – an "overlapping of historical faces". For Bloch this cultural montage of dream kitsch was a historically "intermediate stratum of masquerade" because:

> Capitalism and its technology, which had destroyed the traditional culture, did not confess itself as yet; new forces which could have operated precisely out of the cultural hollow space had not yet arrived, of the collapse there reigning only the dust it created [...] thus there arose this dream kitsch.

Bloch saw the parlour space and its accoutrements as the private analogue of the iron exhibition halls with their global trade markets: "the mendacious world exhibition of all ages and styles". A central characteristic of the exhibition halls, where automaton technology would have been featured, was the core contradiction between the social mode of production being celebrated – with its unleashing and mobilisation of massed techno-economic forces on a global scale – and the privatised capitalist form of appropriation and pleasure. For Bloch this contradiction emerged at the level of the age's material culture in two areas: "the technological engineering one on the one hand and the decorative-individualistic one on the other, or the anarchy of the styles". For Bloch this culminated in the centrality of historical dream appearance in the parlour space, for there really were not two separate aspects in this contradiction, but a symbiosis between the repressed dimension of mechanical infiltration and the distraction of multihistorical and multicultural ornamentation that masked and deferred the repressed content for:

the former [techno-economic production] was ashamed of its existence, did not prevail at all whereas historical decoration dominated room, house, way of life, art and culture from cradle to the grave [...] the historical imitation [...] sprang from the parvenu's desire to dream in the conquered bed of the nobility, to tart himself up in feudal terms.

We can add here the need of the European bourgeois to tart themselves up in colonial relics, collections, and third-world trade curios, which automaton decor replicated and evoked. Further, Bloch's identification of the need to mystify naked productive forces with historical and exotic ornament had a corollary expression in the dispensation from labour and physical exertion and the aestheticisation of mechanised labour in the performance culture of the musical automata. For Bloch this was a domestic culture, with all its historical and exotic ornamental distraction:

where human beings veiled themselves, even things lay in cases as in bed [...] for the 19th century did not only copy [...] the past, but at the same time materialised its dream appearance out of it [...] these areas are only now through shock and decay releasing their meanings.

Conclusion: Oneiric Anticipations of the Cyborg

I have quoted extensively from Bloch, not only because his analysis reveals much about the performance space of the domestic musical automata, but because the promises of the marketing advertisements for these instruments, the latter's decorative casings with their replication of colonial and historical imagery, their semiotic and class antipathy to labour at machines, the various guises under which this aestheticised mechanisation filtered into the domestic space, all partake of this collective dream appearance. Bloch, Benjamin, and the Surrealists like Ernst and De Chirico treated these obscure parlour-phenomena as critical cultural hieroglyphs to be deciphered and re-examined. I have attempted a similar hieroglyphic decoding in relation to clockwork and musical automata, precisely because, in their particular montage of body functions, body-part symbolism, and artificial life, they stand as obscure, esoteric ancestors of the Cyborgian machine-human interface, metabolic exchange, and duality-multiplicity we are supposedly encompassed by today. The crucial aesthetic-moral characteristics of contemporary Cyborgian discourse, individualistic liberation from certain confinements of the body (whether that be sexual-gender identity or industrial labour), the transposition and metabolic, symbiotic exchange between body and machine, the global cultural economy of disseminated body images and

values, the new intimacies of miniaturisation and the related phenomena of space/ time compression, the electronic domestication of the exotic and the global dissemination of the local, can also be proto-typically identified in the design and consumption of clockwork automaton performances and in their 18th- and 19th-century presentation spaces. This is true for the 18th-century cabinet of curiosity, the 19th-century world trade and technology exhibition hall, or the parlour with its layered ornamentations of global cultural contact and its domestication of the archaic and the exotic. We are obviously dealing here with a long-term and long prepared-for perceptual structure of modernity. And this begs the question: What is the inventory of dream appearances and dream kitsch that has yet to be recovered from a critical examination of the hieroglyphs and ornaments of Cyborgian celebration, iconography, and ideology? What interior parlour-like closures, what encompassing cabinets of curiosity and displays of ingenuity have been constructed for us? And just as Bloch and his contemporaries fled the 19th-century bourgeois parlour only to later return to it for a source of ideological critique, will we be able to flee down the long, heavily-ornamented, and eerily-lit corridor of virtual reality spaces, chat rooms, genetic manipulation, fetal imaging, computer graphics, informational fetishism, and digital domains to an exit and to a perceptual site, where all this electronic kitsch can be confronted, in a wakeful manner, as the dream structure it really is?

From Poetry to Prose: Sciences of Movement in the Nineteenth Century

Friedrich Kittler

In these circles, the circler circles. – *E. T. A. Hoffmann*

It is a well-known fact that computer animation, which is nowadays corroding the traditional genre of film from within, is a work of industrial magic. Whatever moves over the screen or monitor no longer proves its existence by virtue of its movement. A strictly algebraic geometry whose points, lines, and planes only exist as floating-point numbers in the processor or graphic chip finally appears to us: it enables an electron beam to light up a computer screen.

The magic of the computer industry has unleashed sheer trepidation among the makers of film and television. An absolute appearance that goes by the name of virtuality is supposed to be divesting all reality of the real, and with this, stripping the analogue media of their dignity in unfalsifiably documenting the prose of this world.[1] It is not a matter of virtuality, however, but rather one of movement. In spite of all journalistic ethics, the same makers of television readily concede that photographs have long been prey to all kinds of retouching and forging techniques – and not only since Stalin and Trotsky. They only start fearing the downfall of analogue image media when computer graphics render the moving pictures falsifiable, as well. The pencil that nature removed from the hands of all painters after 1840 (to speak with Henry Fox Talbot) in order to reproduce itself unfalsifiably was given to us not by the photochemical recording of images as such, but only by the technical transcription of movement. Arnheim's argument, according to which photography draws its guarantee of genuineness from its material determination through this world[2], pales in the face of Eddington's argument, which states that film documents the entropy of this world in its temporal irreversibility.

1

To the Greeks, *mímesis* meant anything but imitation: *mímesis* meant – according to Hans Koller's thesis – "representation through dance".[3] Whatever or whoever danced, however, described the world in a cyclical path. This was the case for the stones which Orpheus caused to dance, for Cretan labyrinths and Phrygian meander patterns, not to mention men and women. Even becoming and passing on the whole, as irreversible and fatalistic as it may have seemed, ordered itself into the great cycle of being after Empedocles.[4] Repetition was so powerful that it continued to have an effect even after modern astronomy had long since broken with the aesthetic of cosmic cyclical paths.

Athanasius Kircher, the leader in media-technical planning of the Counter-Reformation, also propagated, along with countless other optical and acoustical works of wonder, an apparatus which film historians have celebrated as the direct precedent to the object of their love: the so-called *smicroscopium parastaticum*[5]. This device, which in keeping with its epithet could, like the microscope, show or place side by side very tiny things, consisted of a turntable and an optical observation device. The turning disc collected a multitude of tiny images which were then returned to life-size by means of a system of lenses. The images, however, were not just any images, but the holy stations of the Passion, which had been established for centuries and whose mimesis or propaganda was of course the concern of the Jesuits. Paintings or statues which had formerly simply appeared in spatial and temporal sequence in churches or specially built paths of the Passion now began, with Kircher, to run in fast motion: the Stations of the Cross of our Lord, from Pilate to Golgotha, as an endless *ritornello* on a turntable base...

This put Kircher at the forefront of his time. The choreographic figures of the Saviour only repeated the mathematical question as to which trigonometric figures are brought forth by constant angular velocities. The circular motion of the Greeks gave way to those periodic vibrations which Roberval was able to visualise in 1640, in graph form as the sine curve. Only the problem of coaxing nature to reveal its periodic vibrations in a recordable way remained unresolved. The fact that the cosine function carries all the beauty of musical tones might have been mathematically and theoretically proven, but it continued to remain closed to the eye and ear. Even Kant's aesthetics despaired over the task of transferring those vibrations – which he, along with Euler, termed "vibrations of the air",[6] – into aesthetics, which is to say into empirical visibility: four hundred zero-crossings per second subvert any possibility of perception.

This despair of transcendental philosophy sprang from the analogue recording media of the 19th century. Precisely at the point where the "*I think*", the "must *be*

able to accompany all my representations"[7] no longer keep up is where measuring instruments, at first, and later demonstration apparatuses took their place. Roberval's sine curve found its way from the paper version of its mathematical construction to the recording surface of its physical occurrence. In an experiment which ranks among the primal scenes of all sensory physiology, the Weber brothers succeeded in eliminating Kant's aporia: they affixed a simple but pliable hog's bristle onto the prong of a tuning fork, as it had been invented in the 18th century, which in turn slid over a glass plate blackened with an even layer of soot. The tuning fork, when struck, no longer remained a merely acoustical occurrence, but rather emitted graphic or, even more, choreographic occurrences as well: it traced its imperceptible individual vibrations one after another onto the glass. The periodicity of the concert pitch had been made visible.

The same periodicity also determined the first experiments in physiological optics. After no one less than Michael Faraday had explained in theory, or perhaps demystified, the optical illusion of the strobe effect, Plateau and Stampfer were able to start implementing it in practice. Kircher's pious smicroscope became the favourite toy of half a century, the bioscope or what the Germans called the "wheel of life". Of course, wheels of life, which celebrated a basic principle of the period, no longer showed the irreversible tribulation of the Passion, but rather the pirouettes of dancers as they resumed their initial poses after twelve or sixteen lovingly drawn pictures of the individual phases. Without such a periodicity, it would not have been possible to induce a single second to appear as a continuous occurrence through constant repetition. The wheel of life reduced the sequence of events – as did Schopenhauer's contemporaneous and contemptuous philosophy of history – to a "same, even, unchanging nature, which to-day acts in the same way as yesterday and always".[8] To put it briefly, it broke dance on the wheel.

2

Nietzsche, as the philosopher who the physiologists of the period had thoroughly excerpted, traced all poetry back to pure rhythmic return in *The Gay Science*.[9] In this elementary sense, science produced pure poetry from motion until around 1850. Even its "song[s] revolve[d] as does the starry dome, / Beginning, end for ever more the same".[10] In contrast, the art of prose since Flaubert and Nietzsche consists mainly in "poetry [being] continually avoided and contradicted".[11] Prose means writing down movements, or, to be more general, recording them, their future being predictably unpredictable, and so the probability of cyclical repetition being reduced to a statistical minimum.

Today, in the age of transient recorders and contingency reduction strategies, that seems like the easiest thing in the world. But all prose produces massive material preconditions which in the meantime have merely become self-evident. The recording of sequences whose future and thus also whose end are not pre-established at the onset need, in principle, media for infinite storage. No one knew that better than Alan Turing, when in 1936 he postulated a machine with an endless supply of rolled paper to solve the stoppage problem of all prospective computers.

The 19th century approached prose without such mathematical apparatuses. For Wagner, musical prose meant simply to strictly avoid identical repetitions (from the refrain to the aria), yet to burden the singers and spectators with the weight of the new endlessness. Media-technical prose from Léon Scott to Thomas Alva Edison simply meant to search for storage media which might be able to capture at least excerpts of an open future in strips or spirals. The blackened glass with which Scott experimented no longer drew the trigonometric periods of a tuning fork, but rather, as long as there was enough space, the irregular mixture of frequencies in the human voice. As Edison expanded this transcription technology with the corresponding reproduction technology, he only needed a cylinder whose spiral notation increased the storage capacity by several decades. The same happened in the field of optics when Edison and, following him, the Lumières replaced Muybridge's glass plates with reels of celluloid.

Since then, seeing films or listening to records means to breathe in the prose of this world. The fact that the gods no longer guaranteed recurrence or resurrection led to their dethronement. Their endless flight into nothingness fills the final chapter of Flaubert's *Temptation of St. Anthony*. And if the flesh rises once again, then it is only to prove that transcendental subjects have become played out since Weber's hog's bristle: in his *Charcuterie méchanique*, Georges Méliès filmed the entire prosaic path from the pig's slaughter to the pork sausage, but let the film run from the end to the beginning in a manipulation of the temporal axis, until the sausage turned back into pork and the pork once again became a living being. The contrast between film and the wheel of life could hardly have been set into scene more cynically.

"Our new 'infinite'" is what Nietzsche called such games. "We cannot look around our own corner: it is a hopeless curiosity that wants to know what other kinds of intellects and perspectives there *might* be; for example, whether some beings might be able to experience time backward, or alternately forward and backward (which would involve another direction of life and another concept of cause and effect)."[12] The fact that the new infinity no longer belonged to beings, but rather to machines, remained closed to even the gayest of all sciences. Yet, when Arthur Eddington

investigated *The Nature of the Physical World* in his monograph of 1928 – that is, the nature of nature itself – the reversibility of film reels advanced to the only possible empirical proof of their opposite: the fact that the second thermodynamic law prevails – that is, that the entropy of closed systems increases irreversibly – only demonstrated, according to Eddington, its own injury through the animated film. In other words, the prose of this world was its irrevocable drift into heat death.

3

Computer animation is the exact opposite. Precisely as Shannon's mathematical concept of information, on which all digital machines are based, is formally identical with Boltzmann's entropy formula, so do the fundamentally reversible leaps and loops of graphics programs spring from a new poetry. Whatever animated beings skip across the monitors, their movements can only change according to a finite number of degrees of freedom, and so they are dancing (as does all art, according to Nietzsche) in fetters. Whereas eyes, when they follow such virtual performances, are attached to six muscles and thus six degrees of freedom, their virtual counterparts, even in the most elaborate eye-tracking systems, enjoy only one. It is this limitation, though, which transforms the calculated eyes back into perfect balls, and thus into bodies of the Greek ideal.

All computer animation is the application of a science of movement which goes back to the École Polytechnique in France and to the Weber brothers in Germany. Ernst Heinrich Weber and his brother Wilhelm not only visualised the mathematics of waves and tuning forks, but also, quite to the contrary, reduced the drama of movement to trigonometric formulae in order to address the interplay of bones and joints. In a reassessment of Euler, Ampère and Chasles limited their new science of kinematics to ideal – meaning entirely rigid – partial bodies which receive a few degrees of freedom only at their coupling points or joint areas. What sets kinematics into motion, then, is neither machines nor bone structures (in the event that this alternative even offers a degree of freedom). Two leading computer graphics experts called this "inverse kinematics applied to skeletons".[13] It is thus possible that the Man of Sorrows has returned.

In any case, the discovery of prose, this infinite irreversible movement, was a scientific and technical revolution which made Europe's old art forms look old in one fell swoop. Yet neither flesh nor entropy allow for mathematically closed solutions. Computers are machines with a finite number of resources which run in a world of finite resources.[14] They cannot get around admitting that poetry is right.

1. See for example *Television im Überfluß. Programme im digitalen Medienzeitalter*, ed. Peter Christian Hall, 28th mainzer tage der fernseh-kritik, Mainz 1996.

2. See Rudolf Arnheim, "Systematik der frühen kinematographischen Erfindungen", in *Kritiken und Aufsätze zum Film*, ed. Helmut H. Dieterichs, Munich 1977, 27.

3. See Hermann Koller, *Die Mimesis in der Antike: Nachahmung, Darstellung, Ausdruck*, Bern 1954.

4. Empedocles 17 D: "And in so far as is the One still wont / To grow from many, and the Many, again, / Spring from primeval scattering of the One, / So far have they a birth and mortal date; / And in so far as the long interchange / Ends not, so far forever established gods / Around the circle of the world they move." (quoted from *The Fragments of Empedocles*, trans. William Ellery Leonard, Chicago 1908, 22.) See also Alain Martin and Oliver Primavesi, *L'Empédocle de Strasbourg. Introduction, édition et commentaire*, Berlin and New York 1999.

5. See Friedrich von Zglinicki, *Der Weg des Films. Die Geschichte der Kinematographie und ihrer Vorläufer*, Berlin 1956, 56.

6. Immanuel Kant, *Critique of Judgment*, trans. Werner S. Pluhar, Indianapolis 1987, I, §51; see also I §14, where Euler's name is expressly mentioned.

7. Kant, *Critique of Pure Reason*, trans. and ed. Paul Guyer and Allen W. Wood, Cambridge and New York 1998, B 132.

8. Arthur Schopenhauer, *The World as Will and Idea*, trans. R. B. Haldane, London 1883, III 38.

9. See Friedrich Nietzsche, *The Gay Science*, trans. Walter Kaufmann, New York 1974, II 84.

10. Johann Wolfgang von Goethe, *Parliament of West and East, in Selected Poems*, ed. Christopher Middleton, trans. Michael Hamburger, Boston 1983, 205.

11. Nietzsche (note 9), II 92.

12. Ibid., V 374.

13. Alan Watt and Mark Watt, *Advanced Animation and Rendering Techniques. Theory and Practice*, New York 1992, 382.

14. See Yuri Gurevich, "Algorithms in the World of Bounded Resources", in *The Universal Turing Machine. A Half-Century Survey*, ed. Rolf Herken, Berlin 1988, 407–416.

Step by Step – Cut by Cut: Cinematic Worlds

Gertrud Koch

pas à pas

nulle part

nul seul

ne sait comment

petit pas

nulle part

obstinément

– Samuel Beckett[1]

Moving Bodies

The cinematographic body is damned to remaining partial: fragmented into image segments and frozen in single frames. Yet film is nevertheless the medium of the body in motion; it is a motion which, however, frees itself from the body. When someone tap-dances straight up the wall of a room in a musical, we become a part of a dream in which gravity is suspended – and because we are in a fantasised world, this world operates according to other laws. The actor's body, the body on the screen, is thought of as the object of another world; it is made unreal and is brought into the world at one and the same time. The transition from the plausible narrative of a fictive world, which is nonetheless conceived of as being possible, to the unreal world of pure imagination is carried out in film step by step, cut by cut. No sooner is Gene Kelly strolling through Grand Central Station than his step promptly picks up and he is suddenly tap-dancing and singing at the same time. More than a transparent dramaturgical manoeuvre designed to preserve the mores of a respectable realism, these are transitions to movements of the body that

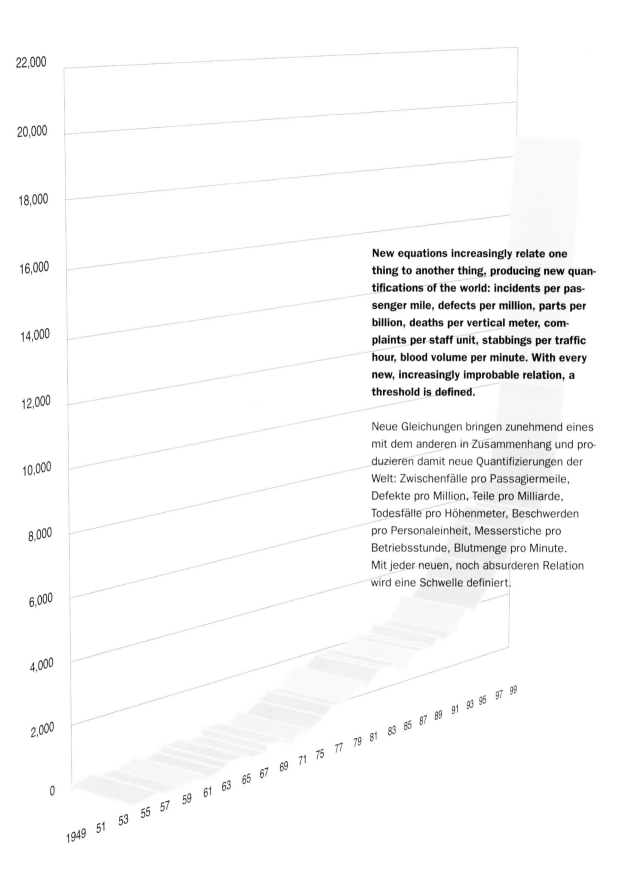

New equations increasingly relate one thing to another thing, producing new quantifications of the world: incidents per passenger mile, defects per million, parts per billion, deaths per vertical meter, complaints per staff unit, stabbings per traffic hour, blood volume per minute. With every new, increasingly improbable relation, a threshold is defined.

Neue Gleichungen bringen zunehmend eines mit dem anderen in Zusammenhang und produzieren damit neue Quantifizierungen der Welt: Zwischenfälle pro Passagiermeile, Defekte pro Million, Teile pro Milliarde, Todesfälle pro Höhenmeter, Beschwerden pro Personaleinheit, Messerstiche pro Betriebsstunde, Blutmenge pro Minute. Mit jeder neuen, noch absurderen Relation wird eine Schwelle definiert.

constitute a world in which the body is light and entirely self-determinant. A world which is made up completely of will and idea. In a conventional visual metaphor for thoughts taking wing, the actor's thoughtful gaze up at the heavens is continued in the flight of a bird. To dream of mobility, film does not even need a dancer. The urge for movement can come from anywhere: it can be a song about the future, *Que sera, sera*, with which Doris Day guides her son out of the Orcus of imprisonment in *The Man Who Knew Too Much*; it can be a kiss that makes Gene Kelly sing and dance in the rain, a first step which takes Donald O'Connor up the wall three times before disappearing through it in *Make 'em Laugh*, a step over the edge of the stage that has Moira Shearer flying in a groundless world of suspension in *The Red Shoes*. What is decisive is film's ability to incarnate movement, and all bodies can be flying bodies, marching bodies, bodies in motion like leaves in the wind.

If this kind of creating a world in film is regarded as dream sequences without a dreamer which are brought forth by a de-realisation, then the question arises of the memory of the body which aspires to pushing its limits in such a way that it makes the whole world into its body: crawling up the wall as a fly, dropping as a waterfall, shooting through the air as an arrow. Cinema is the boundless desire for anthropomorphic projections of highly varying modes of being in its world. The reference to the world of the body as a limitation is negative; the removal of this limitation harbours the memory of the body's failure.

Movement: *Actus Imperfectus*

> Kafka suggested making mixtures, putting phantom machines on the apparatuses of translation: this was very new for the time, a telephone in a train, post-boxes on a boat, cinema in an aeroplane. Is this not also the whole history of cinema: the cinema on rails, on a bicycle, aerial, etc.?[2]

In Kafka's letter to Felice which Deleuze is referring to in this passage, Kafka makes five propositions for increasing the sales of the newly invented Parlograph being propagated by the company Felice is working for: "Here, by the way, is a rather nice idea: a Parlograph goes to the telephone in Berlin, while a gramophone does likewise in Prague, and these two carry on a little conversation with each other."[3] Kafka's letters play with the difference between physical proximity and distance, mental idea and the appearance of the technical media as mediator. But these are not only regarded as surreal automata that merely communicate with each other:

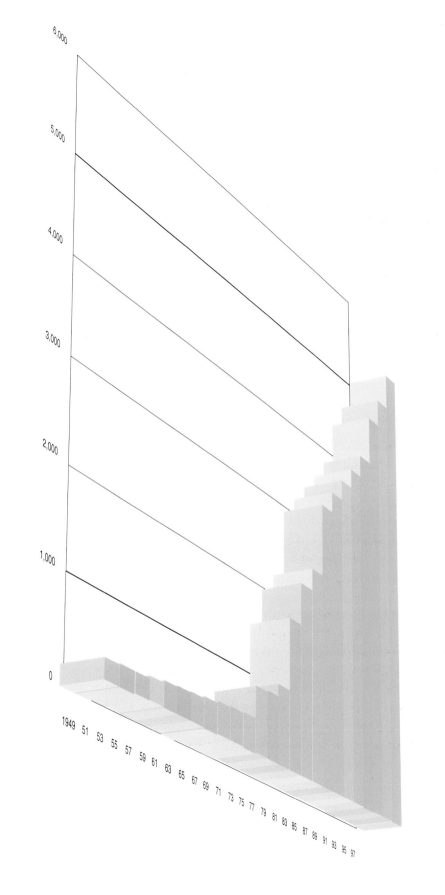

6,000

5,000

4,000

3,000

2,000

1,000

0

1949 51 53 55 57 59 61 63 65 67 69 71 73 75 77 79 81 83 85 87 89 91 93 95 97

the material tangibility which weighs down postal communication is also brought to bear in these images over and over again. Unreliable and full of surprises as all messages Kafka has sent out to us are, they bring us puzzling objects in which the stirrings of reconstruction in the process of remembering crystallise:

> Again we have been of one mind. In your last letter you remind me of my photograph; I got that letter probably the very moment you received mine, written yesterday, with the picture in it. But there is also something unfulfilled. Both letters say we want to meet, but it does not happen.[4]

The fact that the movement of the media is not a movement of the bodies towards each other, but rather produces a "communication with absent others" – Kafka's painful lament in closing, "but it does not happen" – has implications that are as little outlined with the ideologically critical reference to the surrogate and 'deceptive' nature of the (mass) media as Kafka's complaint is to be taken at face value.

The transposition of time and space in a technical and mental movement which is carried out with and through the body, but which does not move the body itself, is based upon the activating of memory. That which does not take place as physical action, activity, or motion is projected out of the memory as a recurrent wish, as a vivid idea. The medium itself becomes the location for a memory that collects corporeal images of bodies which it mentally connects to an already experienced body, that of a person, without it having to be the body in its present form. Photographs have long since become signs of a nostalgic remembrance of that which has not been experienced: part of a narrative design that encompasses far more than the present, out of which issues the narrative projection backwards. Kafka impatiently notes in a letter to Felice:

> That first photograph of yours is very dear to me, for the little girl no longer exists, and so the photograph is all there is. But the other picture only portrays your dear presence, and my yearning carries my glance beyond the disquieting little picture.[5]

St. Thomas Aquinas defined movement as an "actus imperfectus" in two respects: on the one hand, as something whose reality is still incomplete, and on the other, as an uncompleted action. This leads to a mixing of reality and possibility – that specific unease that not only overcame Kafka when faced with Felice's picture, but anyone confronted with most photographs of persons significant to them. The re-presentation of the absent in childhood photographs and in pictures of the

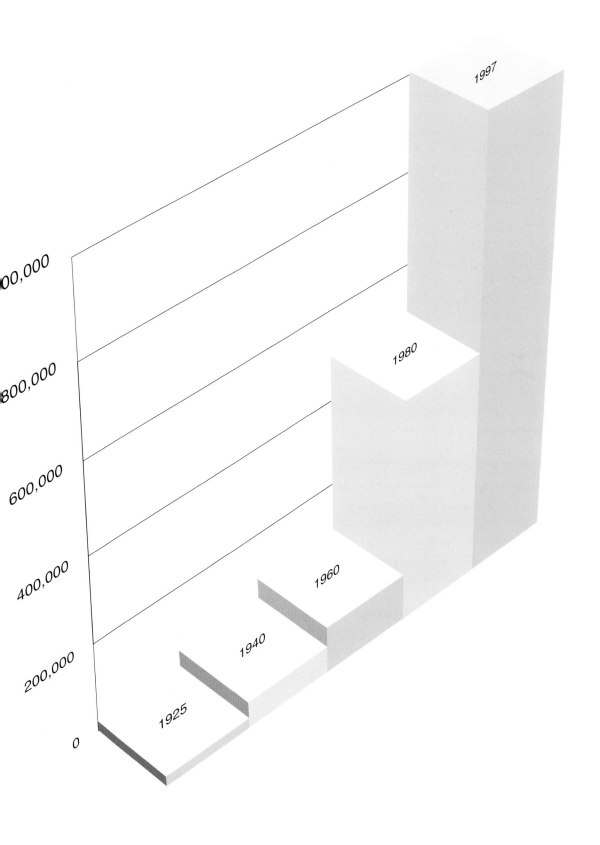

deceased derives a different sort of unease from the mimetic adaptation to the past than "the other picture".[6] This "other" refers to someone who might be absent, but in reality is present somewhere else – and is presumably unsettling for the very reason that their presence lies within the realm of possibility.

These two modes of the visual embodiment of the absent within the medium of technical reproducibility make the different temporal and spatial aspects clear. In the first case, time is turned back without it becoming reversible through this; it is thus a pure movement in the spirit of remembrance. In the second case, persons merely spatially absent are presented to the eye within a temporal continuum. This act harbours a potentiality, that of being able to meet in space at a different point in time. It is a movement which contains a projective component aimed at the future and not at the past. The images of bodies play a crucial role in the movement of recognition. It is a different one than in remembering, although every recognition presupposes remembrance.

As a re-presentation, it is a movement of drawing closer; as a flash of something locked in the past, it is a movement of one's self slipping into the distance. It comes as no surprise that the purely imaginary movement in time is "dearer" to Kafka than the perils of a potential encounter in a future space. "Desire", as a psychic movement towards an object, is characterised by lack, the sign of which Parmenides regarded as being movement in that it cannot take its place in the present, into which the state of being presses forth. In the technical reproductions of the photographic media, this problem of disembodiment and embodiment, derealisation and realisation are carried further.

The astonishing achievement of film is that it has perfected the *actus imperfectus*, and has done so in a way which aligns the nervous mobility of the camera, the moving sequences of the projection with the immobile body of the viewer, who, through the extreme activity of the eye, becomes the tense observer of the plot's development as well as a participant whose 'nerve' has been touched upon by an endless number of perspectives which set down the connection to the object on the screen. From the multiple perspectives of cinematic framing, images of bodies and bodily movement arise which are unavailable in nearly any other visual medium. The Cubist dream of a multi-perspective representation on the surface of the canvas is almost endlessly extended in film. In this tense attentiveness – which is passively guided through various perspectives and, at the same time, has to actively take hold of movements and complete them to form narrative lines – a constant movement takes place between surprise and recognition.

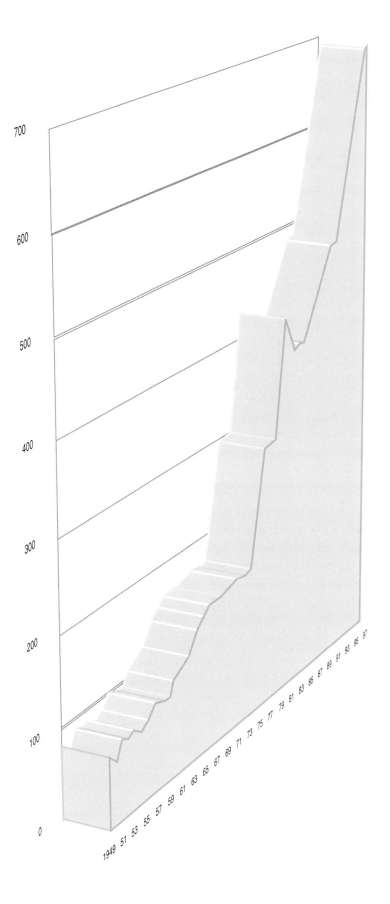

The Eye and the Body

The eye is immovably banished to the front side of the human body. We can touch ourselves everywhere on our bodies with our hands, scratch the backs of our knees with our toes, listen through walls with our ears, smell far-away things with our noses – only the eye remains a curiously localised organ, limited by the dark cave of the skull to the back and attempting to flee from the exactions of the outside by constantly closing the eyelid, before it finally falls shut in exhaustion. This closing, in opposition to the metaphor for death associated with it, is the living movement of the eye; only the dead can no longer close their own eyes. Luis Buñuel made the restricted, organic nature of the eye pour forth with a single razor-sharp cut in *Un Chien andalou*. The motion that he used for this purpose consists of clouds cutting through the moon, the cut of the razor through the eye, and the cut that links them. The only thing that remains immobile is the sliced organ. Movement is the cut of time through the organic: the clouds, the straight razor, and the film projector bring out the organic in the object, the eye, the moon, the film reel. But Buñuel's montage also points to another aspect: that the movement of bodies takes place in time, and that this very temporality is counteracted by an insistence on repetition, on reproducibility – of nature, of the body, of film. It is similar to the way music as movement in time continuously counts on repetition and its reperformance. A haunting tune is the malicious parody of this compulsion to constantly reiterate, in the way that a *déjà vu* marks the compulsion to remember the perceived as recognition. Deleuze pointed out Buñuel's apparant fascination with repetition. Repetition is a form of time, that of things following one upon another, yet it is also a performative act, a staged reperformance, or a scene that stages an image of time. This is shown especially well in *Ensayo de un crimen (The Criminal Life of Archibaldo de la Cruz)*, where the rerun of a scene in which things occurring simultaneously are erroneously remembered as a chain of cause and effect, and repetition have a temporal image as their basis.

Buñuel's cut through the eye has, in the meantime, itself become a visual metaphor: a metaphor for the peculiar position of the film viewer into whose organic body the cinematic images are "cut" via the eye. It is a process which, in Sartre's phenomenology, could be termed a "passive activity", an activity whose goal is passivity. We also go to the cinema to be overwhelmed, to have our eye "cut through", to experience, in Walter Benjamin's words, being "innervated", shocked when a sudden and unforeseen movement on the screen paralyses the viewer and puts him in the state evoked by the title of Stanley Kubrick's last film, *Eyes Wide Shut*. The "passive activity" of the movie viewer's arrested body, this movement

RUPTURE

of an innervation which is beyond all motor activity and somatically laid out in the act of seeing movement, has its famous precedent in Odysseus, who had himself tied to the mast of his ship in order not to plunge towards the Sirens, whose seductive song this first "hero of pleasure in estrangement" survives as a bound viewer.

There are three modes of motion of the body in film: as an object in front of the camera, as a camera movement in reference to the object of the body, and, finally, of the film running before the eye of the immobilised viewer. All allow a de-realisation of the body, while at the same time providing an extremely intense form of identification. In no other medium do dreams oppose gravity and time as vigorously. We see toppling, falling bodies, vertiginous, balancing bodies while in an extremely immobile state, yet at the same time highly agitated from all sides and from perspectives only the technical eye of the camera is capable of taking in. The body of the stunt man who is falling, the camera balanced on the crane: the whole theatre of the hysterical bending of the body, of the playful conversion of body made semiotic to a body made vulnerable, which falls to the earth out of its world of signs, is presented in these intersecting views and movements. "Whee", the mouths in the large faces of people shriek and cry, throwing their bundled-up little children into the air – whose mimetic metamorphosis from being paralysed with fear to crying out in pleasure evokes that very position we find ourselves in when sitting in front of the screen: "whee", the mouths in the faces shriek and cry, while our hands grasp the armrests and our backs are stiffly pressed against the seat.

The memory of older somatic sensations returns, in mirror image, in our relationship to the image of motion on the screen. The gap between the one actively throwing and the one passively being thrown is done away with. Every throw becomes the sketch for a situation which allows for the mental understanding of falling, of racing. Like a yo-yo player who throws the toy away from himself only to pull it back in again, the camera accompanies the fall of the body in a corporeality that remains staged. The actor's body no more smashes to the pavement in reality than the viewer falls from his seat. The fact that he nonetheless experiences the sensual sensation of falling is due to the extension of the organs brought about by the camera. Odysseus bound is a master of this technique: death without dying offers itself to the disembodied eye as an aesthetic of perpetual life. A comment made by the British Film Institute informs us that one of the first films was often shown twice: the film was projected forwards, and then backwards – with the effect that a building was resurrected out of the ruins by the very same industrious

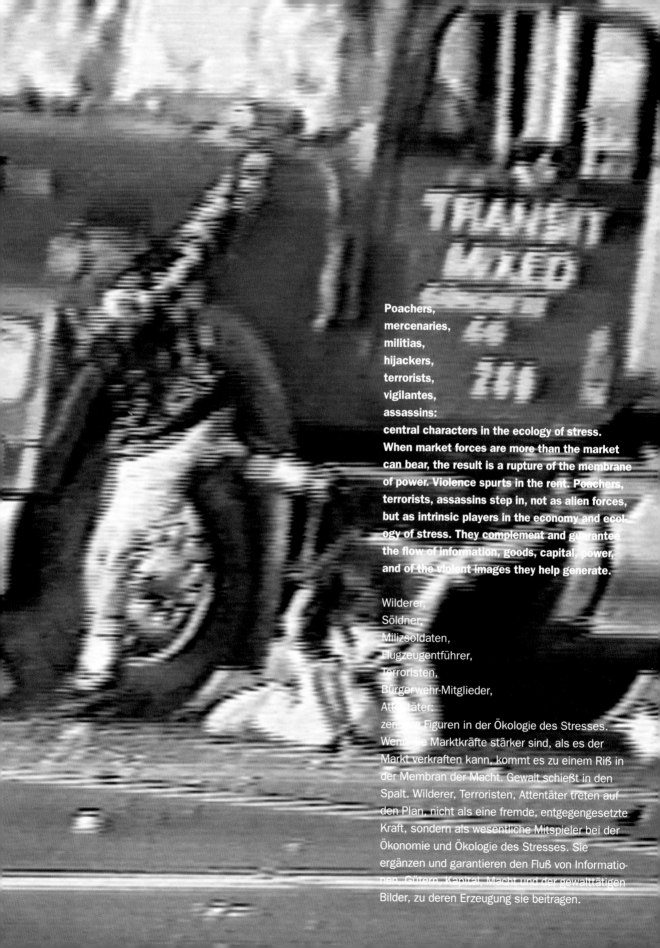

Poachers,
mercenaries,
militias,
hijackers,
terrorists,
vigilantes,
assassins:
central characters in the ecology of stress.
When market forces are more than the market
can bear, the result is a rupture of the membrane
of power. Violence spurts in the rent. Poachers,
terrorists, assassins step in, not as alien forces,
but as intrinsic players in the economy and ecol-
ogy of stress. They complement and guarantee
the flow of information, goods, capital, power,
and of the violent images they help generate.

Wilderer,
Söldner,
Milizsoldaten,
Flugzeugentführer,
Terroristen,
Bürgerwehr-Mitglieder,
Attentäter:
zentrale Figuren in der Ökologie des Stresses.
Wenn die Marktkräfte stärker sind, als es der
Markt verkraften kann, kommt es zu einem Riß in
der Membran der Macht. Gewalt schießt in den
Spalt. Wilderer, Terroristen, Attentäter treten auf
den Plan, nicht als eine fremde, entgegengesetzte
Kraft, sondern als wesentliche Mitspieler bei der
Ökonomie und Ökologie des Stresses. Sie
ergänzen und garantieren den Fluß von Informatio-
nen, Gütern, Kapital, Macht und der gewalttätigen
Bilder, zu deren Erzeugung sie beitragen.

workers who had just demolished it. This impulse for allowing movement and, with it, time to run backwards has held cinema narratively in check. Instead of showing the film again backwards, we remember a story which allegedly kept itself hidden within all the cuts, and which, in retrospect, we retell as the story of a film.

1. Samuel Beckett, "pas à pas", *Akzente* 3, 1978, 227. A poem written by Beckett for Herbert Marcuse on his 80th birthday. In English, roughly: step by step/ to nowhere/ no one/ knows how/ little steps/ to nowhere/ obdurately.

2. Gilles Deleuze, *Cinema 1. The Movement-Image*, trans. Hugh Tomlinson and Barbara Habberjam, London 1983, 101.

3. Franz Kafka, *Letters to Felice*, ed. Erich Heller and Jürgen Born, trans. James Stern and Elisabeth Duckworth, New York 1973, 168 (letter of 22–23 January 1913).

4. Ibid., 75 (letter of 29 November 1912).

5. Ibid.

6. Compare the numerous discussions in connection with Roland Barthes's text on photography, *Camera Lucida*, which I do not wish to go into here.

Images of the Body: On Sensory Perception in Medicine and in Everyday Life

Peter Moeschl

Along with a growing general interest in the human body, anatomy has also become the subject of a broad public interest in the past few years. This may be taken to be the expression of a newly articulated consciousness of the body; this interest is not, however, to be interpreted simply in the sense of a growing awareness concerning health. It is precisely the increasing popularity of anatomical exhibitions, along with the arguments in support of them, which suggest that the motivation is more complex. For example, the anatomical exhibition *Körperwelten (Body Worlds)*[1], which shows human corpses in an especially vivid manner by means of the new technique of "plastination", is presently drawing huge crowds. The popularity that this exhibition enjoys, especially with a lay public, is reminiscent of the public post-mortems in anatomical theatres since the Renaissance. The exhibition, which considers itself a part of this tradition, advertises with the slogan "The Fascination of the Genuine" – that is, with an authenticity that suggests that access to the body via popular anatomy can be had directly and by all.

How exactly does this access to the human body take place; which conceptual and other interests structure and convey it? How does the access of a lay person differ from that of a doctor as a body specialist? There can be no doubt that the doctor who concerns himself with a patient's body – especially the surgeon who penetrates into it – does this in a way different than is permitted by the interpersonal relationships on all other levels of human contact, including artistic or even sexual contact.

Systems of symbols, networks of the appropriate usage of language permeate and structure our everyday life in its different discourses and dispositions. Depending on what we do and how, in which community of work or leisure, social institution or

organisation, under what aspects and goals, in which individual state, and so forth, we live in the many different universes of the allocation of meaning – of symbolising – one by one and yet simultaneously. Every day, we use different symbolic parallel universes and find and experience ourselves according to the dominance of such separate universes and their respective discourses at one moment belonging here, and at the next belonging there. Often, only a slight change in aspect suffices to let us slip from one system of symbols into the other. And the entire world of ideas (the imaginary) connected to it tips along with it into another. A change in aspect of this kind applies to the sensory sphere of the individual perhaps even more funda-mentally than to the intellectual sphere. It virtually forms the motor of our everyday aesthetic experience. Only those people entirely fixed in their ideas, the "dyed-in-the-wool one-track specialists", are no longer capable of such an aesthetic shift in experience; they are professionally anaesthetised.

Along with this aesthetic of the everyday, it should also be mentioned here that it is, of course, art itself which has made a profession out of the aesthetic shift in experience – which forms the core of every aesthetic experience.[2] This profession has allocated the status of its own, so to speak meta-imaginary world (with all its accompanying paradoxical phenomena) to the moving back and forth between the various imaginary worlds.

Our attitude towards the body, the gaze directed at it also follows the customary symbolic structures of the everyday; we are at home in them. It is the surface of the body that guarantees its symbolic unity for our day-to-day perception. For this reason, a look into the interior of the human body is accompanied by unpleasant ideas, not only because we are perceiving its injury. Even more than this, it signifies an injury of the symbolic order of our daily perception of the body, an injury of *aesthesis* itself:

> Let us recall the uncanniness, even disgust, we experience when we endeavour to imag-ine what goes on just under the surface of a beautiful naked body – muscles, organs, veins... In short, relating to the body implies suspending what goes on beneath the sur-face. This suspension is an effect of the symbolic order; it can occur only in so far as our bodily reality is structured by language. In the symbolic order, even when we are undressed, we are not really naked, since skin itself functions as the 'dress of the flesh'.

With these words, Slavoj Žižek defined the radically "superficial" character of tex-tual bodies.[3] In any case, I shall return to this point in a later context.

The professional aesthetic approach to the human body of the specialist, the doctor, is formed differently. The doctor who touches the body and the surgeon

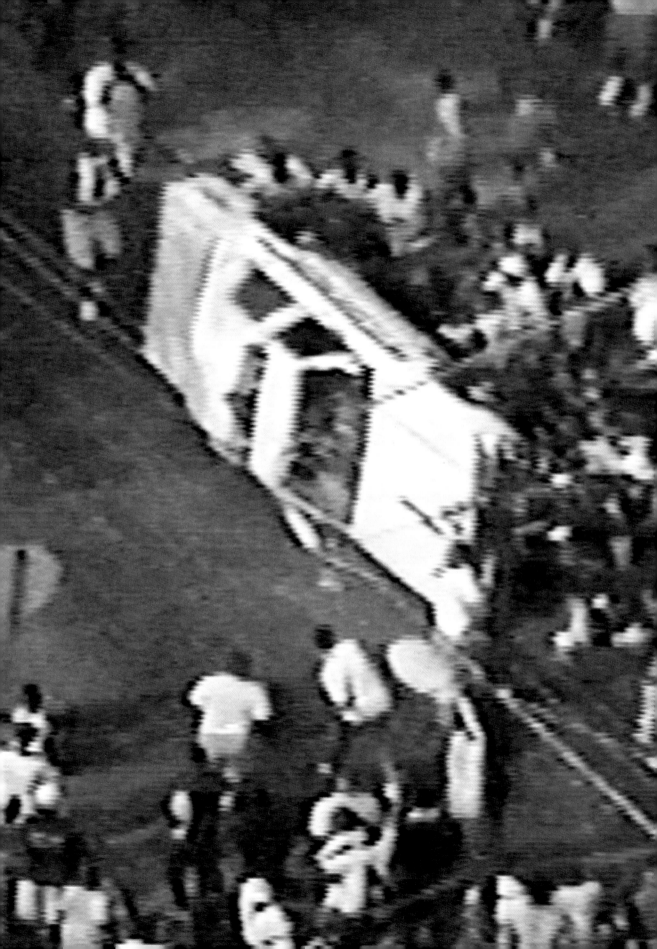

who penetrates into it are doubtlessly driven by a different interest in gaining knowledge, within the framework of a different symbolic system and coming from another imaginative world than the artist, the sexual partner, the father, the brother, the colleague, the friend, the representative of another profession, and so forth – any of which he might also be simultaneously.

Although sufficiently known, hardly any notice is taken of this fact in regard to the confrontations between these different worlds existing within one and the same community, confrontations which occur not all that infrequently, are relevant in terms of content, and are often socially problematic. Without making the dynamic interconnectedness of these parallel worlds in their concrete form the subject of our inquiry, we encounter each other (as representatives of our symbolic worlds) for the most part with unconscious strategies of distancing and disassociation. For this reason, the doctor takes care to maintain the "necessary distance" in bodily contact with the patient. The concept of distance, however, can by no means adequately describe the radical change in language, the other "linguistic operation" on the texture of the body and the fundamental change in aesthetic perception which are connected to the required and appropriate assumption of the doctor's position. Here, the call for distance is not a demand in the sense of the concept of distance in regard to content. In the final analysis, it is clear to everyone that medical treatment of the body demands not only an aesthetic/moral distance, but at the same time a direct technical proximity. The call for distance has, rather, a signalling character for the above-mentioned change in discourse and disposition, comparable to a cut in film. It is a signal with which the doctor might call the "texture" of his profession to mind. It is therefore not yet possible to approach this problem analytically when using the concept of distance alone.

A surgical cut is performed on an area of the body which is carefully disinfected and isolated from other regions, from the rest of the body's entire surface. Thus, the remainder of the body is covered over sterilely and is no longer visible to the operating surgeon during his performance. But this procedure certainly cannot be explained simply by concerns of sterility alone which the operation requires. Rather, it helps the surgeon concentrate both on the detail to be worked on and on the interior of the body. This calls for an approach that must not be disturbed by an everyday, aesthetic perception of the body – which is the perception of "whole" bodies as sensuous entities, particularly in the form of the body's surface! This becomes especially clear when the body is covered again and again, even in interventions which do not require sterility. Moreover, the relationship between (male) doctor and (female) patient has always been subject to special rules of proximity and distance. In the past, doctors demanded that, even on the

STRAIN

examination table, a woman should never be examined when fully naked. One part of her must always remain clothed or covered over, either her upper body or her lower body. So is it not the clothed part of the patient that stands for the medical discussion carried out between the equal parties of doctor and patient, whereas the unclothed part represents the partitioned region of medical activity? Certainly, one will immediately notice that the relationship between the sexes also plays a significant role here. This complicates the doctor-patient relationship even further, but only in the sense in which it renders it radical on an aesthetic level. Accordingly, personal physicians of the Middle Ages were not at all permitted to look at the female body to be treated. As is documented by old engravings, the doctor had to feel the body parts in question through the clothing. Even today it is not at all rare for medical students and young doctors to black out during operations. The circulatory collapse that they experience, however, is in no way caused by the physical effort, as those affected often claim. It is, in the true sense of the word, an "aesthetic collapse" in which the medical/technical perception of the interior, of the opened body, cannot be maintained, but rather falls back into the external, everyday aesthetic perception of a continuous, "whole" body which can suddenly only be seen for what it is – a terribly injured body.

The sensuous element in modern Western medicine, based on instruments, is that of the opened cadaver, that of anatomy. The birth of clinical medicine, the birth of the institution of the clinic[4] is to be regarded within this framework. From the very beginning of their activity, anatomists have had to push ahead from an everyday aesthetic of the entire body and its external aspect to the medical/technical internal aspect they regard as being functionally relevant. By doing so, they separated themselves from the bodily symbolisms of archaic medicine and let themselves be guided by the ideas of mechanical models. Already centuries ago, they advanced to the boundaries of the macroscopically visible and, led by their mechanical world of ideas, created a closed, functional model of the structures of the human body which to this day appears timeless. Not least, the systematics of the anatomically visible, which was closed already at a very early stage, led Hegel to deny anatomy the status of a science because it did not include new areas of knowledge, but rather merely carried on what had already been developed and systematically closed.[5] It can come as no surprise, either, that macroscopic anatomy today no longer occupies an important place in medicine. The universal practice of autopsying corpses is being rejected by the very representatives of pathological anatomy themselves and limited to special, individually relevant questions. Anatomy today has finally assumed the status of being medically self-evident.

They gathered only on perfect, sunny days. Under the open sky, they rehearsed a new pose befitting the anticipated event. They thought the future was suspended high above, so they postponed their lives to look up. They couldn't know that other futures were being secretly forged on that same sky, right over their upward-pointing noses; they had forgotten the sky had always been a surface for the inscription of mysteries. Most importantly, they had forgotten how the consequences of strain for the integrity of the body are unpredictable – just like the future stressing out above them.

Sie kamen nur an schönen, sonnigen Tagen zusammen. Unter freiem Himmel übten sie eine neue Pose ein, die dem erwarteten Ereignis angemessen war. Sie dachten, die Zukunft hänge hoch über ihren Köpfen in der Schwebe, und sie schoben ihr Leben auf, um nach oben zu sehen. Sie konnten nicht wissen, daß an demselben Himmel, direkt über ihren nach oben zeigenden Nasen, andere Versionen der Zukunft geschmiedet wurden; sie hatten vergessen, daß der Himmel schon immer als Folie für die Einschreibung von Wundern gedient hatte. Vor allem hatten sie vergessen, daß die Folgen der Anspannung für die Unversehrtheit des Körpers nicht vorhersehbar sind – genau wie die Zukunft, die sich über ihnen entspannt.

At the same time, however, we are living in an age of a new body cult, which in turn springs from a hope, brought about by techniques of computer simulation, for the endless repeatability of life, an attempt at a cultural "tuning into the long-term"[6], as Bazon Brock calls it: since as living beings (which means as becoming and passing beings) we cannot extend life endlessly, we have shifted over to putting a spell on time itself by means of repetitive techniques, stopping time in order to form the present into something endless. In this way, the endlessness of life – in the true sense of the word! – begins only and precisely after its end. That is the message of current technical theology. It is the end and the endlessness afterwards which we can now bring about within our lifespans by means of technology. According to Brock, we only need to surrender ourselves to the computer and to the sequential repetitions of the mass media... In any case, it is in this context that the mass lay interest for the anatomically visible aspects of the body can be understood. In the final analysis, one's own anatomy forms an ideal object for a technical perpetuation of this nature, which beyond this appears to combine the virtual with the real. On a long-term basis, life is to be placed on the level of the anatomically visible, which for most already comprises the entire sensually experienceable horizon – in the hopes, naturally, that this is the essential part of life itself. More than ever, we have moved over to perceiving and revealing our bodies through its representations, through its appearance, that is, the external aspect. It should therefore come as no surprise that we want to eternalise the body once again via its representative form – and, if possible, by means of its own, authentic material. Even in the intimate area of the body, not simply natural survival is called for, but rather much more culturally symbolic survival – and this both due to and despite the fact that the illusion of the former is always being created through the latter. The exclusivity with which the external aspect of the body – its appearance – is treated could be termed a body fetishism. This aspect is, however, not only relevant for the fitness-conscious body styling which is becoming increasingly widespread in everyday life. It might also be a hidden motive for the body donations[7] occurring within the framework of plastination. In any case, the large crowds attracted by plastination attest to the fact that even after our death, we want to continue to cut a good figure – a "well-prepared specimen", as it is called. An unsuspected narcissism of material makes its appearance here, which is even prepared to settle for namelessness, for anonymity, as statements from body donors prove.

Today's fetishism is essentially a fetishism of the gaze. It is the sensuous experience of seeing which guarantees (and in a certain sense has always guaranteed) our everyday attitude towards the body as a surface – a symbolised surface which synthesises the sensuous appearance of the body primarily by its appearance. On

the other hand, what is the case with the aesthetic of inner surfaces which the doctor has to come to terms with? Here, nothing is obvious yet; the surgeon first has to lay open a path into the "dark interior of the body". Don't tactile feelings play an essential role here: the "sensitivity for tissue" which has to be developed? Doesn't the sense of touch – which dominates again and again, even over sight – form the primary sensory access to the body here? Here it seems that the tangible structure of the body which is relevant to the profession is created more from the inside than from the external appearance, which is always merely controlling. Old texts, reports of experiences by various surgeons who especially point out that the surgeon's handicraft can be learned in a tactile way, seem to prove this (the dissection of cadavers had been performed with bare hands since the late Middle Ages). However, it should be mentioned in this context as well that the recent development of minimally invasive video surgery refers to a renewed dominance of the sense of sight today, particularly as the tiniest, visually usable spaces are being opened up inside the body by means of miniature lenses. And so, it is not suprising that it is easier to make this sort of operation technique understandable to a lay person who comprehends visually.

But, all things considered, what is the fascination of the new anatomical presentation that the anatomist Gunther von Hagens is pursuing today in his method of plastination? The answer that Bazon Brock gave appears to address several central aspects:

> Plastination conveys a relationship between the inside and the outside of the body as has never yet been the case so authentically – between the living organism and dead matter, between perception and making perceptible, observation and concept. Plastination is, then, to be regarded as being a linguistic operation with which scientific conceptions can be shaped through artistic concepts – in the form of the culturally living person in his claim to duration.[8]

This completes the link to the above-mentioned considerations of Slavoj Žižek: the linguistic operation that has been carried out on Gunther von Hagens's specimens consists in pulling off the skin as a – symbolic – "dress of the flesh". What becomes visible through this, however, is nothing other than a new, form-giving surface consisting of muscles, blood vessels, nerves, and so forth, offering our senses a new symbolic form, a new "dress of the flesh". When we speak here of the inside and outside of the body, the problem of presentation lies precisely in the representation of the inner body as something external, as a body that gives an overall impression and

as such emits signs. And precisely the presence of mimicry in the dissected bodies (lent them by the preservation procedure!) prevents them from simply appearing anatomical and thus aesthetically free of values. Even the detail specimens, such as those of hands, evince a gesture. One can rightly contend that, fundamentally, this can never be entirely avoided. There are no aesthetically neutral objects, and certainly no bodies, either, whose conveyance of signs in everyday life we have learned to read virtually unconsciously. Thus, isn't Gunther von Hagens making a virtue out of necessity by consciously having his exhibited specimens assume a pose? To this end, he implements poses that have already been used in early anatomical drawings, for example in those by Vesal. In this respect, von Hagens can certainly count on a high level of acceptance on the part of the entire public. Here, it is habit which restricts the aesthetic challenge to its classical boundaries. When von Hagens imitates artistic representations of the body, however, for example those of Salvador Dali, he becomes entirely the body aesthete, and it need come as no surprise that he has to face the accusation made by certain critics of being a macabre producer of kitsch. Finally, an aesthetic limited to function can also be found where certain human performances and athletic poses are shown. Here, though, he winds up in the proximity of the "pure" muscle aesthetics of a Leni Riefenstahl.

To whom, then, does an exhibition of this kind address itself? For students of anatomy, the value of the specimens is beyond question. The scientific value can only, however, lie in the new preservation technique[9], and hardly in the already well-known specimen itself, to refer once again to Hegel.

What, however, are the exhibition specimens capable of conveying to a lay public? Is it a better understanding for the medical perspective, or merely a sensation for the medically helpless? Will it lead to a more intensive involvement with medicine, to an emancipation of the patient, or will it only be the exploitation of an internal surface for the purposes of a profane corporeal aesthetic – in the sense of a sensationalist game being played with one's own disgust? And is this, then, aesthetically and/or morally reprehensible?

All these questions will certainly only be answered when an extensive empirical observation of the culturally specific reception of this or similar exhibitions has been carried out. What is certain, however, is that an exhibition of this nature primarily has to be accessible to the anatomical interests of a lay public. It would, nevertheless, already have been worth it if it could in this way provide a better structure for the communication between the perspective of the patient and that of the doctor.

In any case, as was shown exemplarily in the exhibition *Body Worlds*, it is not only one body that exists for us, not simply the body, even when it belongs to

one and the same person. Rather, the most varied textures of bodies reveal themselves to us in our life contexts and relationships, and these are constantly being read differently. On a multitude of levels, the body offers us its surfaces, its "user surfaces", from the most external to the most internal. There, correspondences and "interfaces" of the communication of our experience can be found, an experience which has always been one of the entire body. Although suggested by the customary use of the concept, the body cannot be reduced to one single substance, it does not conceal a substantial secret within. The intimacy of the body is, rather, the product of the relationships it has realised, through which it becomes determined retroactively.

Seen in this way, the medical texture of the body is one among many, although perhaps the one which is the most widely generalised. But precisely this universality also carries the danger of reducing the view of the body selectively and impoverishing it at the same time. This, in any case, would remain in anyone's memory who gives himself over to the "fascination of the genuine" which is offered us by anatomy.

1. The anatomical exhibition of the Heidelberg Institute for Plastination has been shown since 1998 in Mannheim, Japan (four locations), Vienna, and Basle.

2. See Ludwig Wittgenstein, *On Certainty*, ed. G. E. M. Anscombe and G. H. von Wright, Oxford 1969, 1977.

3. Slavoj Žižek, *The Metastases of Enjoyment. Six Essays on Woman and Causality*, London and New York 1994, 116.

4. This is something Michel Foucault in particular has analysed. See Foucault, *The Birth of the Clinic. An Archaeology of Medical Perception*, New York 1994.

5. Georg Wilhelm Friedrich Hegel, preface to *The Phenomenology of the Mind*, ed. George Lichtheim, trans. J. B. Baillie, New York 1967.

6. Bazon Brock, "Bildende Wissenschaft. Das Glück der Dauer", in *Körperwelten*, supplement to catalogue, ed. Institute for Plastination, Heidelberg 1998, 57.

7. During a visit to the exhibition, the viewer is offered the possibility of placing his own body at the disposal of plastination in the form of a "body donation". According to Gunther von Hagens, already more than 500 corpses are currently being stored in his institute.

8. Brock 1998 (see note 6), 63.

9. In the new technique of plastination, the body's cellular water is replaced by plastic, so that the specimens basically consist of plastic.

TWITCH

The Other City of Silence: Disaster and the Petrified Bodies of History

C. Nadia Seremetakis

The City of Statues

Known as a capital of European civilisation, Vienna impressed me with its tall, dark, old buildings, over-ornamented in the usual hyperbole of the Baroque era, which lay heavily on wide, green streets and spacious, paved public squares. Walking through these ample spaces that alternate in slow motion, I traveled through an elegant city immersed in built history. Whether in the streets among the numerous old buildings, in the old university, or in the museums proper, I was stared at from above by dozens of eyes of petrified angels and human figures of monumental proportions that conveyed the sense of everyday life as the theatre of the "unknown" dead. In this city of staring angels of stone and famous but generic dead, public history seemed to be featured as a permanent display of an outward-looking past, a collective memory made for the eye.

Walking through this open air museum, the scopic power[1] of the historical monument struck me. Examples came to mind of historical statues as hieratic figures and models of culture and history that can be linked to the practices of a scopic regime, to the ordering and control of public space. Those figures seemed to survey the city with a blind gaze as if enforcing the cultural attention that must be paid to them. I pondered on whether the scopic power of the historical monument necessarily implies passive memory. Rather, it extracts the daily tribute of active recollection from the people who move under the shadows of the statues. Or could we say that all statuary and buildings constitute a vast laboratory of public memory as legacy and inheritance, and thus are meant to persist and persevere as an active force in the present? In Wim Wender's film Wings of Desire, the angels who monitor the events, lives, and thoughts of Berliners tend to roost and congregate on the heights of monuments that overlook Berlin; they survey the city space as they recite to themselves

The intricate cooperation of muscle and
nerve fibers produce the means by which
an organism interacts with its surrounding
environment. That cooperation has a name,
which is movement. When the environment
itself enters into fibrillation, it is the whole
system (organism/environment) that
becomes convulsive. The body absorbs all
the shocks, only to release them later on,
in another time-space, as unforeseen
motions, reorganising as much as outlining
the distribution of violence in the nervous
system.

Das komplizierte Zusammenspiel von
Muskeln und Nervenfasern ermöglicht dem
Organismus, mit seiner Umwelt zu inter-
agieren. Dieses Zusammenspiel hat einen
Namen: Bewegung. Wenn die Umwelt selbst
zu flimmern beginnt, wird das ganze System
(Organismus/Umwelt) von Zuckungen
befallen. Der Körper absorbiert all die
Erschütterungen, nur um sie später wieder
abzugeben, zu einer anderen Zeit, in einem
anderen Raum, als unvorhergesehene Bewe-
gungen, die die Verteilung der Gewalt im
Nervensystem neu organisieren und zu-
gleich vorzeichnen.

the entire history of the city from Neolithic times to modernity. We could say that in Vienna too, as in many other European cities, statues mark out the topography of the corporate body of the city, identifying its crucial intersections and centres. By their positioning in the city, they demarcate where and when public remembering should occur, they index what is culturally central and what is not. Was not the destruction of the statues of Lenin and Stalin in Central and Eastern Europe with the fall of communist regimes, or the gathering and storing of public statues in an obscure park on the outskirts of the city in Budapest, an example of this? By their topographic exile, their lack of any claims on the truth of history was sealed.

Intellectual history in Vienna seemed to be embodied as much in the modern primitivism of the cult of the professorial head as in books and lectures. The decapitated bronze or stone heads of centuries of professors in the old university were mounted on the walls of a "sacred" place, set aside for their observation and appreciation. Apparently, in the 18th, 19th, and a good part of this century, no other part of these thinkers' and writers' bodies required recognition or visibility. Grafted on to the historicising corporate body of the city, the bodies of these intellectuals were historically invisible below the head. Their cultural memorialisation was identical to that part of the body where all their thought was assumed to take place. The normativity of such statuary, thus, does not seem to be limited to the marking of public spaces or the recall of historical events, but it encompasses entire anthropologies – that is, notions of what it means to be human.

Walking through the clean, orderly public squares, I enjoyed numerous spontaneous cultural happenings. In the middle of crowds, visitors and passers-by, political demonstrations and campaigns, the "personification of the statue" caught my eye (fig. 1). Young people played at and emulated the isolated statue – a tall, immobile body frozen in mid-air and mid-gesture. Was this an attempt of the living to elevate themselves from the flux of everyday life to the realm of statuary, the realm of public history? Or perhaps these poses humanised the entity of the statue by integrating the latter into everyday life? Was this mimesis meant to enable one to remember the lonely statue that could no longer incite in the crowd the historical memory it was intended to perpetuate? Or was petrifaction the primary cultural and environmental mode of the city to the extent that even the living needed to emulate and simulate the dead and the immobile?

Was this tendency towards the monumental pose nothing more than performance art? Perhaps, rethinking Adorno[2], it could also be seen as a tactile imitation of an intimidating and possibly aggressive historical other, the monument, which threatens the potential victim with historical petrifaction. Thus the potential victim

Fig.1 Playing statue in Vienna.

imitates, like a chameleon, the very historical negation by which he is threatened. Adorno posited the imitation of inanimate objects (such as stones or leaves) by animals under inferred physical threat as a model and anticipation of the phenomena of reification by which humans transformed themselves into things and objects in a world that identified reason with the aggressive control, usage, and administration of things.[3] Perhaps the performance artists in Vienna imitate the statues, not in order to come under the power of the monument but to appropriate the cultural authority of the ritualised and petrified pose for themselves – a subversive mimesis which is polysemic, implying homage to the statues while undermining their authority through parody.

Perhaps the poseurs in Vienna were also making statements about the public history that was inscribed into the very body of the city, in its buildings as inhabited monuments, and in the anthropomorphic monumental statuary that marked crucial sites. By establishing a mimetic relation to the statue and the monumental, then, performance artists were elevating themselves to the enforced memory that the collation of statues represented, and at the same time, by being historical non-entities themselves, they indicated the actual anonymous, generic quality of many of these ornaments in urban space. They either emptied the statues of the rhetoric of their historical content or confirmed the current lack of historical specificity in the statues. In either case, they pointed not to what each statue recalled, but to the fact that, irrespective of historical content, and even in the absence of any historical information whatsoever, public memory is intended as enforceable memory. And it was the statue's function to do just that, despite the defacement of its historical actuality. Statues, in this case, were icons of mnemonic enforcement even though the details of what they enforced were lost, or were never really necessary. In *Lost Words and Lost Worlds*, Allan Pred addressed this dimension of statuary as public memory.[4] He documented how the 19th-century Swedish working class recoded all of the royal squares and much of the aristocratic statuary of Stockholm with scatological terms, that, like modern-day grafitti, linguistically defaced the historical and usually royal personages and battles these edifices and topographies were meant to commemorate. Perhaps Vienna's contemporary pose artists, as much as Pred's Swedish workers and their scatological topography, indicate that beneath and beyond the supposed solidity and permanence of public memory run other cross-currents and counter-memories that relativise and place in cultural parenthesis the event histories and aristocratic biographies that people are told to remember.

Among the popular postcards sold in the local stores of Vienna, my eye stopped at those featuring a statue, such as a young woman in a café drinking her coffee in the

company of a male statue sitting at her table (fig. 2), or heads of two statues in a frozen, tender posture in a window display, their lips almost touching in a smile of contentment (fig. 3). Was this perhaps another attempt to humanise the statue, to integrate it into everyday life? And, in turn, to socialise humans to these effigies through the sharing of intimate social space?

The benign facial expressions of these statues brought to mind Bahktinian notions of the hegemonic, statuesque, Classical body as a smooth, contoured surface without orifices and the Classical body's other, the carnivalesque body, the scatological, orificial body in its full senses, the body that leaks and ruptures and cannot be posed.[5] The 19th-century Swedish workers, mentioned earlier, transformed the Classical corpus of Stockholm's monuments into a subverting carnivalesque body that refracted their real urban experience to a much greater extent than famous and distant battles and monarchs.

Imagine if an earthquake were to set all these frozen bodies in motion, I thought. Those who have experienced earthquakes can sense motion in every stillness and see impermanence in every human achievement. A flashback brought me back to Kalamata, the lovely coastal city of the southern Peloponnese in Greece, which was completely destroyed by a devastating earthquake in 1986. I re-experienced that earthquake ten years later, when the city, having long since been rebuilt, decided to commemorate the past and celebrate the future.

Excavating Private Memory
We could say that there are two ways of looking at the social production of the past. A sense of the past is produced through public representations. This involves a public "theatre" of history a public stage and an audience – for the enacting of dramas. This stage is occupied by many actors who often speak from contradictory scripts, the agents and agencies of memory that construct this public historical sphere and control access to the means of publication. They constitute "the historical apparatus" that makes up "the field of public representations of history".

In thinking about the ways in which such official representations affect individual or group conceptions of the past, we might speak of "dominant memory". The term refers to the power and pervasion of certain historical representations, their connection with dominant institutions, and the part they play in winning consent. But the dominant memory of public institutions can also generate forgetfulness and inattention, for these public sites of memory select what is to be remembered and how it is to be remembered. But are there alternative memories of collective experience other than that archived by public institutions[6] and the public media?

Figs. 2, 3 Popular postcards in Vienna

Another way of looking at the production of the past is through private memory (which also may be collective and shared), and it draws attention to quite different processes. A knowledge of the past and the present is also produced in the course of everyday life. It is embedded in place and artefacts that are stratigraphies of personal and social experience. I am proposing that memory is not merely a resource pool of ideas; it has material and sensory coordinates that are part of the living membrane of a city. Memory can be found in the emotional connection to particular spaces that have their own biographies and carry biographies within them; memory can be found embedded and miniaturised in objects that trigger deep emotions and narratives; memory is linked to sounds, aroma, and sights.[7] We take this enmeshed memory for granted until the material supports that stitch memory to person and place are torn out from under us, when these spaces suddenly vanish under debris, when interiors of buildings and persons suddenly become devastated exteriors, and when the past itself is buried under the weight of destruction occurring in the present. Then we are not only given events we prefer not to recall, but we are separated from the material of memory that enables an entire city to remember what it was before the disaster.

If memory is sensory and embedded in matter, it comes in pieces, not as a totality. The excavation and assemblage of these fragments is an archaeological process; it does not show all at once, it is a peeling away of layers, the identification and exploration of a multiple stratigraphy. Public and personal memory invest various locales of a city with sensory capacities and powers to revoke, recall, animate, mobilise, calm, impress, order, and rationalise. A city-destroying disaster, like an earthquake, results in the loss of such sensory organs. The urban space dismembered by disaster becomes a body without organs.

Bodies in Ruins

This became apparent to me in Kalamata as, ten years after its traumatic earthquake, I began searching for the other city, the now silent "earthquake city" that still today co-exists with the city that has been rebuilt and restored since the 1986 catastrophe. The authorities of the city and region had decided to commemorate this catastrophe and rebirth, and I was asked to propose and create an historical-cultural event for the occasion.[8] I conducted an urban ethnography of the memories of the quake as inscribed in the city's topography and the consciousness of its inhabitants, which was meant to culminate in a public ethnography – a participatory process and a public exhibition of the social memory of Kalamata before, during, and immediately after its earthquake.

In the course of visiting cemeteries, abandoned schools, and closed-down, ruined factories – sites of urban amnesia – I began to stumble upon fossils of the disaster, a

hidden memory layer of the city itself frozen in limbo. At the same time, citizens brought me objects full of memory, fragments from domestic interiors such as ancestral photographs, curios and bric-a-brac from shelves and cabinets such as an antique phonograph or an old photo of the city square, objects that they had saved all these years, objects of the heart that in themselves represented small triumphs over the attack on memory and identity afflicted by the disaster. Between these "excavation" visits I began to remember a different city, a double of the city rebuilt, a twin city that harbours both its own death and resurrection, a city that bears witness to the birth and rebirth of the city of Kalamata, a city in a transitive state.

These objects, once hidden in private space and private memory and then collected and curated by the citizens themselves, created public history when brought out of isolation in their respective homes and linked and presented together. They were private objects, embodying private experiences, memories, and emotions which were previously not represented in public, but were now placed and staged in the exhibit hall next to the public official record of the earthquake, such as scientific instruments, reports, films, recordings of media and of scientific and governmental institutions.

During the event, the donors visited their objects at the exhibit and hundreds of school kids observed, touched, and dialogued with these objects and the accompanying oral histories (figs. 4, 5, 6). The re-membering of the earthquake of '86 in the drawings of visiting school children transformed the exhibit into a learning space.[9] The mobilisation of institutions and media to excavate their own materials for the exhibition made the event a participatory museum of the present – that is, a museum in action, one that was not presenting finished cultural objects from the distant past or foreign parts. This mobilisation of memory and the creation of a participatory museum of the present bear witness to culture in process and to participants as social actors in this process. Participants used the exhibit as a vehicle to recognise their relation to a traumatic and silenced past.

The photographic image of the city in ruins was another eloquent statement. The pictures had been taken by local, amateur photographers and professionals inhabiting Kalamata in the wake of the earthquake. They revealed parts of buildings detached from each other, skeletal buildings, buildings turned inside out, and the exiled people like the edifices' flesh, cut off and separated from the ruined building. This was an exposure of the devastated interiors of both the persons and the environment they once called home. A pair of glasses lying on top of some scattered papers in the middle of the ruined home gave a freeze-frame snapshot of private life, now vanished, in the moment before its death in the earthquake.

Figs. 4, 5, 6 Citizens visiting and participating in the 1996 commemorative event of the 1986 earthquake in Kalamata, Greece. Photos: Yannis Papdopoulos

The skeletal building struck me as an ironic image. It was a spontaneous historical monument documenting the action of seismic violence. It is also the petrified image of the impermanence of human achievement and effort, of its erasure by nature, and of the vanquishing of modernity. For Walter Benjamin, modernity was always already ruins since its meat-narrative was the eternal return of the new and the incessant creation of the outmoded.[10] But in Kalamata after the earthquake, we briefly witnessed modernity's replacement – the post-disaster city was the Postmodern city *par excellence* where the ruins themselves were an outdoor museum without walls or modernity's limits, that is, apocalypse, death, and fragmentation. Here Baudrillard's argument about the museumification of social reality prevails.[11] The apocalyptic cannot be rendered into a museum exhibit, whether it be the Shoah or nuclear holocaust[12], for we are in the midst of our own living museum as we drift among the debris of modernity. Beheaded and broken sculptures scattered in cemeteries, squares, and art spaces added to the allegorical ambiance of the post-earthquake ruin (figs. 7, 8, 9). A photograph of a beheaded sculpture turned sideways with the ocean and sea cliffs as backdrop made me turn the picture right side up. But the nature in the background immediately indicated the right position. The headless body evoked the destruction or incompleteness of human identity after the earthquake while nature – the ocean and sea cliffs – remains whole, complete, and indifferent.

Ruins such as these confront us with an image of the present suddenly and unexpectedly mutated into the past. The event of destruction exiles its victims from their own present. The ruined and abandoned buildings are that present slipping into the past, into otherness; they can never be recovered and experienced in quite the same way. Even if we return to reinhabit these buildings, they will be restored buildings, thus altered buildings. The edifices shown in the photographic record of the earthquake were buildings in pain. They were wounded bodies of our collective life, bleeding memories of the past and of that 1986 present which the earthquake interrupted.

Ruins give a snapshot of a present as past and force us to take a different stance on time. They freeze the present and confront us with a petrified world, a city full of hieroglyphs that present our past lives in a new language we have yet to decipher. We read the cracks in the walls as the earthquake is rewriting our once-present lives; we stare at the hollowed-out spaces for traces of the activities and relations that once made them intimate parts of our existence. We try to read the message that we must now live in a present without these intimate counterparts of our selves, without this familiar stage for our actions, without these environmental shadows of our persona and embodiment.

Our response is to heal these buildings in pain as a way of healing our selves and

Figs. 7, 8, 9 Fragments and heads of tomb sculptures from Kalamata cemetery, broken by the earthquake of 1986.

the body of the city. We provide them with new supportive scaffolding, new exo-skeletons that are meant to keep them alive, we amputate dysfunctional parts to save the whole, and often execute buildings, thus sealing the destruction began by nature. We rescue elegant and beautiful fragments of the vanished buildings in the hope that they can be refitted to a future city that is still in the making. We seek a place for the past in the future.

And as these interventions continue for long as acts of remembrance that try to recover and revitalise what made the city a breathing body and a membrane for our lives, the scattered shards and fragments of burial stones and grave memorials in the Kalamata cemetery reveal that not only the present is fractured or lost, but also the vehicles by which we remember the past. An old photograph was abandoned with the cemetery debris. The photo, from the first decades of this century, showed a man with a long mustache dressed in a suit and boutonnière. It had not been re-claimed by his descendants. Had the person been forgotten with the picture, now that the place that marked his death was lost?

Entire histories and identities were buried with the earthquake, and at the same time, previously buried pasts were suddenly thrown up, objects appeared that had been lost, items that reminded us of earlier inhabitants of this site or revealed a present that had been hidden away. Walking through the fallen walls of the army camp of the area, we stumbled across fine graffiti covering whole interiors unknown to most, written by anonymous draftees as private ruminations which were now exposed to the public eye. The urban environment was transformed into an archaeo-logical stratigraphy and forced us all to become excavators of our lives and past. Like Wender's angels, we could survey the entire history of the city in the forms of its entrails and innards vomited up and exposed in disarray. Like his angels, we whispered the history to ourselves, we strove to locate these displaced artefacts in order, to resituate a memory and an identity that had also been torn asunder.

The City without Walls

After the earthquake the city was replaced by a tent city. Thousands of tents in a row made these encampments a city within a city. The instability and provisional character of the tents stood in sharp contrast to the heavy ruins, expressive of past permanence. The solidity of the walls of the ruined city, which once guaranteed a private life of discretion, was replaced by the tents, sections of which were made of semi-transparent nylon, through which the people could be seen. If the ruined stone enclosure signifies the termination of private and domestic life by the catastrophe, the transparency of the tents speaks to the fact that the private is an ongoing casualty

of the disaster and the last area usually to receive rehabilitation and restoration. The hierarchy of human needs that emergency relief recognises and implements – such as medical care, food, water, clothing, sanitation – most likely does not include the recovery of private life; earthquake victims are irrevocably public persons.

Not only recollections of people but also collections of pictures by local photographers portray the people of the tents trying in these conditions to reinstall some aspects of past normalcy of their lives. The most mundane acts became crucial and resonant. Consider for instance the image of two women shampooing each other. Actions that partake of the conventional and yet, because of their setting, were marked all the more as strange for they resonated a normalcy that no longer existed. It is as if by engaging in the day-to-day activities of living and surviving in a tent city, people silently and slowly erected their own habitat by accumulating gestures of normalcy in miniature – cooking, eating, shopping, dressing, conversing. They lived both in the tent city and in a city of the imagination – the imaginary normal.

The recollections and images that make the most vivid impression are those of the elderly and the children. The elderly are mostly shown lost in space. A man looking from the small square "window" of a tent appears like an isolated face in the midst of a vast canvas desert. Elderly women standing next to cooking pots with body postures that show the extent to which they were exiled from the customary spaces of food preparation. An old couple in the supermarket surrounded by empty shelves and vacant food baskets go hand in hand with an elderly man who is sitting with his head bent over and resting on his crossed arms in the midst of the abandoned market – signifying the absence of the rich life and activity, the colour and aroma that had once been there. The elderly, with their body postures, faces, and discourse, express most eloquently that they remained violently unreconciled with the tents and with what they lost; they were angry with memory.

The children also despaired, but their bodies adjusted and adapted more easily both to the loss of space and the space that replaced it. They entered the provisional and transitory character of life after the collective, natural disaster and familiarised the surprising and the unexpected. They used play and their imagination to create new places in which their bodies could relax, rest, and find a habitat. The children discovered permanence and stability in the spaces of their imagination and in their capacity to imagine. They played with the tents, transforming them into something other. The image of children playing hide-

and-seek or peekaboo was commonplace: in one photo three children crouch with their heads lined up one above the other in a vertical row and peer out of the tent opening – the children turned the tents into a carnival mask, a costume, and a play space. The Bahktinian body of the disaster-city was a fertile landscape. Children can take the most unexpected spaces and transform them into playgrounds and sites for the imaginary. In other photos, kids standing on the roof of a building that overlooks the devastated city blow up balloons – in a city that has been broken down, they are playing with what floats. Others turned their tent into an imaginary mountain which could be climbed or a treehouse on which one could sit and look down upon the world. Children can exploit the very precariousness of built structures. The lack of solidity and the impermanence after the quake were naturalised as the children walked around balancing on ruined walls or balancing debris on their heads.

Children in Greece always used their bodies and imaginations to explore and insert themselves into spaces of ruins, abandoned or unfinished buildings in their neighbourhood.[13] After the quake in Kalamata, through spatial play and exploration, they investigated what new identities this space of ruins could offer. The ruins mediated by play passed through the children's bodies as building blocks of new spatial and topographic identities. The children rebuilt with the tools they had at hand and constructed a city of the fantastic – the space of alterity, the city of tents, was remade into a second alterity. They transformed the strange and made it stranger, thereby rejecting the given conditions of post-disaster existence that was arbitrarily imposed on them and inaugurating their own rehabilitation.

At first they played, but once they had remodeled their bodies and selves to the new space, they also read and studied; they cultivated a seriousness of their present state, which was different than the seriousness of despair and mourning of the elders. It was as if once they had remodeled their bodies around this new space, they got busy with the task of re-membering the present.

There was that single, powerful image of the girl who stares quizzically at the photographer as she sits assertively on the stone banister of a ruined building with one of the central scenes of destruction behind, her legs carelessly crossed, declaring with body and face, "This is still my place", "still my city". She, at least, had returned with a determination that hints at the inevitability of the future reoccupation and restoration of the city and its many lives by the others who will follow in her tracks.

utes to Make
usand Copies.

od Time

g Systems?

n

This Just M

World's Fas

– Wah

The intensified perception that all limits
are destined to be surpassed finds its
most abominable manifestation in the
contemporary, telegenic, smooth-talking
ultraconservative.

Die zunehmende Einsicht, daß alle Grenzen
dazu bestimmt sind, überschritten zu wer-
den, findet ihre widerwärtigste Manifesta-
tion in dem zeitgenössischen Typus des te-
legenen, wortgewandten Ultrakonservativen.

The Objects of Memory

The problem in the pursuit of "popular memory" is to explore by which means social memory is produced.[14] The exhibit I planned and designed with the involvement of the citizens attempted to answer this by examining the popular and spontaneous ways in which the people of Kalamata recorded the events of the earthquake; what strategies, practices, and materials they used to preserve or to recover the past and the immediate present of Kalamata in 1986, both of which were destroyed by the earthquake. So this exhibit was less a commemoration of the disaster than it was a commemoration of the popular memory of that event and more particularly of the struggle for memory in wake of the defacement of the earthquake. In this context, the acts, forms, and vehicles of popular memory were and are integral elements of the post-earthquake reconstruction of the city: popular memory was as much a collective contribution as the work of clearing and rebuilding. The exhibition sought to explore the city of the imagination built and recollected by popular memory.

Thus memory was the site of excavation in this exhibit. And memory, as stated above, was defined as embedded in sensory experience, in matter, which made this exhibit an archaeology of memory. The assemblage of these fragments was not their aestheticisation, but it re-enacted the process by which the people of Kalamata reassembled their lives and their city from the fragments made by the earthquake – a process we could term the "poetics of fragments" because it focused on how the people restored meaning, order, pattern, and aesthetics to their lives in the aftermath of disaster.

This exhibition sought to make a space and opening for the memory of the city before the disaster and of that moment when all that housed the city's memories were put into crisis. That moment of memory under threat was an episode of disaster that should also be recalled. For until we appreciate what was taken away from the city in 1986, we cannot fully acknowledge what has been restored and what still needs restoration. Thus the exhibition proposed that Kalamata was not rebuilt as an act of forgetting, but was rebuilt with multiple memories of all that existed before the quake and with the memories of the quake itself.

We must understand that the archaeological process does not happen all at once; it is a peeling away of layers, the identification and exploration of multiple stratigraphy. This exhibition was like an archaeological dig, and we only penetrated and exposed to public view some layers of the history and memory of the 1986 quake, while other layers remain to be uncovered. Once the

ht Be The
st Shaver.

SA

Most moms don't
in the morning.
90 seconds to mal
Oatmeal – so i
and easy as

– Quak

exhibit began to cohere into a meaningful whole, people and institutions contacted me, declaring they did not want to be left out. In fact, they were saying, "I want to be remembered." They saw the exhibit as an event that they had to reclaim for their personal and institutional memory. They often interpreted this event as one that would definitively write the public memory of the earthquake. Yet this exhibition was mounted in opposition to any closing of memory and history or any final monopolisation of the past by a single memory, narrative, or institution. It was structured to accommodate many narratives and memories.

Cultural documentation as a form of archaeology takes time. It requires research, careful ethnographic research. Ethnographic documentation frequently deals with experiences, histories, practices that have been devalued, abandoned, and forgotten – this pertains to much of the popular memory of the earthquake, thus the recovery of these abandoned memories and experiences becomes a long process of recovery. Too often we delegate the task of archiving our history to public institutions and specialists and thus many things are left out and forgotten. Cultural documentation, particularly of popular memory, is sensitised to the process of official forgetting and works as a counter-memory to this inattention to everyday experience and lives;[15] but memory, like an entire city, can vanish overnight, and the rebuilding of a city takes time and has to be done brick by brick, fragment by fragment. The 1996 commemoration challenged the distinction and the hierarchy between public and private memory and history, and sought to rearticulate that which had been silenced. A public space was created for the presentation of both official public memory and alternative memories.

By blurring the distinction between public history and private memory, the exhibit transformed the latter into a particular type of poignant public history, a public chronicle of everyday life prior to, during, and immediately after the earthquake. This transformation of private memory into public history occurred through the material vehicles of objects of memory. Some survivors by chance or intent had rescued the old as if such antique objects could replenish the temporal continuity and stability that the quake had ruptured. They used these artefacts to search for threads through time to lead them out of the labyrinth of disasters and destruction. There was the small antique oil lamp that the contributor stated was originally from his grandmother's farm: "I had brought it to our home in Kalamata that afternoon before the earthquake. The night after the earthquake [after the electricity had been shut off] we needed it. We lived

ave a lot of time

it only takes

Instant Quaker

just as quick

ld cereal.

Oats

What Are You

Life in the Fast

the Breathtaking S

and Performance

a U.S. Roboti

The Busin

– US R

under the light of this small oil lamp." There was the framed needlework, given by a middle aged man: "My mother's last needlepoint. She was embroidering it when she died and left this life. It is incomplete." A woman contributed a kerosene lamp of the last century, a decorated wind-up clock, and a tea saucer:

> I remember we were a company of twelve, all happy [the night of the earthquake], talking at the harbour as the passenger ferry was sailing for its first trip. That was when the misfortune came, it was nine o'clock at night. Right in front of me was the doctor's young child with his little hands trying to reach out, with his arms spread, screaming, "Earthquake!'" But our hands couldn't reach each other for we were moving left and right, back and forth. And staring at his little feet, I saw the earth splitting open. A few steps down was the ocean. "We will drown," I thought. Bad experiences, I don't want to remember them, yet we must, in order to be prepared, all of us, especially young people. Ever since then I walk around with a little flashlight in my handbag and the matches are still by my bedside. We had no electricity after the earthquake; we lit up this little lamp. It is very old, my grandmother's from the days when there was no electric light in Kalamata. When I look at it and the flashlight, I recall the days of the earthquake. What I do not want to see any more are tents, any kind of tents.

In one corner of the exhibit, among 19th-century window shutters and wooden doors that had been rescued from now-vanished houses, there was a framed, turn-of-the-century family photograph with these comments: "A photograph of my family. Here my father is thirty or thirty-five years old, he died in 1968 when he was eighty-six." An elderly woman contributed a card and shuttle from a loom and a wooden spigot from a wine barrel, saying: "A few tracks I kept, remainders. I will give you these [for the exhibit] but no other objects; I cannot separate from all of them for that long."

In my attempt to assemble a public exhibit, I discovered that some citizens had assembled their own secret museums. A middle-aged man contributed a broken, wooden tobacco pipe, a shard of a ceramic vase, a china coffee cup minus its saucer, a glass bottle stopper minus its bottle:

> These objects tell their own story. I have them on display in a cupboard at home; I call it "the earthquake display". What can we say today? The earthquake was a shattering event. Do you know what it means to be looking for your own wife in the dark when she has lost her voice?

VERTIGO

Perhaps the most startling image of absence and loss was the contribution of brass keys by an elderly man: "The keys to our home now destroyed" (fig. 10). And there was the chair that was brought by a bank clerk with the note stating: "This arm chair is made out of the fragments of three others that the earthquake rendered useless", and a painting that featured a coat and hat which were draped as if the body that had worn these items had suddenly vanished: "I had painted him in 1984; he appeared from under the ruins of my house that the earthquake piled up – the 'Invisible Man'."

Re-Membering the Present

As I am writing this piece, Turkey, Greece, and Taiwan have been shaken by earthquakes in various parts. Writing history from the point of view of such devastating events may no longer be the writing of the history of exceptional events as previously assumed; rather it may offer us a different perspective on social experience, opening up a field of social relations and exchanges within and among cultures.

To a certain degree, in Habsburgian Vienna there was an attempt to write history through structures of permanence. The same holds true in Greece with its attachment to Classical Antiquity. Except that now this type of memorialisation and the entire ideology of the monument have been rendered especially problematic since the history of our present is marked by national and international disasters. History can no longer be written with structures of permanence alone. It has become more apparent than ever that history emerges out of precariousness, contingency, and self-organising randomness; there is no hidden rationality or directional spirit of history. In the face of all these processes, we will either end up living without history or subsist without long term-memory, in the succession of recent events, each one erasing the preceding. It is no wonder that certain nation-states hold on desperately to archaic, authenticating history and renew their modern legitimacy with the forged past.[16] Yet both responses bring dissatisfaction.

We need different methods for capturing historical experience and for transforming it into public knowledge. The commemorating event of the quake of '86 is perhaps partly an answer. The intervention of the Viennese artists is perhaps another part of the answer, but others are needed.

The commonality between the event commemorating the earthquake and the performance artists of Vienna is the emerging need to bridge the ever-increasing distance between official history and everyday experience. One site where this gap can be bridged is the human body, both the experiential body and the symbolic body. This symbolisation can be encountered not only in the body proper as in the practice

Fig. 10 **Objects of Memory** from the exhibits of the 1996 commemorative event of the 1986 earthquake in Kalamata.

Urbanscapes stretch out as our new horizons, replacing and flattening out the old panoramic curve. The urban delivers space as continuous linearity and renders place as detachable form. Everywhere feels here. As in a dream, the urbanscape stumbles in.

Stadtlandschaften bilden unseren neuen Horizont und ersetzen und planieren die Wölbung des alten Panoramas. Das Städtische liefert Raum als ununterbrochene Linearität und gibt den Ort als eine ablösbare Form wieder. Alles kommt einem wie hier vor. Wie in einem Traum stolpert die Stadtlandschaft herein.

of performance artists, but also in various structures and relations with the built environment, the architectural surroundings, and the spatial order of the city.

The lessons of Kalamata and the implicit critique performed by the Viennese artists point to the fact that the built environment and architectural space have to abandon much of their monumental aspirations and tendency towards petrifaction and permanence, and that the built environment has to become more of a living membrane and empathic skin upon which citizens can write and capture the flux, immediacy, and indeterminacy of everyday life. We must learn to cultivate and to live in unfinished cities and cities of polyphonic history. And that is perhaps what the current state of our entire eco-system can teach us. Here geography and history reflect each other; the shifting tectonic plates are geological correlates of the ever-shifting foundations of historical consciousness. And as my hand tries to freeze this last thought on paper, my feet sense another tremor from the depths of the earth.

1. Allen Feldman, "Violence and Vision: The Prosthetics and Aesthetics of Terror", *Public Culture*, no. 24, 1977.

2. Theodor Adorno, *Negative Dialectics*, New York 1973.

3. Michael Cahn, "Subversive Mimesis: Theodore W. Adorno and the Modern Impasse of Critique", in *Mimesis in Contemporary Theory: An Interdisciplinary Approach*, ed. Mihai Spariosa, Philadelphia 1984.

4. Allan Pred, *Lost Words and Lost Worlds: Modernity and the Language of Everyday Life in Late Nineteenth-Century Stockholm*, Cambridge 1990.

5. Mikhail Bakhtin, *Rabelais and His World*, trans. H. Iswolsky, Bloomington, Ind. 1988.

6. C. Nadia Seremetakis, *Crossing the Body: Culture, History and Gender in Greece*, Athens 1997 (in Greek).

7. Seremetakis, *The Senses Still: Perception and Memory as Material Culture in Modernity*, Chicago 1996. Also published in Greek: Athens 1997.

8. Seremetakis, "Development, Culture and Paedeia in the Region of Messinia (Southern Peloponnese)", *Eptacyclos*, Sept. 1998 - Jan. 1999, no. 2, Athens (in Greek).

9. Ibid.

10. For Benjamin, modernity emerges in the form of ruins: the ruins of prior historical periods, cultures, and human experience. This framework allowed Benjamin to treat modernity as allegory. See also Susan Buck-Morss, *The Dialectics of Seeing: Walter Benjamin and the Arcades Project*, Cambridge, Mass. 1989.

11. Jean Baudrillard, *Le Système des Objets*, Paris 1968.

12. Seremetakis and Jonas Frykman, eds., *Identities in Pain*, Lund, Sweden 1998.

13. Seremetakis, "The Memory of the Senses, Part II: Still Acts", in Seremetakis 1996 (note 7).

14. Seremetakis *The Last Word: Women, Death and Divination in Inner Mani*, Chicago 1991. Also published in Greek: Athens 1994.

15. Seremetakis, "Memories of the Aftermath: Violence, Post-traumatic Stress and Cultural Transition to Democracy", in *Women and the Politics of Peace*, ed. Centre for Women's Studies, Zagreb 1977 (in English and Croatian).

16. Seremetakis 1996 (note 7).

Still: On the Vibratile Microscopy of Dance

André Lepecki

At the still point of the turning world. Neither flesh nor fleshless;
Neither from nor towards; at the still point, there the dance is,
But neither arrest nor movement. And do not call it fixity,
Where past and future are gathered. Neither movement from nor towards,
Neither ascent nor decline. Except for the point, the still point,
There would be no dance, and there is only the dance.
I can only say, *there* we have been: but cannot say where.
And I cannot say, how long, for that is to place it in time.
– T.S. Eliot, from "Burnt Norton" in *Four Quartets*

There we have been. Emphatically, we have been. Not in fixity, however. Not arrested, but also not quite in motion. Neither pushing towards a goal nor arriving from some faraway land, neither ascending to the heavens nor descending to the netherworlds. *There* we once were, we are told, and *there* we have been – less still than *within* stillness proper. Such a stillness, which denies fixation, proposes an altogether different notion of itself. In that nowhere, in that unlocatable place both in space and especially in time, *there* a force initiates its quiet work. At the still point that is neither fixity nor motion lies the stillness that initiates dance – which is, we are told, only all. This stillness does not pose; it is not fixation. What could be the ontological status of such a still point which, at the moment, appears to possess all the vibratile contours of a fluttering *punctum* – that gaping wound, teasingly arresting and pricking our attention, as Barthes would write, that hole at the surface of the image, propelling signification into vertiginous motion while it stays put, vibrating, *there*.[1] What act, labour, or thought could such a vibrating stillness perform in the improbable but nevertheless

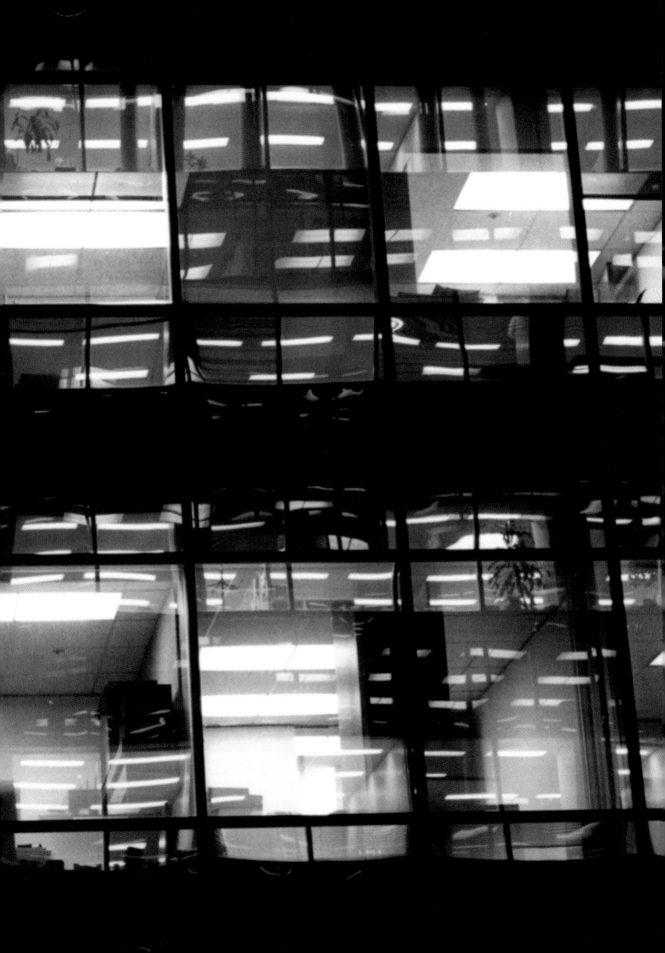

quite possible eventuality of its unlocatable *there* becoming corporeal? To answer these questions is not only to address the poem's intriguing identification and collapse of its most enigmatic element – a non-fixed stillness – with dance, but it is to identify dance's project as gradually moving along and within this restless stillness, as dance enters into modernity.

Eliot's fragment suggests dance and stillness are unavoidable problems for an assessment of our turning world. An assessment that could not be completed without a critique of the relationship between what is known as "modern subjectivity" and that intriguing dancing stillness. That is, without a critique of the relationship between the subject of modernity and its body, its body-image (and those surrounding the subject), and the motions which body and body-images initiate and allow the subject to engage in. The formation of modern dance and of modern subjectivity partake of the same generative problematics of embodiment and subjection, namely the continuous probing of actions suitable for the body to perform while it strives to maintain a subjective integrity attached to a recognisable body-image. Moreover, the parallel stories modernity and its foundational art *par excellence* – choreography – which tell us about the invention of the subject and the rehearsal of possible body images for that subject to incorporate and move in, have the problem of stillness at their core. In these histories, as well as in this essay, stillness emerges as a shared, ghostly zone for subject formation and bodily experimentation – a slippery force field of history turning itself over. *There*.

Eliot posits at the core of dance, of the world, of "everything" a mysterious *there* – non-locatable, not subjected to chronometrics, still, yet never fixed. Under these terms, the poem forbids us to ask "where" this elusive *there* might be located; rather, it forces us to ask "what" could there be? Let's assume it is corporeal, so one may at least be able to recognise its presence. One then has to describe this corporeality, and the question becomes: How does one describe a body? Firstly, the body inherited from the passage into modernity has a *proprietary* relationship to "its" subject (the body always "belongs" to a self); secondly, modernity allows the subject to experience its body's surface as a screen rendering the subject to the world as an *image*; and thirdly, the body's surface as an image is experienced as a *detachable organ*, permanently floating between subjectivity, alterity, and the experience of the corporeal, as an ill-fitted mask. In this sense, the modern individual, that "entity closed within itself, withdrawing the feeling of itself from an image lived as an essence"[2], can only *be* within the confined, unlocatable gap between subjectivity (experienced as a core) and the ill-fitted mask of the body image. The experience of modern subjectivity takes place as a confined, circular movement within this uncharted, atemporal emptiness – in the mysterious

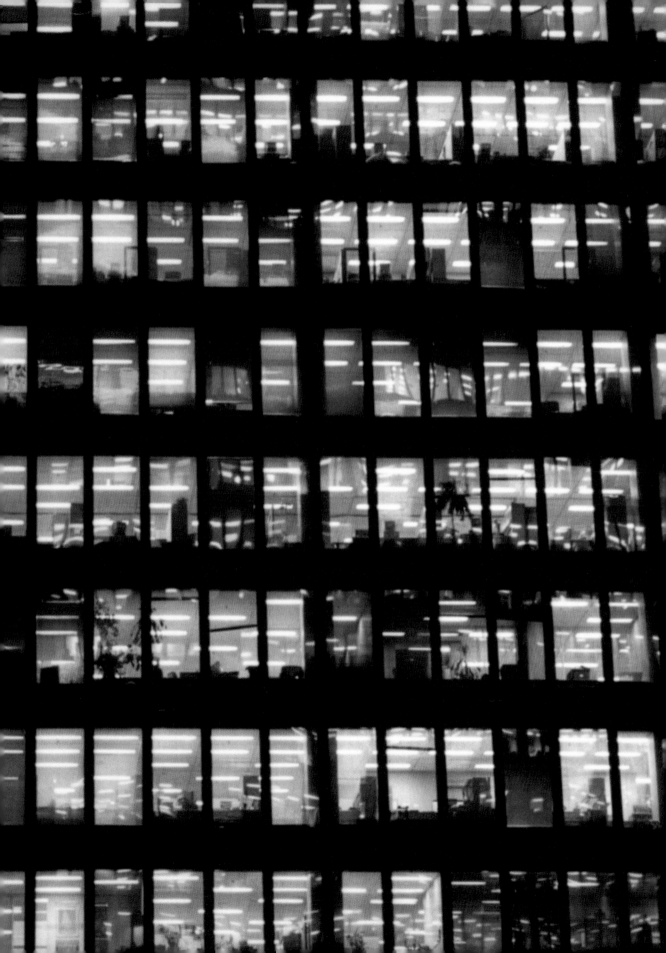

there spreading between the image of the body perceived as a projected skin/screen and subjectivity perceived as an inner core. On rare occasions, the subject "fills up" the *there* between mask and subjectivity, and subjectivity and body-image become one – those are moments of plenitude, ideologically and psychologically sanctioned as such. More often, feelings of disconnectedness, dissatisfaction, and alienation are the rule scripting the complicated dance between subjectivity, corporeality, and body image. This is why Eliot must invoke dance as central problem: with the advent of modernity, dance emerges as a powerful representational force field – a zone of corporeal and image density where radical experiments of embodiment and subjectivity can be rehearsed, and where our fall into modernity and into its modalities of subjection and incorporation can be performed.[3] It is *there* that the work of a non-fixed, dancing stillness propels the subject to and from the choreographic project of modernity. What needs interrogation is why Eliot locates at the centre of the dance and of the world, at the centre of the empty space of the subject's struggles with the world – *there* – a restless, vibrating stillness. What could this kind of movement operate within the confines of the subject's experiential zone of subjectivity and embodiment?

In his prehistory of modern dance from the mid-19th century to the 1930s, cultural historian Hillel Schwartz summarises the parallel path of modernity and dance (and of modernisation and dance) as the development of a "new kinaesthetics [...] in the century between Delsarte's public lectures [circa 1840] and the modern dance of the 1930s [...] in which, above all, movement transforms."[4] Such transformation was both physical as well as intellectual, spiritual, political, and choreographic. In other words, the "new kinaesthetic" experiments from the mid-19th century to the early modernist dances offered both practitioners and audience the possibility to reinvent the body as well as the experience of the self. Either by creating specific movements and postures that accommodated the body to the industrial mode of production, or by inclining the body towards the performative thrills of ideological raptures, or by rehearsing the development and incorporation of modernity's very specific nervous system – in the sense that Michael Taussig uses the term, as a specular sensorial probe, springing from the body and cutting deep into the world only to entrap the body within the very nervousness of its worldly creations[5] – one can say that dance becomes, eventually, inevitably, isomorphic to the modern condition.

What needs emphasis is that the "new kinaesthetic" praises and defines dance as continuous, ongoing flow, as never-ending motion. In this sense, the "new kinaesthetic" falls into a historical context of *longue durée*, by recycling early Romantic ballet's notions of dance as flowing, continuous motion. Within the Romantic tradition, moments when the body stopped still were perceived as clearly being non-dance.[6]

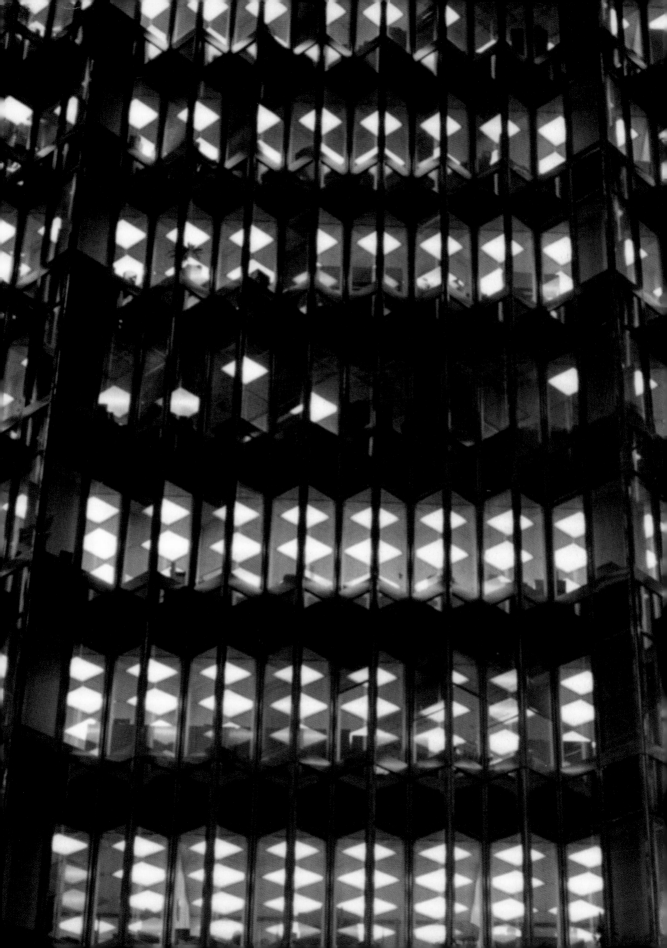

Stillness as an emerging concern for choreographers, *maîtres de ballet*, dancers, and critics had, in a first moment, a structural function – that of being dance's ghostly other. Granted, the fixity of the pose was part of the vocabulary of choreography, but such stillness operated semiotically and physiologically as "pauses", thus clearly falling outside of the motions and gestures considered as dance proper – moreover those poses as pauses were nothing but an all-too-human imperfection, a compromise of form before the ideal of dance as flight. Indeed, if not as a fleeting pose, stillness was that disturbing element which, by its impending menace, could not only catastrophically disrupt the magic flow of dance but, moreover, undermine the very identity of an art form moving towards its autonomous, stable definition.[7] In a manner reminiscent of the way Maurice Merleau-Ponty describes the invisible as never fully independent of the visible, but as the visible's interstitial "filigree"[8], stillness operated as the interstitial threat whose imminent and uncontrollable eruption defined and contained the very limits of choreographic imagination. A similar case could be made regarding the "new kinaesthetics" of modern dance. Schwartz emphasises how dancers of "modern dance" insisted on the notion of fluidity and on keeping the momentum of the body's "natural" flow. However, one must note that the emergence of "modern dance" at the very end of the 19th century was defined by its fierce opposition to ballet. Techniques as well as new choreographic languages were invented, broadly characterised by a contrary spirit regarding ballet's technique and language: the search for "spontaneous", "natural" movements, and an embrace of gravity and downwards motions. Those inventions were prefaced by the most revolutionary act of modern dance, an act that in itself radically positions dance outside of the ideologies of the Romantic ballet tradition: stillness envisioned no longer as a threat, but as the very source of the dance.

In the body in repose, there are a thousand hidden directions, an entire system of lines that incline it toward dance.[9] – *Jacques Rivière*

Jacques Rivière's sentence above is a landmark in the perceptual landscape of the modern history of dance. Written under the effects of the blasting power of Vaslav Nijinsky's choreography for Igor Stravinsky's *Le Sacre du printemps* (1913), the sentence repositions the question of the still body in unprecedented manners. The still body, for Rivière, is dance in potential – it stands in a position radically different from the one it had been cast in until then by ballet, and most notably by the ideologies of the Romantic ballet. It is precisely because of the relationship of Nijinsky choreography to stillness that, I would argue, Rivière can state forcefully that *Le*

WAITING

Sacre du printemps "no longer has any ties whatsoever to the classical ballet."[10] For Rivière, the choreography is much more revolutionary than Stravinsky's score. Such a judgment can only be sustained under the scrutiny of the radical effect of stillness, when no longer an accursed element of dance, but another device of dance's corporeality. In the rendition of *Le Sacre du printemps* that Jacques Rivière gives us, stillness emerges in Nijinsky's treatment of the body as temporally fragmented. The dancing body derives expressivity from a tension between still figure and moving image. Such a deep choreographic change, where stillness moves from the background to the foreground of perception, launches dance into new ontological grounds. On this new ground, the still body is perceived not as something to be repressed, but as generative of the dance. Transfixed by the potency of Nijinsky's reconfiguration of motion and arrest, Rivière can claim "the body in repose" as full of hidden possibilities for "inclining" the body "towards dance". Let us pay close attention to the semantics. If, with Rivière and Nijinsky, stillness starts to be perceived as part of the dance, it is in a somewhat peripheral manner, as a precondition to the dance. Rivière notes its compositional importance and its revolutionary implications, but at the same time he contains the notion: Stillness must somehow be present, its effect accepted, but only as originator of the dance. Stillness is no longer dance's other, but it remains outside dance, as potential, as a "system" which allows the body to "incline" itself towards dancing. Stillness is potential dancing, it is perhaps even the primal source for dancing, but it is not quite dancing. Isadora Duncan, in her narration of how her "new dance" came into being, evokes stillness in a similar manner. The passage in her memoir is well known:

> For hours I would stand quite still; my two hands folded between my breasts, covering the solar plexus [...] I was seeking and finally discovered the central spring of all movement.[11]

Only after stillness, silence, and deep inner auscultation could movement and dance take over Duncan's body. As with Nijinsky, stillness was not dance, but it was no longer a threat to dance. Its power was metaphysical, even transcendental, but not choreographic.[12] At the turn of the 19th to the 20th century, when dance leaps into modernism, either by reformulating the ballet tradition, or by creating the tradition of what Schwartz called the "new kinaesthetic", stillness takes on the role of dance's invisible, generative matrix. However, as much as it propels, it still does not perform – stillness remains as a blank note defining the initial steps of a perceptual transformation.

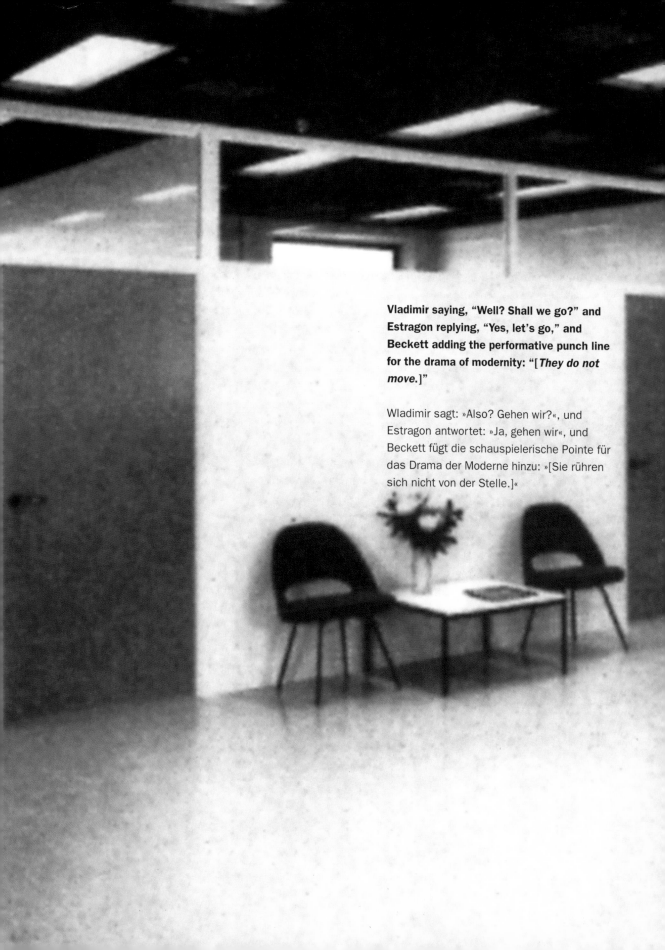

Vladimir saying, "Well? Shall we go?" and
Estragon replying, "Yes, let's go," and
Beckett adding the performative punch line
for the drama of modernity: "[*They do not
move.*]"

Wladimir sagt: »Also? Gehen wir?«, und
Estragon antwortet: »Ja, gehen wir«, und
Beckett fügt die schauspielerische Pointe für
das Drama der Moderne hinzu: »[Sie rühren
sich nicht von der Stelle.]«

Only that which was once capable of dissimulating itself can make itself apparent.[13] – *Georges Didi-Huberman*

In the early 1970s, Steve Paxton, while developing the technique that became known as contact improvisation, finally embraced the blank notes that the moderns had unveiled and timidly utilised, and promoted them to full compositional and technical devices. Paxton brought stillness into full phenomenological and ontological status as dance (and not just "potential to dance", or dance's "origin", background, or other). Paxton describes an exercise he used for his piece *Magnesium* – an exercise he calls, appropriately, "stand" or "the small dance" – as follows:

> Well, first of all, it's a fairly *easy perception*: all you have to do is stand up and then relax – you know – and at a certain point you realise that you've relaxed everything that you can relax but you're still standing and in that standing is quite a lot of *minute movement* [...] the skeleton holding you upright even though you're mentally relaxing [...] Call it the "small dance" [...] It was a name chosen largely because it's quite descriptive of the situation and because while you're doing the stand and feeling the "small dance" you're aware that you're not "doing" it, so in a way, you're watching yourself perform; watching your body perform its function. And your mind is not figuring anything out and not searching for any answers or being used as an active instrument but is being used as *a lens to focus on certain perceptions*.[14]

In this quote we can identify Paxton's ongoing concerns, since the early 1960s, with a "democratisation" of dance and of the dancing body, such as it had been practised and explored by him and others at the Judson Church in New York.[15] Also manifest is the clear articulation of certain aesthetic affinities between Paxton's ideas on the dancing body with earlier Cagean experiments on musical composition, most notably to John Cage's uses of silence. The Cagean revolution does not derive from the introduction of silence into composition, but to the radical affirmation of silence as composition, silence as music. Remember the manifest intentions of *4'33"*: The silenced piano, rather than performing a negation of the sensorial, generates intensification of the aural; the audience is asked to perceive that silence is actually full of small sounds. The implication is that there is indeed no silence, but thresholds of sensorial perceptions that can be intensified by the means of microscopy. Similarly, Paxton's revolution derives from his claiming of stillness as dance – ultimately, as he writes in the quote, there is no stillness, but only layers of minuscule motions. At the still point of the body, we are to find neither ascent nor descent, but also not fixity. Stillness is full of microscopic moves.

Paxton's embrace of stillness as a form of dancing necessitates, implicates, produces a radical rearrangement of the subject's perceptual field. At this perceptual threshold a sensorial rearrangement takes place on the level of the microscopic, of what Paxton calls "minute movements", and stillness reveals its many layers of vibratile intensities. What Paxton's stillness-as-dance evokes (puts into motion, brings to the foreground of perception) is dance's moving away from concerns to create a "new kinaesthetic", and towards increasing concerns to create a "new sensorial" by the means of intensification of perceptual thresholds. Paxton's stillness, just as Cagean silence, is less a compositional strategy than an experiential rehearsal for what philosopher José Gil calls microscopy of perception, a mode of perception leading to a "meta-phenomenology"[16]. One question arises when we move from stillness to the microscopic, and from there to the phenomenological: Do the experiences of sonorous silence and vibratile stillness qualify as "perception" or should the term be used only in its metaphorical aspect? Only by answering the first question in a positive manner can we then move towards phenomenology, more particularly to a metaphenomenology of small perceptions. Inasmuch as the "small dance" enhances the inner, muscular, nodal, lymphatic, vibratile dance of the body, as described by Paxton, its sensorial structure is isomorphic to the descriptions of what studies in the psychology of perception call "introspective proprioception". In this type of perception we "involute some of our perceptual attention away from its natural visual and auditory objects, and actively turn it instead in an immediate mode onto some body part like an arm."[17] Introspective proprioception is not a cognitive exploration (although it causally may sustain one), but truly an "attentive experience", that is to say, "a perceiving"[18]. In the case of the small dance, standing still engages not one specific body part, but the whole body is the target of introspective proprioception – which adds to the intensity of the perception and therefore to the increased awareness of microscopy. Moreover, introspective proprioception resulting from the small dance profoundly merges what modernity always tried to dissociate – the subject and its body. As the subject stands still, listening, sensing, smelling its own bodily vibrations, adjustments, tremors streaming through, across, within the space between core subjectivity and the surface of the body, there is nothing more than the revelation of an infinite, unlocatable space for microexploration of the multiple potential for otherwise unsensed subjectivities and corporealities one harbours. The "small dance" happens in that nowhere; the dancer must explore the unlocatable *there* between subjectivity and body-image.

If what has been said summarises, in a simple manner, the psychology of proprioception, it is to the relationship of the latter to philosophy that one must turn now in

order to probe deeper into the aesthetic, social, and existential problems brought forth by stillness: The problematics of the body's stance regarding the world and regarding the self, as the subject plunges into a microscopy of perception, a phenomenology of interiority, that *there* where, standing in vibratile stillness, the subject attempts to meet its body.[19]

We are continuously surrounded by imperceptible metaphenomena, of which the microperceptions emerge as odd indexes. From the standpoint of the small perceptions, everything endures change – stillness becomes movement, and the stable unstable.[20] *– José Gil*

In which manners does the process of the metamorphosis of stillness into motion, of the stable into instability described above by José Gil actually take place? We know it is a matter of intensity – of the multiple layers of intensities the body performs by the means of stillness. But the experience of stillness in dance has been described so far from the perspective of the dancing subject. Indeed, in Paxton's description of the "small dance", the main focus lies on the experience of the dancer. While stillness does perform as dance in *Magnesium*, it is important to mention how the threshold of introspective, small perceptions remains invisible to the audience. To turn our discussion to the social ground, to the ethical work of stillness when operating as choreographic device, and as intensifier of the audience's sensorial, we must turn to the question of stillness's impact upon the spectator gazing at the image of a dancing body that remains still. By which (choreographic) means can the still body engage the audience into perceptual intensification?

We know how the eye must permanently dance, imperceptibly, in order for any image to be perceived. Studies in visual perception tell us that when the relative motion of object and retina achieve absolute stillness, the image soon vanishes from the scopic field.[21] This particular kind of blindness is relevant, for it demonstrates that not only the movement of an object across the retina is essential for visual perception, but it also shows how the eye must engage in movement in order for the still object to appear and sustain its appearance. Before the fixed object, it is the small tremor-like movements of the eye, operating as a scanning device, that prevent the loss of the image. If our eyes are constantly engaged in a small dance, a dance composed by infinitesimal vibrations, those vibrations can be said to be nothing more than so many desperate movements the eye must perform in order to avoid drowning in its own blindness.

This necessity for the senses to be in a constant state of tremor in order to perceive

The sign of mystery, of the pornographic, of interdiction, of the experimental, of highly classified information is also the heraldic symbol of the systematic trespassing of unthinkable scientific thresholds. Crossing away, the State hopes to mask its propensity to act as mad scientist.

Das Zeichen des Rätsels, des Pornographischen, des Verbots, des Experimentellen, der streng geheimen Information ist auch das heraldische Symbol für die systematische Überschreitung von undenkbaren wissenschaftlichen Schwellen. Durch das Durchkreuzen hofft der Staat seinen Hang, als verrückter Wissenschaftler zu agieren, zu kaschieren.

is not only a matter of the eye. Against a background of static objects, perception can only be obtained as long as the whole body engages in vibration. For it is such a tremor, such a vibration, that ultimately produces the differentiation needed to distinguish object from background, to generate any perceptual and eidetic experience. Such is the basis of Merleau-Ponty's phenomenology when he talks of perception as "the advent of difference"[22]. Such is also the foundation of that extraordinary (and currently, intriguingly neglected) project of binding human "mind" with "nature", the complicated epistemology of perceptual interspecific interfaces in which Gregory Bateson engaged himself throughout his life. Bateson's idea on perception coincides with Merleau-Ponty's in many aspects (only to diverge, profoundly, from Bateson's emphasis on stochastic processes), but most particularly on the role attributed to difference. Bateson summarises the emergence of a perception as a double-layered play of differences:

> Human sense organs can receive only news of difference, and the differences must be coded, into events in time (i.e. changes) in order to be perceptible. Ordinary static differences that remain constant for more than a few seconds become perceptible only by scanning. Similarly, very slow changes become perceptible only by a combination of scanning and bringing together observations from separated moments in the continuum of time.[23]

Differences must be "coded" within time in order to produce the effect of change. Before a still object, one that does not initiate or endure change over a certain amount of time, the act of generating difference has to fall upon the body, either by means of "scanning" (as in the example of the minuscule eye movement in relation to the object), or, most intriguingly, by an active engagement of the mind in recollecting scattered mnemonic traces of previously stored sensorial elements and then engaging those elements in the reconstitution of a perceptual whole, out of fragments. What Bateson emphasises is that without activity of sensorial organs and activity of memory, we are left with a blind spot.

What Bateson names "scanning" is more appropriately described on the level of the movement performed by the sensorial apparatus as tremor or vibration. Vibration performs the function of supplementing the lack of information provided by the immobile object as it fuses itself, by means of stillness, against the background. If we take vibration under this light, we must inevitably consider that the term, once again, starts to take the shape of a phenomenological partner of stillness. The question then becomes: Is vibration inscribed in stillness just to make immobility visible? To make the perception of immobility possible? If that is so, then vibration would be to stillness

what the invisible is to the visible. Remember how Merleau-Ponty writes on the relationship between these last two categories: that they are not opposites of each other, but rather deeply imbricated in each other, the visible already contained by and containing the invisible. It is worth quoting the whole fragment (of 15 November 1959):

> Meaning is *invisible*, but the invisible is not the contradictory of the visible: the visible itself has an invisible inner framework (*membrure*), and the in-visible is the secret counterpart of the visible, it appears only within it, it is the *Nichturpräsentierbar* which is presented to me as such within the world – one cannot see it there and every effort to *see it there* makes it disappear, but it is *in the line* of the visible, it is its virtual focus, it is inscribed within it (in filigree) – [24]

This is where we stand, at the filigree of perception, within the fine membrane where two apparent opposites embrace each other, implicate each other, plunge into each other, while remaining distinct from each other in order to continuously create and sustain the difference that creates perception. Merleau-Ponty includes yet another layer of interstitial imbrication. In a move parallel to Bateson's, Merleau-Ponty invokes the mutual inscription of perception with memory. For Merleau-Ponty, however, perception is double movement – to the outer as well as to the inner layers of the body; it is giving oneself to the world as much as it is excavating memories: "A certain red is also a fossil drawn up from the depths of imaginary worlds."[25] By including the work of the memory apparatus within the very fabric of perception, we can write: When the still-image evokes vibration, it mirrors not only the motions the eye produces in order to generate the very image it is beholding, but the excavational motions memory must perform in order to collect and create perception. The vibratile still-image is thus a double reflection, its mimicry is doubly layered. It reflects the eye's and memory's unstoppable dance – precisely so it can manifest itself as an immobile image. But we are still in too fragmented a narrative to please and utilise correctly both Merleau-Ponty's and Bateson's phenomenologies. For we have yet to invoke that element which binds, the pattern that connects: the body – hopefully not as trope, but as matter, as thick and unstable mass as it stands. It is now time to expand the discussion from eye and difference and memory, and bring the whole body as tremulous or vibrating organ standing between outer stimuli and inner impressions; the body as "thickness" which, "far from rivalling that of the world, is on the contrary the sole means I have to go unto the heart of things, by making myself a world and by making them flesh."[26] It is time to investigate the relationship between the body and the sensorial dimensions it generates or destroys.

The body is "a being of two leaves, from one side a thing among things and other-

wise what sees and touches them", and Merleau-Ponty adds, "it cannot be by incomprehensible accident that the body has this double reference."[27] In other words, for Merleau-Ponty, the body in itself is difference. Such a statement immediately positions the body as generator of perceptions, both as stimuli and as mnemonic "excavations". One must add, however, that this body – because it is double, because it lends itself to the world, because it allows itself to be covered, penetrated, lifted up, embraced by the world upon which it projects its flesh – this body then is always under the spell of a certain indeterminacy. What needs be emphasised is that such indeterminacy is tremendously generative; for, more than describing an ontological status of the body, it narrates a specific rendering of the body. The indeterminacy of the body lies firstly on the level of its physical integrity, since Merleau-Ponty emphasises that the flesh is not matter. Secondly, the body is also undetermined both temporally and spatially (which does not mean it does not exist in time and space): "[...] one can indeed say of my body that it is not *elsewhere*, but one cannot say that it is *here* or *now* in the sense that objects are."[28] Such intriguing spatialisation of the body, such failure to render it a place, a *there* where it undoubtedly stands, brings us back to the problem of where the body stands in this zone where subjectivity and body-image collide. It brings us back to the question of what the body, when standing, performs in itself and for itself – neither in flesh nor in matter, neither here or now, but vibrating in some unlocatable *there*. It is at this point, which is a turning point, that one must return to the matter of stillness, the matter that first brought us here by the poetic power of its incantation, and address the central problem underlying this entire discussion: What force is produced and condensed at the *there* of the body that dances in stillness?

The imperceptible has a social structure based on culturally prescribed zones of non-experience and cancelled meaning.[29] *– Nadia Seremetakis*

In what has been said so far – in the introduction around a modernist poem, in the historical discussion of the shifting role of stillness in dance, in the phenomenological investigations in proprioception and the work of microscopy – an ongoing argument has made itself evident: The stillness under discussion does not partake of the qualities of fixity, but it is an ontological category, a sensorial threshold, a vibratile intensity provoked by the subject's refusal to engage its body in thoughtlessly continuous, overdetermined, prescribed motions, subjectivities, and body-images. Such vibratile stillness reconfigures the very relationship between embodiment and subjectivity, as these clash in the formation of sensorial thresholds in the cultural-historical

force field that is the world. Stillness operates on the level of the subject's desire to invert a certain relationship with temporality, and therefore with corporeal rhythms. To engage in stillness is to engage in different experiences of perceiving one's own subjectivity, by the means of a vibratile stance. Such is the position which psycho-analyst and cultural theorist Suely Rolnik proposes with her notion of "vibrating body" (*corpo vibrátil*) as deep auscultation of the sonic density of the world as it resonates within and throughout the subject. For Rolnik, such auscultation is essential for the creative reconfiguration of the subject's relationship regarding the world, regarding its own subjectivity, and its body-image. This specific effect of stillness, as intensifier of disruption and invention, is also and precisely that which Nadia Seremetakis theorises in her three important essays on the memory of the senses. "Against the flow of the present," she writes,

> there is a stillness in the material culture of historicity; those things, spaces, gestures, and tales that signify the perceptual capacity for elemental historical creation. Stillness is the moment when the buried, the discarded, and the forgotten escape to the social surface of awareness like life-supporting oxygen. It is the moment of exit from historical dust.[30]

Seremetakis's invocation of the resisting work of "stillness" against "historical dust" is rendered in such powerful metaphors that in order to put those concepts into their full critical capacity, in order to fully use their potential for hermeneutic and social work, one must start by strategically literalising them to pragmatically perceive their epistemological and social agency. Such literalisation could start by noticing how, in this past decade, dust has been particularly active across Europe, relentlessly covering the bodies of its inattentive citizens. Dust started its work of sensorial anaesthesia in that unforgettable January of 1991 when, for the fist time in history, hypertrophied eyes detached from our bodies and free-fell, at an incrementally accelerating speed, surgically precise and "live", into a foreign landscape, exploding in brilliant blindness amidst greenish fumes. Suspended in the warm breezes of the burning Iraqi desert, the resulting cloud of dust hovered hesitantly, without any definitive direction. Meanwhile, further north, another historical force field was intensifying its activity. Fatally attracted, the desert dust headed northwest, across the Mediterranean, never touching water, with resolute aim. It took its time as it traveled across the waters. After almost a year of suspension, its slow pace gained increased intensity once it passed over the new force field of violence and history: the blasting streets of Sarajevo. There, it mixed with recently pulverised concrete powder in a new greyish combination and sprang forth, eventually showering over Berlin, Paris,

London, Madrid, Rome, even (otherwise dusty) Lisbon. With the pace of any monomaniacally self-enclosed history, dust covered our skins, stuffed our mouths, reddened our eyes with tears, and dried our throats, leaving a bad aftertaste. Dust was the first new palatable, palpable, sensorial impression of the new world order.

The dust of wars, in Europe, in the West, never quite settles, but is constantly re-energised by this century's atrocious horrors and sensorial anaesthesia. This dust that shuffles the division between the sensorial and the social also penetrates deep into the inner layers of the body, where it finds its final rest, and operates its final work of rigidifying the smooth rotation of joints and articulations. Some choreography, in its quiet work of auscultation, sometimes follows the unsettling trajectory of this dusty century, as it charts the tensions of the subject under the strains of history's nervous system. The brutality of historical dust, literally falling onto bodies and reshaping the subject's stance regarding body-image and movement, evokes dance's response regarding glowing radioactive dust microscopically showering over the population of Hiroshima and Nagasaki. The impact of such venomous dust determined the shape of Butoh's rhythm and body-image, not only as the dance of darkness, but as the dance of vibratile stillness proper. More recently, in Europe, some choreography has also engaged in a careful investigation of the bodily and subjective transformations brought about by imperceptible residues of history's faltering building as its dust infects our lungs, petrifies our language, and traps our nervous systems within the shit of history. The choreographers in question performed their work by the means of a non-fixed stillness. During that particularly dusty fall of 1992, stillness as a gesture against historical dust spontaneously erupted in a group of choreographers, musicians, critics, and artists gathered in Paris, in a choreographic laboratory called SKITE. Portuguese choreographer Vera Mantero and Spanish choreographer Santiago Sempere were there, both stating that the predicament of the world was such that it prevented them from dancing; Meg Stuart choreographed a still-dance for a man lying down on the ground, reaching for his past memories;[31] Australian choreographer Paul Gazzola lay quietly in the night, naked in an improbable shelter by a highway. I see that moment in Paris as one where historical dust engaged choreographers into radical rearrangement of the notion of dance and of the position of the subject within the motion of wordly events, by means of stillness. At the time, the performances had the quality of a spontaneous burst; there had been no conscious decision to elaborate on dramaturgies of stillness. But isn't precisely the spontaneous eruption and use of stillness the very dynamic that Seremetakis describes when material historical transformation performs its gesture against historical dust? In this case, the spontaneous act exactly matched Seremetakis's

description of stillness interrupting the background of historical dust as "life-support-ing oxygen". Moreover, this stillness was not one of statuesque rigidity. It had the instability of breath, the tremor of touch; it provoked the vibration of an active gaze. It oscillated between intention, expression, emotion, and subjectivity, and was pro-pelled by a sudden crisis of the image of the dancer's body as isomorphic to a mov-ing image. Stillness was unlocatable, but definitely *there*.

Consolidation of this dispersed, diverse use of stillness by some contemporary European choreographers was noticed by critics, programmers, and audience alike. I had the chance to write how its use approached dance in an "ontology of perform-ance", in the sense that emphasis on stillness privileges presence rather than move-ment.[32] However, only now am I prepared to understand what such a moving stillness offers, what may be the gift of such vibratile body dances. Consider the most accom-plished example of a choreography of the vibratile, still body: French choreographer Jérôme Bel's autographic piece, *Jérôme Bel* (1995). This hour-long piece performs Rolnik's definition of the vibrating body as aurally immersed in the sonic vibrations of historical forces. How else could one explain the uncanny way the piece revolves around and evokes precisely those same notes that, almost a century before, Nijinsky choreographed the steps in which Rivière perceived the radical emergence of still-ness as potential dance? *Jérôme Bel* is a piece centred around a vocal rendition of Stravinsky's *Le Sacre du printemps.* It is also a piece for naked bodies, a piece for a naked theatre, a piece that initiates with dusty chalk scripting the normative account-ing of the dancer's lives: weight, height, age, bank-account balance, telephone num-ber; and the names of historical figures that define the force field of each action or section (Thomas Edison, Igor Stravinsky, Dior). It is against this dusty background of history (both personal and worldly; of technologies as of art) that a non-fixed stillness operates its labour of vibratile intensification. It is a stillness similar in all respects to the one Eliot writes about in his poem: never fixed, never locatable, but always danc-ing. It is a stillness that performs, powerfully, the opening up to the world of that vibra-tile, unlocatable, yet essentially generative *there* by problematising the matter of the body and its image, and of the subject's relation to its body as the subject surrenders itself to the world. Stillness becomes action in *Jérôme Bel*, particularly in those initial moments of the piece when dancer Claire Haenni stands downstage and meticu-lously stretches her skin, as if in doubt of her body's containment within that surface, as if probing the limits of inclusion of her self within that fleshy shell. She takes her time, the stage is lit only by a domestic light bulb, Stravinsky's orchestral mass is reduced to the voice of a single woman. She stands, time expands. It expands in such a manner that it loops out of its chronometrical, pre-scripted pace and merges

Jérôme Bel **Jérôme Bel** 1995

with duration – it initiates a collective move towards what could only be described as attentive microscopy of perception, when all endures instability and transformation. This stillness, because it is enacted as a gift, mindful that it stands before an audience, performs more towards the public than the plunge into proprioception of Paxton's small dance. It performs a call for multi-layered perception – while it is attached to a performing subject, it nevertheless resonates with the many frailties and histories each body (the dancer's, the audience's) carries in that space between subjective core and body-image. Bel presents the dual aspect of the body Merleau-Ponty described, as both object in the world and subject of the world. The intensity of those moments when the still body emerges as unlocatable and undetermined are breath-taking; stillness vibrates the subject's core towards a position beyond the boundaries of the body-image, and beyond the manifestation of a body-image restrained by its attachment to the self. The audience is asked to plunge into this unlocatable territory of vibratile stillness – *there* where the sensorial and the subjective, body-image and identity core negotiate their stance under the winds of history. If one chooses to follow this stillness, one soon finds oneself amidst a representational reshuffling – that of the vibratile body taking over and blowing away historical dust from dulled senses. In stillness one is in uncharted territory: *there*, at the vibratile zone where the dance of the subject and the dance of history clash. Stillness is the generative threshold of dance's critique of modernity's fabrication of embodiment, subjectivity, and the sensorial, by means of a vibratile body engaged in a microscopy of perception.

1. I am borrowing Roland Barthes's well-known concept of the *punctum* in the photographic image as being both a "wound" as well as an "accident which pricks me"; see Roland Barthes, *Camera Lucida: Reflections on Photography*, trans. Richard Howard, New York 1994, 27. Although Barthes's use of the *punctum* was restricted to the photographic image, its application in performance theory is particularly useful, given the *punctum's* metonymic "power of expansion" (ibid., 45).

2. Suely Rolnik, "Molda-se uma alma contemporânea: o vazio-pleno de Lygia Clark", unpublished manuscript, forthcoming (fall 1999), 3.

3. For the period from the Baroque to the late 19th century, see particularly Mark Franko, *Body as Text: Ideologies of the Baroque Body*, Oxford 1993; Susan Leigh Foster, *Choreography and Narrative: Ballet's Staging of Story and Desire*, Bloomington and Indianapolis 1996; and Lynn Garafola, ed., *Rethinking the Sylph: New Perspectives on the Romantic Ballet,* Hanover and London 1997. For the 20th century, see particularly Susan Manning, *Ecstasy and the Demon:*

Feminism and Nationalism in the Dances of Mary Wigman, Berkeley 1993; Randi Martin, *Critical Moves*, Durham 1998; and Ramsey Burt, *Alien Bodies*, London and New York 1998.

4. Hillel Schwartz, "Torque: the New Kinaesthetic", *Incorporations*, ed. Jonathan Crary and Sandford Kwinter, New York 1992, 77.

5. See Michael Taussig, *The Nervous System*, London and New York 1993, particularly the introduction and chapters 7 and 8.

6. For a vivid description, see Deborah Jowitt, *Time and the Dancing Image*, Berkeley 1988. Anticipating the first Romantic ballet, Heinrich von Kleist wrote in 1810: "Puppets, like elves, need the ground only so that they can touch it lightly and renew the momentum of their limbs through this momentary delay. We [humans] need it to rest on, to recover from the exertions of dance, *a moment which is clearly not part of the dance*." See Kleist, "The Puppet Theatre", *An Abyss Deep Enough: Letters of Heinrich von Kleist, with a Selection of Essays and Anecdotes*, ed. Philip B. Miller, New York 1982.

7. The threat of stillness still haunts contemporary definitions of dance. The pressure for movement as ontological definition of dance can be seen in numerous reviews and in some strong ideological positions by certain programmers. As example of the latter, the yearly dance festival in the city of Oporto is the most evocative, with the imperative title *Dancem!* ("You dance!"). As for the identification of dance as movement, the following passage by Arlene Croce, in her notorious blind review of Bill T. Jones's *Still/Here*, is exemplary: "Theoretically, I am ready to go to anything – once. If it moves, I'm interested; if it moves to music, I'm in love. And if I'm turned off by what I see it's seldom because of the low-definition dance element." See Arlene Croce, "Discussing the Undiscussable", *The New Yorker* 43 (1994) LXX, 56. Needless to say, the "dance element" is always already movement, something the title of Jones's piece undermined, from the start.

8. Maurice Merleau-Ponty, *The Visible and the Invisible*, Evanston 1961, 215.

9. Jacques Rivière, "Le Sacre du printemps", quoted in Lincoln Kirstein, *Nijinsky Dancing*, New York 1975, 165.

10. Ibid, 164. I disagree with Lincoln Kirstein's proposal that Nijinsky negates ballet only to remain within its premises. Under the perspective of stillness, Nijinsky's is a radical departure also different from the "new kinaesthetic" emphasis on flow. This aspect of Nijinsky's work in relation to modern dance needs further exploration.

11. Isadora Duncan, *My Life*, New York 1927, 75.

12. For a discussion of this point, particularly in Duncan, see Mark Franko, *Dancing Modernism/Performing Politics*, Bloomington and Indianapolis 1995, 1-22.

13. Georges Didi-Huberman, *Phasmes: Essais sur l'Apparition*, Paris 1998, 15 (my translation).

14. Steve Paxton, *Contact Quarterly*, vol.3, no.1, 1977, emphasis added by author.

15. For an account of the Judson Church "post-moderns" and their project of a democratic

YESTERDAY

dancing body, see Sally Banes, *Democracy's Body: Judson Dance Theater, 1962-1964*, Ann Arbor and London 1983. For an account of Paxton's ongoing concern with democratising the dancing body in contact improvisation, see Cynthia Novack, *Sharing the Dance: Contact Improvisation and American Culture*, Madison 1990.

16. José Gil, *A Imagem Nua e as Pequenas Percepções*, Lisbon 1996.

17. Brian O'Shaughnessy, "Proprioception and the Body Image", *The Body and the Self*, Cambridge, Mass. 1998, 175.

18. Ibid., 176.

19. As this essay was being completed, I came across Suely Rolnik's extraordinary notion of "vibrating body" (*corpo vibrátil*). The concept was developed in Rolnik's book, *Cartografia Sentimental. Transformações Contemporâneas do Desejo*, São Paulo 1989. In a personal communication, Rolnik explained to me how the "vibrating body" is "potential our bodies have in vibrating with the music of the world" and in this sense "our subjectivity is made out of such sensorial composition". My use of the word 'vibratile' in this text precedes my knowledge of Rolnik's sophisticated notion. However, the closeness in semantics is not at all coincidental. Although my use of 'vibratile' does diverge in the emphasis I give to the tactile and the proprioceptive rather than the musical, our concurrent theorisation of such a "vibrating body" seems to be imposed by a shared interest in the interface between subject/desire/movement in relation to the problem that is dear to Rolnik as art critic and psychoanalyst and to me as dramaturge: how to unite art with life.

20. Gil 1996 (note 16), 20 (my translation).

21. See, for instance, Lothar Spillmann and John S. Werner, eds., *Visual Perception: The Neurophysiological Foundations*, San Diego 1990; James T. McIlwain, *An Introduction to the Biology of Vision*, Cambridge, England 1996.

22. Maurice Merleau-Ponty, *The Visible and the Invisible*, Evanston 1968, 217.

23. Gregory Bateson, *Mind and Nature*, New York 1979, 70.

24. Merleau-Ponty 1968 (note 22), 215.

25. Ibid., 132.

26. Ibid., 135.

27. Ibid., 137.

28. Ibid., 147.

29. Nadia Seremetakis, *The Senses Still: Perception and Memory as Material Culture in Modernity*, Chicago 1996, 13.

30. Ibid., 12.

31. The man in question is French critic and programmer Jean-Marc Adolphe.

32. André Lepecki, "Skin, Body, and Presence in Contemporary European Choreography", *The Drama Review*, forthcoming (winter 1999).

Every incomplete past as it dreams of its fantastic future casts the experience of todayness as perpetual *déjà vu*: the past erupts in the present to announce the immediate future as already lived, immediately recognisable, and predictable. *Déjà vu* is a psychogenic state clinically linked with tiredness. When fatigue is the prevailing societal condition, *déjà vu* becomes the collective back entrance for all of yesterday's postponed tomorrows.

Jede unabgeschlossene Vergangenheit träumt von ihrer phantastischen Zukunft und gibt dabei der Erfahrung der Gegenwart die Form eines ständigen Déjà-vu: Die Vergangenheit bricht in der Gegenwart hervor, um die unmittelbar bevorstehende Zukunft als bereits gelebt, sofort wiedererkennbar und vorhersehbar anzukündigen. Das Déjà-vu ist ein psychogener Zustand, der aus klinischer Sicht mit Ermüdung zu tun hat. Wenn Erschöpfung der in der Gesellschaft vorherrschende Zustand ist, wird das Déjà-vu zum kollektiven Hintereingang für alle gestern aufgeschobenen Morgen.

Selected Bibliography

Marie-Louise Angerer, *Body Options. Körper. Spuren. Medien. Bilder*, Vienna 1999.

Aleida Assmann, *Erinnerungsräume: Formen und Wandlungen des kulturellen Gedächtnisses*, Munich 1999.

———, ed., *Medien des Gedächtnisses*, Stuttgart 1998.

Aleida Assmann et al., eds., *Schrift und Gedächtnis: Beiträge zur Archäologie der literarischen Kommunikation,* Munich 1983.

Jan Assmann et al., eds., *Self, Soul, and Body in Religious Experience,* Leiden and Boston 1998.

France Borel, ed., *Le Corps-Spectacle*, Brussels 1987.

Gabriele Brandstetter, *Tanz-Lektüren: Körperbilder und Raumfiguren der Avantgarde*, Frankfurt am Main 1995.

Elisabeth Bronfen, *Over Her Dead Body: Death, Femininity, and the Aesthetic*, New York 1992.

Judith P. Butler, *Bodies that Matter: On the Discursive Limits of "Sex",* New York 1993.

Rüdiger Campe and Manfred Schneider, eds., *Geschichten der Physiognomik: Text, Bild, Wissen*, Freiburg im Breisgau 1996.

Guido Ceronetti, *The Silence of the Body: Materials for the Study of Medicine*, trans. Michael Moore, New York 1993.

Beatriz Colomina, ed., *Sexuality & Space*, New York 1992.

Cynthia C. Davidson, ed., *Anybody*, Cambridge, Mass. 1997.

Georges Didi-Huberman, *Invention de l'hysterie: Charcot et l'iconographie photographique de la Salpêtrière,* Paris 1982.

———, *Ce que nous voyons, ce qui nous regarde*, Paris 1992.

Mary Douglas, *Natural Symbols: Explorations in Cosmology,* New York 1970.

Dresden 1999
Der neue Mensch: Obsessionen des 20. Jahrhunderts, exh. cat., Deutsches Hygiene-Museum Dresden, 22 April – 8 August 1999, Ostfildern 1999.

Dresden 1999–2000
Fremdkörper – Fremde Körper: Von unvermeidlichen Kontakten und widerstreitenden Gefühlen, exh. cat., Deutsches Hygiene-Museum Dresden, 6 October 1999 – 27 February 2000, Ostfildern 1999.

Guy Ducrey, *Corps et graphies: Poétique de la danse et de la danseuse à la fin du XIXe siècle*, Paris 1996.

Barbara Duden, *The Woman beneath the Skin: A Doctor's Patients in Eighteenth-Century Germany*, trans. Thomas Dunlap, Cambridge, Mass. 1991.

Richard van Dülmen, ed., *Körper-Geschichten: Studien zur historischen Kulturforschung*, Frankfurt am Main 1996.

Norbert Elias, *The Civilizing Process: The History of Manners*, trans. Edmund Jephcott, New York 1978.

Valie Export, *Das Reale und sein Double: Der Körper*, Bern 1987.

Michel Feher, ed., *Fragments for a History of the Human Body*, 3 vols., New York and Cambridge, Mass. 1989.

Susan Leigh Foster, *Corporealities: Dancing, Knowledge, Culture, and Power*, London and New York 1996.

Michel Foucault, *Discipline and Punish: The Birth of the Prison*, trans. Alan Sheridan, New York 1977.

———, *The History of Sexuality*, trans. Robert Hurley, New York 1978.

———, *The Order of Things: An Archaeology of the Human Sciences*, trans. from the French, New York 1970.

Frankfurt 1990
Das Fragment: Der Körper in Stücken, exh. cat., Schirn Kunsthalle Frankfurt, 24 June – 26 August 1990.

Julika Funk and Cornelia Brück, eds., *Körper-Konzepte*, Tübingen 1999.

Catherine Gallagher and Thomas Laqueur, *The Making of the Modern Body: Sexuality and Society in the Nineteenth Century*, Berkeley 1987.

Marjorie B. Garber, *Vested Interests: Cross-Dressing and Cultural Anxiety,* New York 1991.

Gunter Gebauer und Christoph Wulf, *Mimesis: Culture, Art, Society*, trans. Don Reneau, Berkeley 1995.

Arnold Gehlen, *Man in the Age of Technology*, trans. Patricia Lipscomb, New York 1980.

———, *Das Bild des Menschen im Lichte der modernen Anthropologie*, Reinbek 1961.

Claudia Gehrke, *Ich habe einen Körper*, Munich 1981.

Elisabeth Grosz, *Volatile Bodies: Toward a Corporeal Feminism*, Bloomington 1994.

Michael Hagner, ed., *Der falsche Körper: Beiträge zu einer Geschichte der Monstrositäten*, Göttingen 1995.

———, *Homo cerebralis: Der Wandel vom Seelenorgan zum Gehirn,* Berlin 1997.

Christiaan L. Hart Nibbrig, *Die Auferstehung des Körpers im Text*, Frankfurt am Main 1985.

Deborah A. Harter, *Bodies in Pieces: Fantastic Narrative and the Poetics of the Fragment*, Stanford 1996.

Anselm Haverkamp and Renate Lachmann, eds., *Gedächtniskunst: Raum, Bild, Schrift: Studien zur Mnemotechnik*, Frankfurt am Main 1991.

———, eds., *Memoria: Vergessen und Erinnern*, Munich 1993.

George L. Hersey, *The Evolution of Allure: Sexual Selection from the Medici Venus to the Incredible Hulk*, Cambridge, Mass. 1996.

David Hillman and Carla Mazzio, eds., *The Body in Parts: Fantasies of Corporeality in Early Modern Europe*, New York 1997.

Luce Irigaray, *Le Langage des déments*, Paris 1973.

———, *Speculum of the Other Woman*, trans. Gillian C. Gill, Ithaca 1985.

Henri-Pierre Jeudy, *Le Corps comme objet d'art*, Paris 1998.

Thomas Kahlcke, *Lebensgeschichte als Körpergeschichte: Studien zum Bildungsroman im 18. Jahrhundert*, Würzburg 1997.

Dietmar Kamper and Volker Rittner, eds., *Zur Geschichte des Körpers: Perspektiven der Anthropologie*, Munich and Vienna 1976.

Dietmar Kamper and Christoph Wulf, eds., *Die Wiederkehr des Körpers*, Frankfurt am Main 1982

———, eds., *Das Schwinden der Sinne*, Frankfurt am Main 1984.

———, *Der andere Körper*, vol. 1, Berlin 1984.

———, eds., *Transfigurationen des Körpers: Spuren der Gewalt in der Geschichte*, Berlin 1989.

Ernst H. Kantorowicz, *The King's Two Bodies: A Study in Mediaeval Political Theology*, Princeton 1957.

Reinhard Klooss and Thomas Reuter, *Körperbilder: Menschenornamente in Revuetheater und Revuefilm*, Frankfurt am Main 1980.

Pierre Klossowski et al., *Sprachen des Körpers: Marginalien zum Werk von Pierre Klossowski*, Berlin 1979.

Arthur Kroker, *Der digitale Körper: Nach der Schnittstelle*, Bern 1996.

Thomas W. Laqueur, *Making Sex: Body and Gender from the Greeks to Freud*, Cambridge, Mass. 1990.

Henri Lefebvre, *The Production of Space*, trans. Donald Nicholson-Smith, Cambridge, Mass. 1991.

Rudolf zur Lippe, *Naturbeherrschung am Menschen,* 2 vols., Frankfurt am Main 1974.

Mannheim 1997–98
Körperwelten: Einblicke in den menschlichen Körper, ed. Kai Budde and Gerhard Zweckbronner, exh. cat., Mannheim Landesmuseum für Technik und Arbeit, 30 October 1997 – 1 February 1998.

Gert Mattenklott, *Der übersinnliche Leib: Beiträge zur Metaphysik des Körpers*, Hamburg 1982.

Marcel Mauss, "Die Techniken des Körpers", in *Soziologie und Anthropologie,* vol. 2, Frankfurt am Main et al. 1978, 199–220.

Pia Müller-Tramm and Katharina Sykora, eds., *Puppen - Körper – Automaten: Phantasmen der Moderne*, Düsseldorf 1999.

August Nitschke, *Körper in Bewegung: Gesten, Tänze und Räume im Wandel der Geschichte*, ed. Peter Dinzelbacher, Stuttgart 1989.

Claudia Öhlschläger and Birgit Wiens, eds., *Körper, Gedächtnis, Schrift: Der Körper als Medium kultureller Erinnerung*, Berlin 1997.

Paris 1993–94
L'âme au corps: Arts et sciences, 1793–1993, ed. Jean Clair, exh. cat., Galeries nationales du Grand Palais, 19 October 1993 – 24 January 1994, Paris 1993.

Mario Perniola, *Il sex appeal dell'inorganico*, Turin 1994.

Philippe Perrot, *Le Travail des apparences, ou, Les Transformations du corps féminin XVIIIe – XIXe siècle*, Paris 1984.

Helmut Plessner, *Philosophische Anthropologie. Lachen und Weinen. Das Lächeln. Anthropologie der Sinne*, ed. Günter Dux, Frankfurt am Main 1970.

Patrick Roth, *Corpus Christi*, Frankfurt am Main 1996.

Claudia Schmölders, *Das Vorurteil im Leibe: Eine Einführung in die Physiognomik*, 2nd rev. ed. Berlin 1997.

Marianne Schuller et al., eds., *BildKörper: Verwandlungen des Menschen zwischen Medium und Medizin*, Hamburg 1998.

Richard Sennett, *Flesh and Stone: The Body and the City in Western Civilization*, New York 1994.

Chris Straayer, *Deviant Eyes, Deviant Bodies: Sexual Re-Orientations in Film and Video*, New York 1996.

Stuttgart 1989
Kunstkörper – Körperkunst: Texte und Bilder zur Geschichte der Beweglichkeit, exh. cat., Kulturamt der Landeshauptstadt Stuttgart in der Galerie der Stadt Stuttgart, 12 October – 26 November 1989.

Sherry Turkle, *The Second Self: Computers and the Human Spirit*, New York 1984.

———, *Life on the Screen: Identity in the Age of the Internet*, New York 1995.

Paul Virilio, *The Art of the Motor*, trans. Julie Rose, Minneapolis 1995.

Klaus Völker, ed., *Künstliche Menschen: Dichtungen und Dokumente über Golems, Homunculi, Androiden und lebende Statuen*, Munich 1971.

Peter Weibel, ed., *Der anagrammatische Körper: Der Körper und seine fotografische Kondition*, exh. cat., Kunsthaus Muerz, Mürzzuschlag, 9 October 1999 – March 2000.

Frances A. Yates, *The Art of Memory*, Chicago 1984.

Index

Adorno, Theodor W. 226, 304
Agrippa, Menenius 60, 76, 82
Akhenaten of Amarna 70
Alberti, Leon Battista 140
Ampère, André Marie 268
Amun 70
Anderson, Laurie 122
Anubis 54, 66, 68
Aphrodite 86
Aquinas, Thomas 276
Arcimboldo, Giuseppe 158, 160
Ariadne 108
Arnheim, Rudolf 260
Atum 56, 58, 70, 84

Bahktin, Michail 308, 318
Banes, Sally 148
Barthes, Roland 160
Bateson, Gregory 350, 352
Baudelaire, Charles 16, 40
Baudrillard, Jean 16
Beckett, Samuel 272
Bel, Jérôme 358, 360
Benjamin, Walter 14, 130, 132, 226, 236,
 252, 258, 280, 312
 Berlin Childhood around Nineteen-
 Hundred 130
Bentham, Georges 226, 228
Bergson, Henri 110
Bloch, Ernst 236, 254, 256, 258
Boltzmann, Ludwig 268
Bracelli, Giovanni Battista 162
Brock, Bazon 294, 296
Büchner, Georg 40
Buñuel, Luis 280
Burrows, Jonathan 128
Burton, Sir Richard 250, 252

Cadmon, Adam 84
Cage, John 344, 346
Cambiaso, Luca 162
Caus, Salomon de 232
Certeau, Michel de 16, 18, 118, 120
Chasles, Michel 268
Chirico, Giorgio de 258
Clea 90

Cornelisz, Cornelis 154
Cunningham, Merce 114, 120
Curtius, Ernst Robert 140

Daedalus 108
Dali, Salvatore 298
Dante Alighieri 108
 Purgatorio 108
Danti, Vincenzo 154
Day, Doris 274
Deleuze, Gilles 274, 280
Didi-Huberman, Georges 344
Diodorus, Siculus 76
Dior, Christian 360
Duncan, Isadora 342
Dunn, Douglas 120, 126
Dürer, Albrecht 162

Eddington, Arthur Stanley 260, 268
Edison, Thomas Alva 266, 360
Egberts, Arno 74
Eliot, T. S. 38, 158, 334, 336, 338
 Burnt Norton 334
Empedocles 262
Ernst, Max 258
Euler, August Heinrich 268
Eurydice 26, 108

Faraday, Michael 264
Ferdinand I 158
Festugière, André-Jean 72
Flaubert, Gustave 264, 266
 Temptation of St. Anthony 266
Fludd, Robert 28, 232
Fontainebleau school 138
Forsythe, William 16, 26, 28, 104, 106,
 114, 116, 118, 122, 124, 126, 128, 148,
 150, 152, 156, 158, 164
 Alie/n A(c)tion 150
 Artifact 114
 Hypothetical Stream 2 158
 Limb's Theorem 104, 108
 Self Meant to Govern 116
 The Vertiginous Thrill of Exactitude
 124
Foucault, Michel 28, 146, 226, 228
Freud, Sigmund 112

Friedlaender, Walter 140
Fuller, Loïe 28, 148, 154, 156, 164
8

Garber, Marjorie 40
Gazzola, Paul 358
Geb 54
Gil, José 346, 348
Gracian, Balthasar 164

Haenni, Claire 360
Hagens, Gunther von 296, 298
Hamilton, Ann 162
Hapy 54, 66
Hauser, Arnold 140
Hegel, Georg Wilhelm Friedrich 292,
298
Hero of Alexandria 230
Hill, Gary 162
Hocke, Gustav René 140
Hoffmann, Ernst Theodor Amadeus
260
Holbein, Hans 148, 150
Horace 24, 76, 86
Horus 54, 64, 66, 74, 76, 78, 90
Hu 54
Husserl, Edmund 124

Illyricus, Matthias Flacius 88
 Clavis Scripturae Sacrae 88
Imset 54
Isis 64, 68, 78, 82, 88, 90, 92, 94

Jacquet-Droz, Henri-Louis 232
Jacquet-Droz, Pierre 232
Johnson, Marc 118

Kafka, Franz 118, 274, 276
Kant, Immanuel 124, 262, 264
Kelly, Gene 272, 274
Kempelen, Wolfgang von 30, 250
Khepri 54
Kircher, Athanasius 28, 32, 224, 226,
 232, 234, 262, 264
 Musurgia universalis 232
 Smicroscopium parasiticum 32
Kleist, Heinrich von 30, 34

Knoop, Vera Ouckama 102
Koller, Hans 262
Ktesibios 230
Kubrick, Stanley 34, 280
Küpper, Joachim 146

Laban, Rudolf von 116, 150, 152, 164
 Choreutics 152
Le Roy, Xavier 104
Lenin, Vladimir Ilyich 80
Leonardo da Vinci 152
Livy 60, 82
Lucian 76
Lukács, Georg 228
Lumière, Auguste Marie Louis Nicolas
 266
Lumière, Louis Jean 266

Maillardet, Henri 232
Mallarmé, Stéphane 154
Mantero, Vera 358
Mao Tse-tung 80
Marey, Etienne-Jules 120
Marx, Karl 236
Meier, Christian 50
Méliès, Georges 266
Merleau-Ponty, Maurice 40, 124, 340,
 350, 352, 360
Meyrink, Gustav 248
Michelangelo (Michelangelo Buonarroti)
 140
Miller, Amanda 128
Milton, John 22, 24, 88, 90, 92, 94
Müller, Heiner 102
Muybridge, Eadweard J. 120, 266

Nephthys 54, 64, 66, 68
Nietzsche, Friedrich 16, 264, 266
Nijinsky, Vaslav 38, 340, 342, 360
Nut 54

O'Connor, Donald 274
Odysseus 282
Orpheus 20, 24, 76, 86, 108, 150, 262
Osiris 20, 22, 24, 48, 54, 58, 64, 72, 74,
 76, 78, 82, 90, 92, 94
Overlie, Mary 128

Panofsky, Erwin 142
Parmenides 278
Parmigianino 136, 138, 140, 148
 Self-Portrait in a Convex Mirror 139
 The Madonna with the Long Neck
 139
Paxton, Steve 34, 128, 344, 346, 348, 360
 Contact Improvisation 128
 Magnesium 344

small dance 348
Pellegrini, Matteo 164
Petrarch, Francesco 84, 86
Piacenza, Domenico da 110
Plutarch 74, 76, 78, 82, 88, 90, 92, 94
Pontormo, Jacopo da 136, 140
 Descent from the Cross 136
Porta della, G. B. 146
Pred, Allan 306
Proust, Marcel 16

Qebehsenuf 54

Rabinbach, Anson 246
Rachmaninov, Sergei Vasilyevich 224
Re 64
Riefenstahl, Leni 298
Rilke, Rainer Maria 102, 104, 106, 120
 Sonnets to Orpheus 102, 120
Rivière, Jacques 340, 342, 360
Roberval, Gilles 262
Rolnik, Suely 354, 358
Rossi, Aldo 106
Rosso, Fiorentino 140
Rudolf II 146, 160
Ruti 54

Schikowski, John 156
Schlemmer, Oskar 28, 148, 160, 162,
 164
 Egocentric Delineation of Space 160
 Triadic Ballet 160
Schnitzler, Arthur 34
 Dream Story
Schön, Ehard 162
Schopenhauer, Arthur 264
Schott, Caspar 232
Schwartz, Hillel 338
Scott, Léon 266
Sempere, Santiago 358
Seth 22, 64, 70, 76, 78, 82
Shakespeare, William 82, 84
 Coriolan 82
 Antony and Cleopatra 84
Shannon, Claude 268
Shearer, Moira 274
Shearman, John 140
Shu 54, 56
Sizzo, Margot 102
Solomon 60, 84
Spielberg, Steven 150
Stalin, Joseph 260
Stravinsky, Igor 340, 360
 L'Après-midi d'un Faune 38
 Le Sacre du printemps 38, 340, 342,
 360
Stuart, Meg 16, 28, 104, 124, 128, 148,
 162, 164, 358

Talbot, Henry Fox 260
Taussig, Michael 338
Tefnut 54, 56
Tesauro, Emanuele 158, 164
Teshigawara, Saburo 110
Thoth 54
Tiepolo, Giambattista 158
Trotsky, Leo 260
Turing, Alan 266

Valéry, Paul 16
Vasari, Giorgio 140
Vaucanson, Jacques de 28, 232, 238,
 240
Vesalius, Andreas 298
Vitruvius 230

Wagner, Richard 266
Waldenfels, Bernhard 124
Weber, Ernst Heinrich 268
Weber, Wilhelm 268
Wenders, Wim 302, 316
Wittgenstein, Ludwig 106

Zeuxis 86
Žižek, Slavoj 282, 284

ZERO

Biographies

Aleida Assmann, professor of English and comparative literature at the University of Constance since 1993; studied English and Egyptology in Heidelberg and Tübingen; doctorate in Heidelberg and Tübingen, 1977; habilitation in Heidelberg, 1992; publications (selection): *Die Legitimität der Fiktion* (1980), *Arbeit am nationalen Gedächtnis. Eine kurze Geschichte der deutschen Bildungsidee* (1993), *Zeit und Tradition* (1999), and *Erinnerungsräume* (1999); editor of anthologies of comparative literature and cultural studies, including *Weisheit* (1990), *Mnemosyne* (1991), and *Texte und Lektüre* (1996).

Jan Assmann, born in 1938, has been a professor of Egyptology at the University of Heidelberg since 1976. The main subjects of his research are Egyptian religion and literature in theoretical and comparative perspectives, theology, and cultural theory; and Egypt's reception in European intellectual history. Recent books of more general content are *Das kulturelle Gedächtnis* (3rd ed., Munich 1999), *Ägypten. Eine Sinngeschichte* (2nd ed., Frankfurt 1998), and *Moses der Ägypter* (Munich 1998).

Gabriele Brandstetter, professor of German literature at the University of Basle; studied German literature, history, and theatre studies in Munich, Regensburg, Vienna; doctorate in Munich, 1984; habilitation in Bayreuth, 1993; from 1993 to 1997 professor at the Institute of Applied Theatre Studies, University of Giessen. Publications on literature, theatre, dance, and performance from the 18th century to the present. Special focuses: theory of representation, concepts of body and movement in writing, image, and performance; research on theatricality and gender difference. Book publications (selection): *Loïe Fuller. Tanz * Licht-Spiel * Art Nouveau* (1989, co-author Brygida Ochaim), *Tanz-Lektüren. Körperbilder und Raumfiguren der Avantgarde* (1995).

At the zero point of energy, when all should be at perfect rest, particles still endure infinitesimal vibration. In this sense, vibration is the last threshold of the persistence of reality. Zero announces not the beginning, nor the end, but the constant, microscopic, vibratile motion towards endless modification.

Am Nullpunkt der Energie, an dem alles sich im Zustand vollkommener Ruhe befinden sollte, sind die Partikel immer noch einer infinitesimalen Vibration unterworfen. Insofern ist die Vibration die letzte Schwelle der Fortdauer der Realität. Die Null zeigt weder den Anfang noch das Ende an, sondern die konstante, mikroskopisch kleine, vibrierende Bewegung hin zu einer endlosen Modifikation.

Allen Feldman, PhD, is a cultural and medical anthropologist specialising in the political anthropology of the body, violence, and human rights. He is currently a Guggenheim Foundation Senior Fellow writing an ethnographic analysis of the South African Truth and Reconciliation Commission with a focus on the militarisation and failed demobilisation of youth. His second book, *Formations of Violence: The Narrative of the Body and Political Terror in Northern Ireland* (University of Chicago Press), now in its third printing, has been praised as a cutting edge ethnography of political terror as a symbolic system. Feldman has published numerous articles on political violence, the body, the senses, and visual culture in essay collections and journals such as *Public Culture*, *American Ethnologist*, and *American Anthropologist*. He is also a practitioner, deeply involved in the design and evaluation of harm reduction interventions for the homeless, sex-workers, substance-misusers, and people affected by AIDS.

Friedrich Kittler has held the chair of aesthetics and media history at the Department of Aesthetics, Humboldt University of Berlin since 1993. He studied German, Romance languages, and philosophy at the University of Freiburg im Breisgau. Publications (selection): *Aufschreibesysteme 1800/1900* (Munich 1985, 3rd ed. 1995); *Gramophone Film Typewriter* (Berlin 1986); *Dichter Mutter Kind* (Munich 1991); *Draculas Vermächtnis. Technische Schriften* (Leipzig 1993).

Gertrud Koch is a professor of film studies at the Free University of Berlin. She has been guest professor and had research residencies at numerous international institutions, most recently at the Getty Center in Los Angeles. Co-editor and advisor of *Constellations*, *October*, *Philosophy and Social Criticism*, *Women and Film*, and *Babylon*. Book publications on Siegfried Kracauer, film theory, perception theory, and the Holocaust.

André Lepecki is an essayist and dance dramaturge based in the US. His writing on dance and performance has appeared in *Mouvement*, *ArtForum*, *Ballet International*, *Contact Quarterly*, *Performance Research*, and the *Drama Review*, among others. He has contributed to anthologies in the field of dance studies and Portuguese studies. He has a master of arts degree from New York University, and is currently preparing his doctoral dissertation in performance studies at NYU. He has received grants from the Portuguese Institute of Scientific Research, and the Gulbenkian and Luso-American Foundations. Since 1992 he has collaborated as dramaturge with Meg Stuart/Damaged Goods. He has also done dramaturgy for Vera Mantero, João Fiadeiro, and Francisco Camacho. In 1999–2000, he co-created *STRESS* with designer Bruce Mau.

Bruce Mau founded his design company in 1985. Since then, Bruce Mau Design has worked with a list of international artists, publishers, architects, and cultural institutions. From 1991 to 1993, Bruce Mau served as Creative Director of *I.D.* magazine. In 1996, he launched the much anticipated book *S,M,L,XL* in collaboration with Rem Koolhaas. Presently he is the design director of Zone Books and an editor (with Sanford Kwinter and Jonathan Crary) of Swerve Editions, a Zone imprint. He is also the Associate Cullinan Professor at the Rice University School of Architecture in Houston, Texas. He has lectured widely throughout North America and Europe, and in 1998 was awarded the Chrysler Award for Design Innovation.

Peter Moeschl, professor in the Faculty of Medicine at the University of Vienna. Founder of the discussion forum and cultural-political magazine *der streit*. Art theoretical works and collaboration with the philosophical circle *Neue Wiener Gruppe* (Lacan Group). Numerous publications in the medical field, as well as diverse publications on questions in cultural studies, including "Bedeutung und Ansinnen – Tendenzielles zu Gronius/Rauschebachs Dramen", in *edition echoraum*, ed. Josef Hartmann and Werner Korn, Vienna 1992; "Ästhetik und Kunst – Differentieller Prozeß gesellschaftlicher Wortbildung", in *Texte. Beiträge zur psychoanalytischen Forschung im interdisziplinären Austausch*, vol. 14, no. 4, 1994; "Ästhetik und die stille Sprache der Ideologie", in *Texte*, vol. 14, no. 4, 1994; "Die Form als Prozeß. Zum generativen Verhältnis von Ästhetik und Kunst", in Martin Strauss and Eveline List (eds.), *Partizip Perfekt. Form in der Gegenwartskunst*, Vienna 1999.

C. Nadia Seremetakis, published/translated, award-winning author in cultural anthropology and literature, C. Nadia Seremetakis is best known for her ethnography *The Last Word*, based on long-term fieldwork in rural and urban Greece, and her book *The Senses Still*, both published by The University of Chicago Press and in Greek by Livanis Publishing Co. (Athens). She has taught extensively in major universities in the US and Greece, and she has done comparative field research in areas such as New York (minorities), Mexico, Ireland, and Albania.

Gerald Siegmund, born 1963, studied dramaturgy, English, and Romance languages in Frankfurt am Main. He received his doctorate in 1994 on the subject of "Theatre as Memory" (Tübingen 1996). He is an assistant at the Institute for Applied Theatre Studies in Giessen and is also a freelance writer in the area of dance for the Frankfurter Allgemeine Zeitung and for dance magazines in Germany and abroad. He has published numerous papers and essays on contemporary dance aesthetics. Gerald Siegmund lives in Frankfurt am Main.